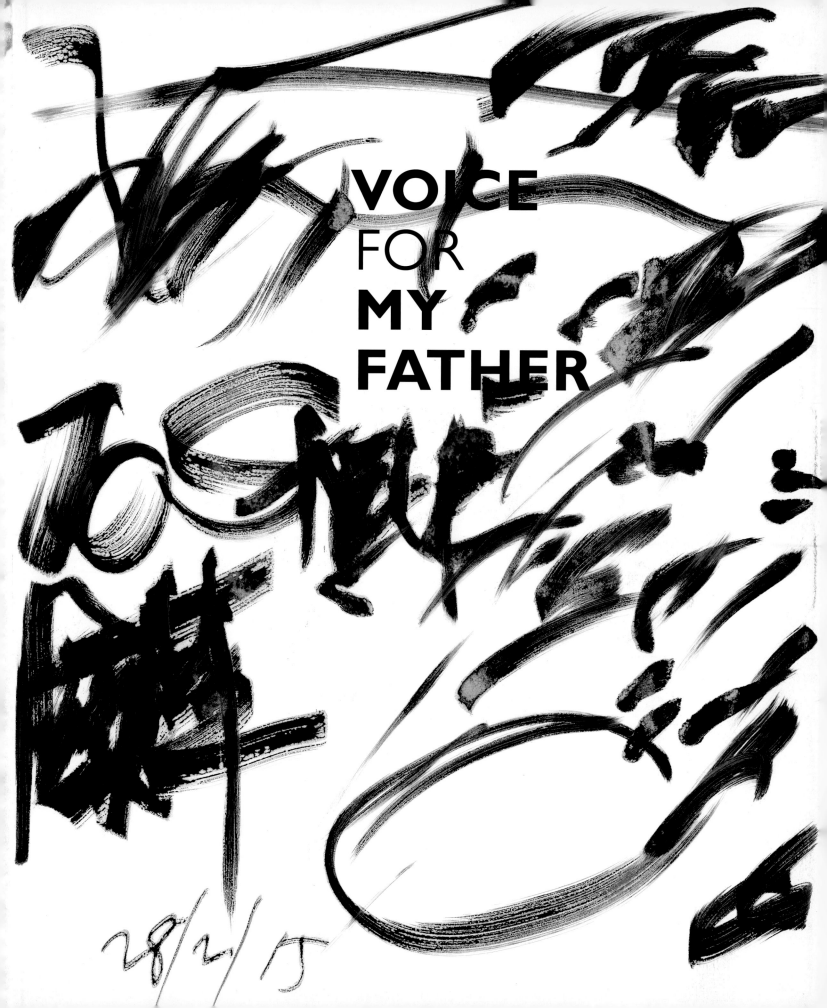

VOICE
FOR
MY
FATHER

28/2/15

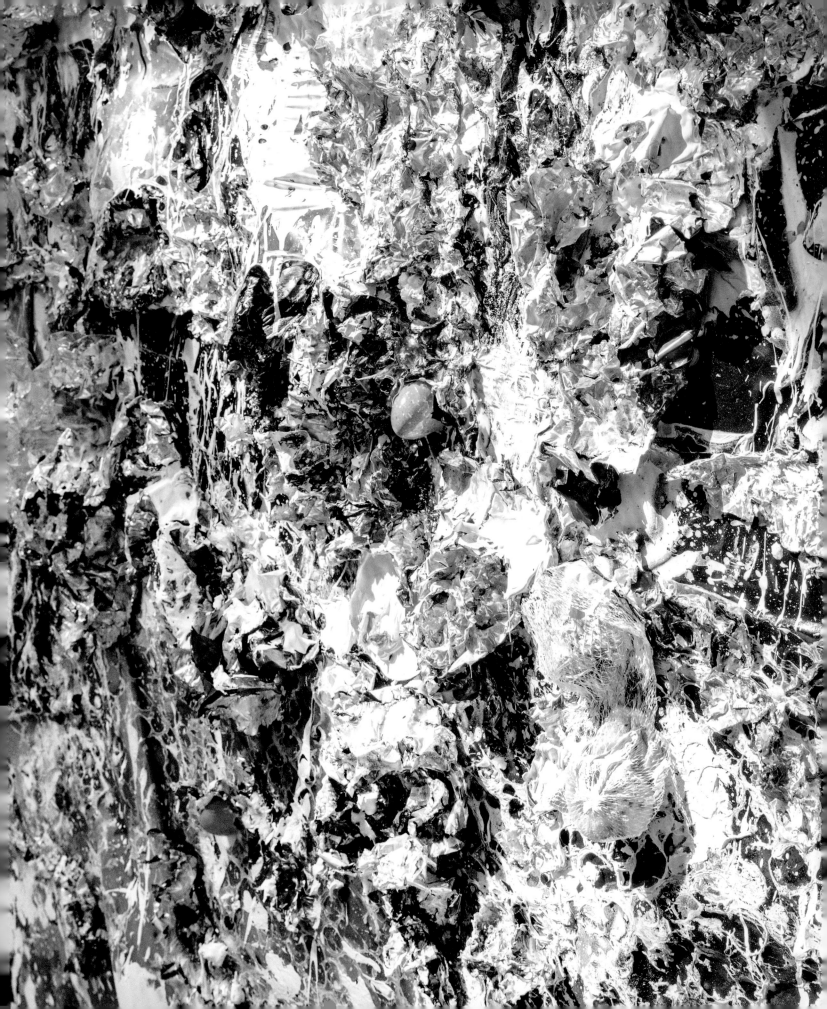

VOICE FOR MY FATHER

MICHAEL CHOW
AKA ZHOU YINGHUA

edited by Karen Marta and Philip Tinari

UCCA

Ullens Center for
Contemporary Art
尤伦斯当代艺术中心

上海
当代艺术
博物馆

Power
Station
of Art

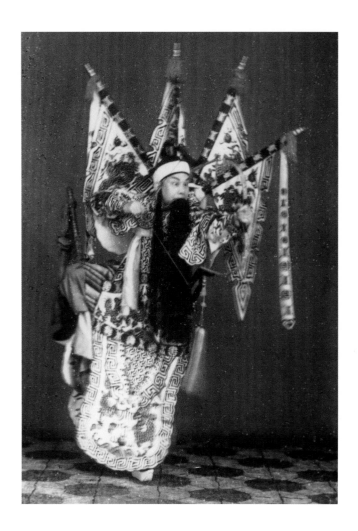

Zhou Xinfang as Zhang Xiu in *Battle at Wancheng*

Contents

for my father, Zhou Xinfang

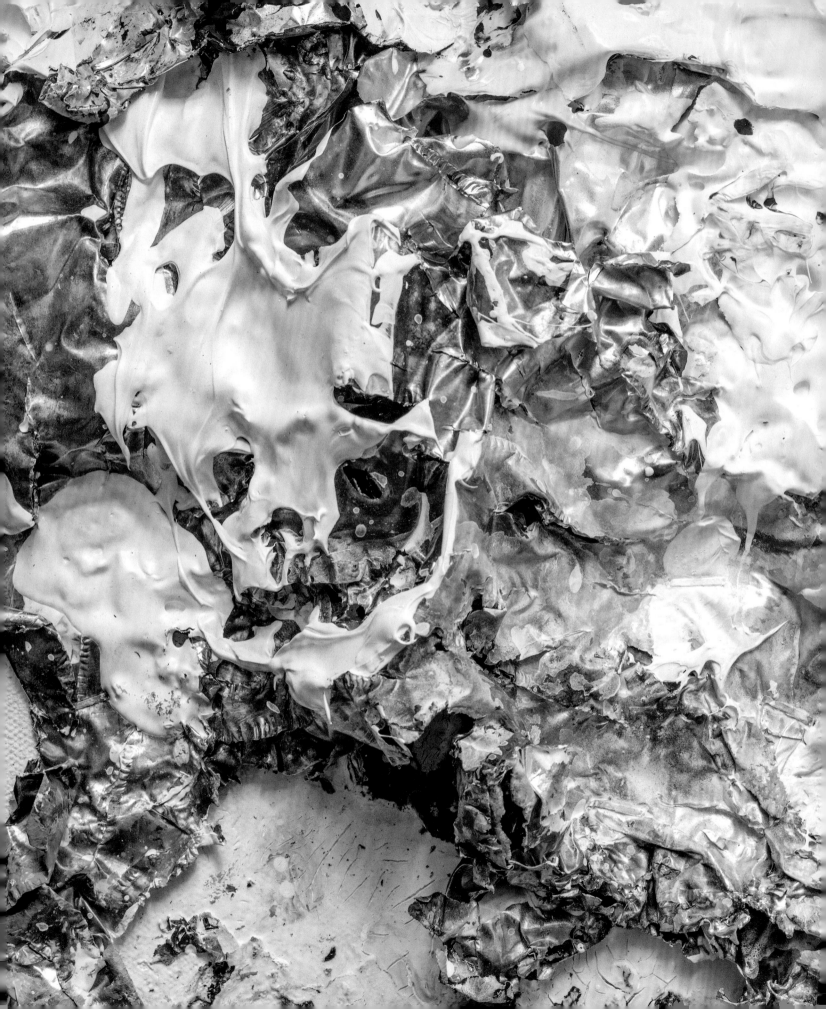

PREFACE

A figure like Michael Chow does not come along often. He is one of those rare humans whose biography borders on mythology or perhaps parable: a narrative winding and complex, yet which nods provocatively at some immediate truth. His uniquely cosmopolitan experience—grounded first in a cultured Shanghai upbringing, then in a London art training—has only recently become anything other than a historical exception. He is exactly the sort of personage that the Ullens Center for Contemporary Art is deeply proud to feature—one who, through the idiosyncratic breadth of his talent, proves an exception to many of the systems we have created for understanding the world, in a way that only enhances our knowledge of these institutions. His story is as universal as it is uniquely Chow.

UCCA has been devoted to global cultural exchange since its establishment—a place in China founded on and committed to the idea that exchange with the West is critical if they both are to grow. While the social and historical contexts of contemporary culture are always at the forefront of our investigations, we are excited, for this exhibition, to cast our curatorial eye all the way back to the heady days of early modern China, a period whose intellectual and artistic potency astounds to this day. The Center is also increasingly interested in the dynamic art scenes of the American West Coast and particularly Los Angeles, which Michael Chow has called home for several decades now.

Michael Chow: Voice for My Father has three main components: his work, portrait collection, and archival images, which together flesh out his lived experience at different moments in his history. We work backward from the present toward the past. The centerpiece of the show is of course Michael Chow's distinctive creative output, a monumental suite of paint and plastic, household detritus, and culinary ephemera. Presented alongside this is a selection of portraits commissioned by Chow, rendering his (perhaps charmingly anachronistic) activity as a patron of the arts. Finally, a special section documents the life of Zhou Xinfang, Michael Chow's Beijing opera star father, sketching out a lineage of artistry crucially important to understanding both generations. The exhibition has different titles in Chinese and English, but both titles position Chow, critically and acutely, as his father's son.

Perhaps our greatest aspiration for this publication is that it might capture, however obliquely, the peculiar, globe-spanning, deliriously ecumenical world of Michael Chow. All of these documents, from painting to portrait to photograph to book, are merely icons of the lives they claim to represent, a familial history far more valuable than the sum of these totems. In this uncertain age of China's ascendancy and ingrained globalization, it becomes all the more important that we learn from his story, and see what new lessons his special history might hold for our current era.

May Xue
CEO, Ullens Center for Contemporary Art, Beijing

In the west, Zhou Yinghua is best known for his famous MR CHOW restaurants, but in China, people are more interested in talking about his legendary life experiences and his father, Zhou Xinfang, the grand master of Beijing opera. Zhou Xinfang's self-conscious pursuit of a performance style that emphasized the expression of true emotion as well as subjective feelings, deeply influenced his son. Although Zhou Yinghua's life in distant lands led him to take a different path, it's not difficult to recognize that both father and son's sensibilities in art are the same. Zhou Yinghua once mentioned that he and his father were both Expressionists in the same sense. Indeed, in his work, the tradition of expression in Chinese ink painting and Western painting have been perfectly integrated.

Voice for My Father, Zhou Yinghua's first solo exhibition in China, includes his thematic art collection accumulated over many years, recent paintings, and rare archival documentation of Zhou Xinfang and his family. This exhibition gives us the opportunity to reexamine the emotional changes that have taken place in art, life, and history from the point of view of an extraordinary Shanghai family.

On behalf of the Shanghai Power Station of Art, on the special occasion of the 120th anniversary of Zhou Xinfang's birth, I personally welcome Zhou Yinghua home. I am certain that *Voice for My Father* will not only be loved by audiences but will become an important moment in both art history and the life of Shanghai.

Congratulations on the success of the exhibition!

Gong Yan
Director, Power Station of Art, Shanghai

上海
当代艺术
博物馆

**Power
Station
of Art**

MICHAEL CHOW, QI PAINTER

By Philip Tinari

IT'S EARLY ONE EVENING AT THE START OF OCTOBER, and Mr. Chow is sitting in his restaurant on Camden Drive in Beverly Hills, at the corner table closest to the door. He surveys the dining room, swarming with white male waiters in livery straight out of Toulouse-Lautrec, captains in white jackets, footmen in black. "Do you know the secret of serving a glass of water?" he asks his dinner companion in a tone somewhere between Socratic interlocutor and drill sergeant. His companion offers a reply along the lines of putting the glass down. "That's right!" he confirms. "The landing!" A few minutes later Chow starts on another path of inquiry. "How do you approach a table?" This one is harder to answer. He jumps up from his seat to demonstrate—to the delight of the diners, who universally recognize him in his trademark mustache and round glasses—how one closes in on a group of guests: the approach beginning a few feet away and moving through a mannerist flow of steps until shoulders are aligned squarely with the table and the waiter is confidently present. It resembles nothing so much as the sequence of hand and foot motions that precede the beginning of song in Beijing opera, accented by syncopated bangs of the *luo*. "There is an incredible amount of *gongfu* contained in that single action," Michael Chow notes. "And that is how I've managed to stay creative running a restaurant all these decades. This is theater. We are a musical that has been on stage for forty-five years!"

To talk about Michael Chow the artist, one must first solve the problem of Mr. Chow the restaurateur. This is after all what the world knows him for, and more to the point,

where he has spent the bulk of his professional life. The restaurant, at its core, is two things: a place where Chinese food is served on fine silver by Caucasian waiters in formal dress; and a place where artists (and actors, and models, and titans) come to congregate, often in the presence of its owner. A happening ahead of its time, MR CHOW, first in Knightsbridge, then Beverly Hills, then midtown Manhattan, is relational feast as a functioning business. And it is actually premised on a very specific set of circumstances that became a starting point for Michael Chow's involvement in the world: "Everything I do is to fight racism," he states, with an impassioned combination of adamancy and wist. While he would deny it, one could just as easily make a case for MR CHOW—at once the vessel of his fame and the content of his daily practice—as what Joseph Beuys called "social sculpture." "When all of these elements are accumulated and put together, they become very powerful," Chow concludes, speaking of both his restaurants and his paintings.

"The key question for me was always: How to overcome that China is treated as the lowest of the low," he argues, as the prawns arrive. To go any further is to engage a stock narrative that has been recounted many times: the story of Michael Chow. Other texts in this volume contextualize the privileged Shanghai world into which he was born Zhou Yinghua in 1938 and the unique artistic contributions of his father, Zhou Xinfang, the inimitable grand master of Beijing opera. Still others speak of Michael Chow's outsized position in the art/film/fashion nexus from the late 1960s onward, as evidenced by the range and caliber of the artists who have admiringly portrayed him. In interviews Michael Chow has spoken about his life as that of a journeyman artist, particularly since leaving China in 1951 at the age of thirteen, in advance of a cascade of social movements that would lay waste to his family's fortune and legacy for many decades.

We have seen his two key extant early works, one from 1959, one from 1962, in which his central techniques of collage and drip painting become separately apparent. We know that he studied painting at St. Martin's: the communist exile became a beneficiary of the great postwar boom in British art education, when the schools opened art-making to the working class. We know that he showed in a range of exhibitions in the early sixties with titles like *Three Contemporary Chinese Artists* and *Artists of Fame and Promise*. And he tells us that, at a certain point, the burden of trying to lay claim to a position in an art history—and a place in an art scene—that was still chauvinistically Euro-American became simply too great. In the London of the Swinging Sixties, no one had heard of Zhou Xinfang. That's when the restaurant—that Gesamtkunstwerk of anti-racism—was hatched and his painting career went into hibernation. "There are three things that eliminate racism," he once said. "Being a prince, being eccentric, and/or being creative. If you possess two out of the three things, then society will embrace you."[1]

The paintings that Michael Chow began to make in 2012 have already garnered a healthy amount of critical and journalistic attention. Inevitably they have been discussed in the context of a "return," the endpoint of a Homeric journey. Like many artists, his biography lends itself to precisely this sort of mythmaking. Less attention has been paid to the works themselves, products of an alchemical arsenal of techniques ranging from splashing to burning to stapling. These paintings incorporate a pharmacopeia of materials, breathtaking less for their physical properties than for the range of technical and aesthetic demands they imply. In a single painting one finds sheets of gold and silver foil poking through plastic wrap which has been burned; small-denomination US currency sealed in Ziploc bags and stapled to sheets of dried paint, stapled in turn to the canvas below; rubber gloves and rubber tires and egg yolks preserved in resin; colors straight from cans poured and dripped with the profligacy of Pollock in his timeless *LIFE* magazine pictorial. This ecumenism of source material is less remarkable however than the compositional tenor of the resulting works, abstract meditations on timeless structures: the four seasons, sunrise, sunset, the sea.

Hanging on the walls of his studio, along an industrial street tucked away in West L.A., the paintings pose more questions than they answer. The most pressing however is also the key question of Michael Chow's life: put crudely, are we to view these creations through a Chinese, or a Western, lens? The arguments for the latter are certainly strong. On the canvases, aside from the aforementioned traces of Pollock, we see hints toward the skepticism of the pigment–support relationship of Fontana, the radical combinatory logic of Rauschenberg, the performative palimpsests of Yves Klein, and the no-holds-barred materiality of Schnabel. As works inhabiting a particular tradition—that of gestural abstraction, as practiced from the mid-century onward—Michael Chow's works find a natural and loving home. These are not the imaginings of a distant practitioner, but responses honed over decades of close contact with some of the key protagonists of postwar Western art. They speak not only for themselves, but for all that their maker has seen.

And yet, at the peril of Essentialism, might we also not effectively look at Michael Chow's artistic persona as somehow innately Chinese? To begin we need only examine the portrait collection—assembled in the time-honored artist-scholar tradition of lively exchange among peers and the poetic commemoration of jovial encounters—to find a very different kind of connoisseur. From there we might look at his own creations in the light of modern Chinese masters who, over the course of the long twentieth century, each made their separate peace with Western modernism. Zao Wou-ki, a senior contemporary, comes to mind for the gentle luminosity of his palette and for the ineffable *qi* which infuses his compositions. But so does Wu Guanzhong, with his inky drips that nearly seem to

tessellate, Liu Kuo-sung and his cosmic reflection on how to make ink modern, or the early oilists Hiunkin Pang and Yan Wenliang with their studied embrace of European technique put to the service of another aesthetic register. In more recent Chinese history, we might usefully compare him to Xu Bing, who remains fascinated with the meaning-making potential of language and its instruments, or Cai Guo-Qiang, who has embraced the creative potential of the singular explosive moment. Might we not then see Michael Chow in the same trajectory of Chinese-born artists who, driven by the disruptive pressures of a nation seeking a return to what scholars Orville Schell and John Delury have recently called "wealth and power,"[2] have found themselves on extended sojourns that have lasted anywhere from a few years to a lifetime?

Perhaps the real question is what it means that Michael Chow, himself the product of uniquely profound historical experiences, has embraced an artistic language—that of abstract painting—that grows from another distinct history. In other words, what, about our larger predicament, can be gleaned from the fact that this man, at this moment, has decided to make these things, in this way? The terrain of art expanded during the second half of the twentieth century such that, now, disparate objects can be stapled to a canvas without a lick of subversion, even with a certain amount of classicism. Likewise the world has opened so that young Chinese artists now work in contexts and languages that are implicitly global, while their elders in the generation that emerged during the eighties command market prices on a par with, and often exceeding, those of their peers in Europe and the United States. Michael Chow has witnessed both of these arcs, and now lives comfortably at their intersection. The corollary to this question might be: What does it mean for China that it produced such a son? How does his prolonged presence on the global scene work to enrich and subvert our most persistent understandings of China and its place in the world? What sort of exceptionalism might be built from this single case? These are the tensions that swirl implicitly around his studio.

Back in the restaurant, on to fried rice, he starts to point out details. The junior waiters' aprons are just tablecloths, tied from behind in a fastidious single knot. The square tables are illuminated by square spotlights, the round tables by round spotlights. "Alex Israel has built a career out of appropriating Hollywood glamour and kitsch," he notes of the young Los Angeles artist whose video interview, which is part of Israel's *As It LAys* series, constitutes the most recent addition to Chow's ongoing portrait collection. "I did that decades ago!" he says, pointing to the restaurant's storied black-and-white checkerboard floor. "Back then there was nothing more glamorous than a floor like this!"

Conversation returns to the importance of timing, placement, technique—the common body of skill shared by opera singers, painters, restaurateurs. From there to loss: the Shanghai of his childhood, multiply vanished, multiply rebuilt. His signature balance of delight and melancholy, perhaps the fate of the successful émigré, prevails. "My life is like a movie," he says. "In a movie, you always find a parking space, you win over the beautiful woman, you live in a lovely house." President Obama is coming for breakfast the next morning, and it is getting late. His father, first censured during the Anti-Rightist campaign of the late fifties and later destroyed during the Cultural Revolution, has been rehabilitated; in a few months Michael Chow will travel to Shanghai and Beijing first to commemorate the 120th anniversary of his father's birth, then to show his paintings for the first time on the Chinese mainland, in a museum inside a former factory built just a few years after he first left home. A homecoming, a reunion, a testament: history vindicated not just by auditoriums renamed or official biographies rewritten, but through the sort of living, filial creation that carries on the legacy of one's forebears, reshaping it for a world reshaped. An actor of the Qi school begets a painter of the Qi school, the son one in being with the father. A kind of salvation through another kind of reincarnation.

"My whole life has been about trying to create something that could recreate the extraordinary world I knew as a child," he glosses as he heads for the door. "And I have done all of this in order to prove to my father that it could be done."

1. "Michael Chow Interviewed by Jeffrey Deitch," *Recipe for a Painter* (Shanghai: Pearl Lam Galleries, 2014).

2. Orville Schell and John Delury, *Wealth and Power: China's Long March to the Twenty-first Century* (New York: Random House, 2013).

THEATER
OF
PAINTING

By Jeffrey Deitch

IT LOOKS LIKE AN EXPLOSION IN A PAINT FACTORY. Every surface of Michael Chow's studio is splattered with paint spray. Layers of spilled paint pool on the floor. Crinkled sheets of metal, bales of plastic, fishnets, and blown-out rubber tires are thrown against the walls. Large sheets of acrylic paint are drying on an adjacent terrace. Pliers, shears, scrapers, staplers, and propane torches are laid out on a worktable next to tins of lighter fluid. An immense flat expanse that looks like a topographical model is propped on a set of tables in the center of the room. Michael Chow asks me to climb the ladder beside it and look down.

Michael Chow's latest painting in progress looks like an apocalyptic battlefield. The ladder is not there just to offer a better view. It is the perch from where the artist pours thick household paint, shoots from a paint gun, and scatters studio debris to create a controlled composition out of the chaos. Dismounting the ladder and working closer to the painting, he fastens sheets of paint, plastic, and metal foil to the surface, going through one to four thousand staples per painting. Cracked eggs, bumper stickers, and see-through bags of money are among the other elements that are added to complete the composition. It is a demanding physical process, almost a performance. While he is making the work, the artist is virtually inside the painting.

One month later, on a return visit, the turbulent landscape that I looked down upon is now mounted vertically on the wall of Michael Chow's second studio. The violent composition has been reshaped into a luminous, atmospheric rendering of the cosmos.

A galaxylike form sweeps across the surface, punctuated by rhythmic diagonal lines. It has become the artist's ambitious response to one of the seminal American paintings, Jackson Pollock's *Blue Poles*.

Michael Chow's work fuses Asian, American, and European aesthetic approaches, drawing on his extraordinary international background. His paintings embody his experience in theater, painting, and even cuisine. His sixty years of creativity have now been distilled into the most concentrated and perhaps the most challenging art form: abstract painting.

Michael Chow points to two modest paintings leaning against the wall of his pristine auxiliary studio in a warehouse area near the 405 Freeway. The calm order of this second studio, where he has the space to contemplate his work, contrasts with the whirlwind inside his home studio in his former pool house. "This is where it all comes from," he says, referring to the two paintings from the early 1960s. They are the only works he has retained from his early, promising painting career when his work was presented at the ICA and the prestigious Redfern Gallery in London. One of the paintings is cut and slashed like a work by Lucio Fontana, with a thick, earthy surface reminiscent of Antoni Tàpies. The other is a poured painting in Pop colors, in dialogue with American Color Field painters like Jules Olitski and Larry Poons. These works represent the European and American approaches to abstract painting that Chow has combined with a Chinese conception of space and texture to form his unique aesthetic.

The necessity to earn a living during a period when contemporary art still had a small audience, and then the tremendous success of MR CHOW, the restaurant he started in London in 1968, took Michael Chow away from painting, but not away from creative expression. His MR CHOW restaurants are like Gesamtkunstwerks, where he orchestrates the art, architecture, design, and cuisine into a participatory theater. He remained engaged in art through his famous collection of portraits and his friendships with Andy Warhol, Ed Ruscha, Jean-Michel Basquiat, and other leading artists. But despite his celebrity in the art world, Michael Chow stopped painting for fifty years.

I had seen the small poured painting leaning against a wall near the kitchen of his house when I visited Chow in early 2012 to prepare a talk at Soho House about his creative achievements in architecture, design, acting, and other fields. At the time, I did not know that painting had once been the focus of his life. I was intrigued by this diminutive but impactful painting, and, responding to my interest, he retrieved a 1962 ICA catalogue that reproduced works from this series.

I was presenting *The Painting Factory*, an exhibition of new abstract painting at the Museum of Contemporary Art, Los Angeles. During the run of the show, I would often find Michael Chow in the galleries studying the paintings by Andy Warhol, Christopher

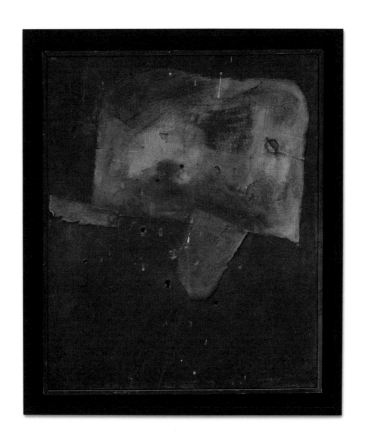

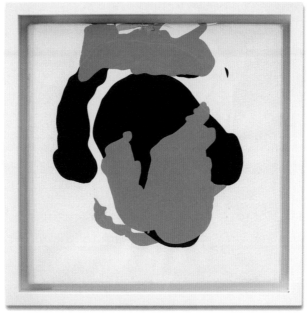

TOP *Black Painting*, 1959
Acrylic paint and collage on canvas
35 × 30 inches (89 × 76 cm), framed
BOTTOM *Untitled*, 1962
House paint on canvas
18 × 18 inches (46 × 46 cm), framed

Wool, Rudolf Stingel, and promising younger artists. One day he confidently announced to me that he might not be able to stand up to the work of the senior artists, but he could make paintings that could match or surpass the achievement of most of the artists in the show. He was ready to begin a remarkable painting marathon that would compress into two years what an artist would normally take five years to achieve. The work would build on where he left off in the early sixties but would also incorporate his fifty years of insights and his conversations about art with the world's greatest artists and connoisseurs.

Michael Chow now starts his working day watching artist interviews and documentaries on YouTube. His actor's facility of remembering lines is now channeled into quoting statements from the artists he most admires. He often repeats his own version of a comment by Francis Bacon, declaring that he wants to use every variation of painting known to man. Inspired by the artists' insights, he then plunges into his own painting, spending the entire day in the studio. He works alone, without an assistant, pouring, burning, tearing, scraping, melting, flipping, dripping, and stapling. The fifty years of creative energy that he held back is now bursting out. Michael Chow does not want to waste time. Aware of his age and the tremendous physical demands of the work, he wants to accomplish as much as he can while he can still climb up and down the ladder and punch in thousands of staples a day.

Michael Chow's first paintings in 2012 were dense all-over compositions built up with accumulations of sheets of silver. The silver gives the paintings a powerful, magnetic quality. They are both otherworldly with their reflective surfaces and earthy with their abundant use of natural metal. They evoke the texturologies of Jean Dubuffet and the physical approach to painting of Alberto Burri, Lucio Fontana, and Antoni Tàpies.

These "early" paintings are startling in their boldness. Chow did not return to painting tentatively; he began painting again with outsized ambition and confidence. After the density of the first series, the compositions opened up. The work soon began to incorporate the spatial structure of Chinese landscape and the grace of Chinese calligraphy. The negative space became just as important as the image. Energized by the examples of Jackson Pollock and Yves Klein, and the concept of immersing the body into the painting process, he became freer in his gestures. He also became more comfortable mixing chance with control in composition. The latest work is characterized by a sense of movement and fluidity.

It is now Michael Chow's paintings, much more than the living theater of his restaurants, which synthesize all aspects of his remarkable background and creative life. When he first returned to painting he was advised by many of his friends to paint under his Chinese name and to separate his work as a painter from the celebrity of MR CHOW. Rather than contradicting each other, his accomplishments as a restaurateur, architect, actor, and visionary collector contribute to his achievement as a painter. Michael Chow's paintings represent not only an exceptional artistic vision, but an extraordinary life story.

STUDIED ELEGANCE

By Christina Yu Yu

MICHAEL CHOW'S LARGE, AMBITIOUS PAINTINGS have been slowly fermenting for the last fifty years—his last one-person exhibition was in London at the Lincoln Gallery in 1962. Without any prior warning, in 2012, they suddenly reemerged, to the surprise not only of his family and wide circle of friends and admirers, but also seemingly to the artist himself.

Although today he is somewhat dismissive of the self-conscious answers he gave to questions posed by English critic Kenneth Frampton in the catalogue of the Lincoln Gallery exhibition, much of what Chow said then still pertains to the 2012 and later paintings.[1] Here in embryo, then, is an approach to painting that would lie dormant for fifty years until two years ago, when Jeffrey Deitch was visiting Chow at his home and happened to notice a small painting of Chow's from 1962 leaning against the wall. It impressed Deitch so much that he encouraged the reluctant painter to pick up his brushes again. The floodgates opened!

Michael Chow has returned to painting at an age—he is seventy-five years old—when some of the greatest artists have begun developing a "late style," a stylistic definition that means much more than the chronological period close to the end of an artist's life. The late works of such colossal figures as Titian, Rembrandt, Picasso, and Matisse are characterized by a new-found freedom in which all constraints, formal and technical, are swept aside. This is the point where Chow has resumed his career, after the self-imposed abstention from painting during which he concentrated on other aspects of his innate creativity.

While it is tempting to investigate the psychological causes of this unusual phenomenon— this late blooming—we would be ill-advised to do so, as Michael Chow is very much in charge of this effusion of challenging paintings. They are paintings insofar as they hang on the wall, but the word *paintings* is not sufficiently inclusive, as their heavily encrusted

surfaces project into the viewer's space and incorporate all kinds of found materials. In *Recipe for a Painter*,[2] Chow gives an account of the earliest stages of this fast-paced journey, describing a gold-colored sculpture by Miró that inspired him to make pure silver sheets, which he stretches and welds to create works in which two- and three-dimensional qualities vie for priority.

There is a strange metaphorical aspect to this story, an egglike sculpture giving birth to an ongoing body of work that rivals Miró's oeuvre in its total disregard for any distinction between high and low, traditional materials and all kinds of debris. This was a freedom that Miró claimed for himself in his extraordinary Surrealist objects of the 1930s and then largely abandoned until he was near the end of his life; it is a similarly extraordinary abandon that first impresses a visitor to Chow's studio. Initially, the wild visual rhythms of the heavily encrusted paint surfaces seem to be a development of the gestural abstraction that reached a climax in American Abstract Expressionism of the 1940s and 1950s, or with the more painterly members of the Gutai group, until one notices the array of readymade materials that have been swept into the maelstrom. Among these bits and pieces might be mentioned the following: sponges, plastic gloves, netting, nails, eggs and eggshells, newspaper, ashes, and money—two-dollar bills stapled to the painting or enclosed in Ziploc bags.

Of course, such a practice has a long history in Western modern art, from Picasso and Kurt Schwitters to Jasper Johns and Robert Rauschenberg, but seldom are the objects embraced with such lavish applications of pigment. Certainly the obvious relish in the materials and the sculptural treatment of the surfaces can be traced back to the paintings of the 1950s and 60s, but the art that Michael Chow has been exposed to in the fifty years since that brief efflorescence has undoubtedly contributed vastly to the magisterial scale and ambition of his recent works. In conversation and interviews, he has referred to artists whose work he has admired since then; these include Jackson Pollock, who also on occasion incorporated objects such as cigarette butts, nails, and screws into his canvases, although not to any great degree, Cy Twombly, and several artists of a younger generation, above all Jean-Michel Basquiat. Notably missing from the list of his artistic affiliations are any Pop artists, perhaps because they are too specific in their references to contemporary life.

Under different circumstances this stagestruck youngster might have followed the family tradition—he is the son of Zhou Xinfang (1895–1975), one of China's greatest twentieth-century Beijing opera singers and composers, well known not only for his vocal and acting abilities but also for his personal involvement with every aspect of the productions—but this was not to be. In 1952 Chow was sent to boarding school in England, a rude shock and certainly the greatest contrast possible with the colorful world of Shanghai. There would not have been much emphasis on the visual arts in this new environment but, three years later, he managed to escape. An interest in photography led to a year at Saint Martin's School of Art, and from 1956 to 1958 he studied architecture at the Hammersmith School of Art and Building.

Success came fairly early. His work was shown in important London venues such as the Leicester Galleries and the Redfern Gallery. His show at the Lincoln Gallery revealed the work of a young artist who knew exactly what he was doing. Like Chinese artists of a slightly earlier generation who went to Europe to study—such as Zao Wou-ki (1920–2013) to France and Hsiao Chin (b. 1935) to Spain—Chow, while immersed in London's experimental art community, was fully aware of the ancient Eastern traditions and philosophy he grew up with. Discussing the influence of Zen, in an interview with Ken Frampton in 1962, he remarked:

> I aspired to "paint by not painting," and in spite of the inevitable western influence I work towards these characteristics. I also work towards a certain feeling of "aloneness," which is peculiar to Zen thought. For this reason the feeling of space in my work suggests the isolation of man dwarfed in nature. My painting is specifically concerned with trying to capture certain moments when the rhythm of life is brought to a height. It is only at these moments that one can hope to see the "oneness" of life. I place elements in my canvases in order to create a pause. A composer once said that "music happens between notes." I am rather interested in this idea. For instance, the particular moment just before a bird lands. This notion of pause is closely connected to a sense of awakening which gives one an unexpected feeling of enlightenment.[3]

Always keenly interested in locating commonalities between Asian and Western art, Chow refers to a number of influences, including Mark Tobey, Barnett Newman, and Ad Reinhardt, "for their tendency to obtain the maximum from the minimum," and also admits to the role of "controlled accident" in his work, stating that, "within the limit of my thrown-paint technique, I can anticipate results only up to a certain point."[4] The clearest debt seems to be to Alberto Burri, whose use of commonplace materials he particularly admires. Relatively small in scale (none larger than five by four feet), Chow's early paintings emphasize the materiality of the pigment and the manner in which it is applied to the canvas support. In recent work such as *Remembering 1781 at Sea* (2014), one can see a clear reference to J. M. W. Turner in composition and color, and above all in the burst of vigor and energy ("violence," to use Chow's own word), anticipating more to come.

Reflecting on the relationship between the Chinese and Western sides of his personality in a recent interview with Emily McDermott, Chow said, "My Chinese side is never conscious. It's all subconsciously coming out," in contrast to his Western side, which is "much more conscious."[5] That is to say, the material aspect of his paintings reflects an inborn

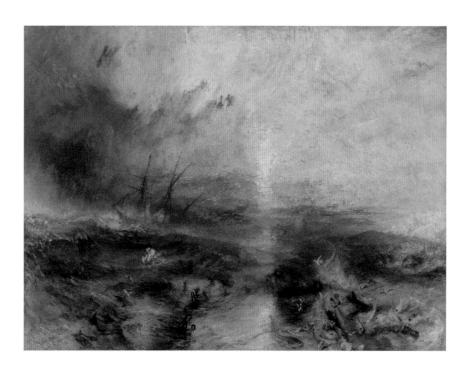

J. M. W. Turner, *Slave Ship (Slavers Throwing Overboard the Dead and Dying, Typhoon Coming On)*, 1840
Oil on canvas
36 × 48 inches (91 × 122 cm)

acknowledgment that the artist is part of a much larger whole, that his role is not to express his own emotions but the harmony between all things, from the humble to the sublime. It is important to see how this might manifest itself in his return to painting. In a recent series, *Four Seasons* (2013–14), inspired by a set of Ming dynasty flower-and-bird paintings that he saw at the Los Angeles County Museum of Art, there is an explicit acknowledgment of a deep-rooted philosophical connection with the aesthetics of classical Chinese painting.

For his whole life, Michael Chow has been in the public eye. He developed a persona that has served him very well. However, when he is in his studio he is alone, confronted with his materials—orthodox and not so orthodox—and with a lifetime of memories, of family life in Shanghai, of heady days in London in the sixties and seventies, followed by equally stimulating periods in New York and Los Angeles. He has always been in the right place at the right time. As a public figure he is deservedly renowned for the panache of his entrepreneurial activities, the elegance of his designs and lifestyle. Now that he has taken the major step of returning to painting, he is performing for himself, gleefully handling large

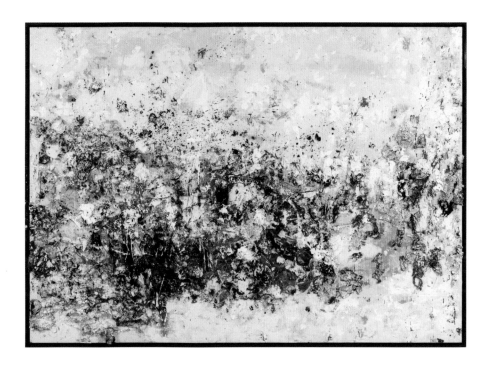

Remembering 1781 at Sea, 2014
105 × 147 × 8 inches (267 × 373 × 20 cm), framed

masses of seemingly incompatible materials. Notable for its Dionysian quality, his painting is in marked contrast to the studied elegance that most people associate with his name. In the performative aspect of his work, the spontaneous assembly of diverse materials in dynamic visual displays, it is difficult not to look for antecedents in the triumphant career of his father and hero, Zhou Xinfang, in whose productions and compositions singing, acting, acrobatics, and visual qualities were triumphantly melded. In spite of the fact that Michael Chow saw very little of his father as a child, even while still living in China, and did not see him again after he moved to England, he always idolized him. A career in the Beijing opera was not for him, but he felt a strong desire to make his mark in a creative field that would equal in distinction the trailblazing career of Zhou Xinfang. Even before the Cultural Revolution was over, Michael Chow was representative of a newly confident China that was not to become a reality until the 1990s. This was accomplished in his hugely successful business empire, which placed him at the forefront of many interlocking facets of the business, cultural, and fashion worlds.

Michael Chow's career as an artist has recommenced after a hiatus of fifty years, perhaps a unique phenomenon in the visual arts—or any other art form, for that matter. The paintings of 1958–62 give us a foretaste of the paintings that began to emerge from his studio in 2012, but no hint as to the grand ebullience of his "late style."

1. "Some questions to the artist by Kenneth Frampton," *Michael Chow* (London: Lincoln Gallery, 1962).
2. "Michael Chow Interviewed by Jeffrey Deitch," *Recipe for a Painter* (Shanghai: Pearl Lam Galleries, 2014).
3. Ibid.
4. Ibid.
5. Emily McDermott, "Where Michael Chow Paints," *Interview Magazine,* accessed September 15, 2014, http://www.interviewmagazine.com/art/michael-chow-restaurant-for-a-painter#_.

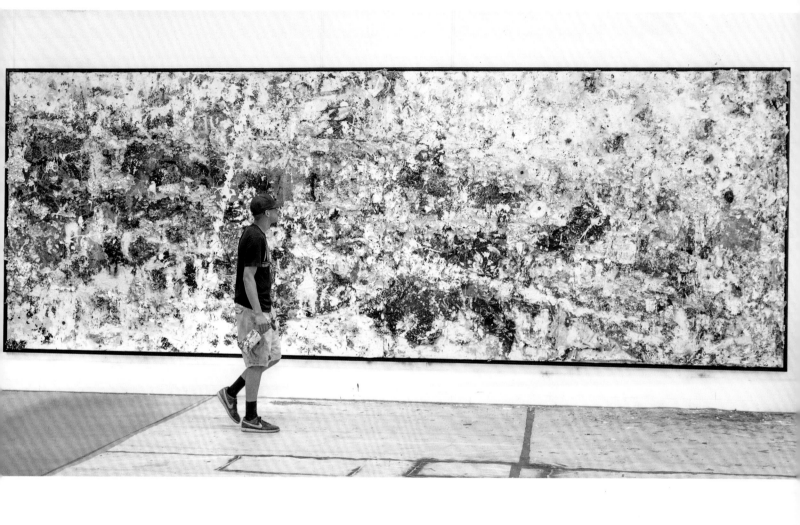

View of *Beyond White Poles*, 2014

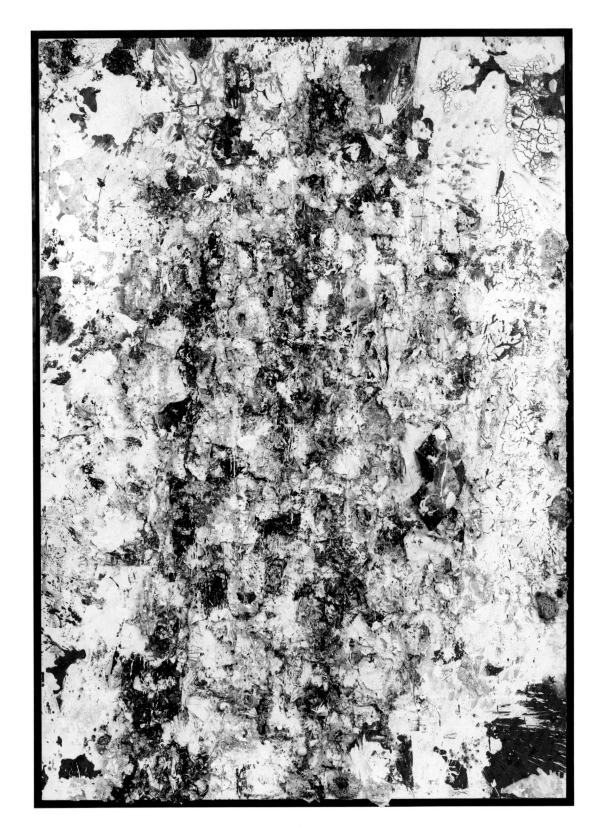

Four Seasons (Summer), 2013–14
147 × 105 × 8 inches (373 × 267 × 20 cm), framed

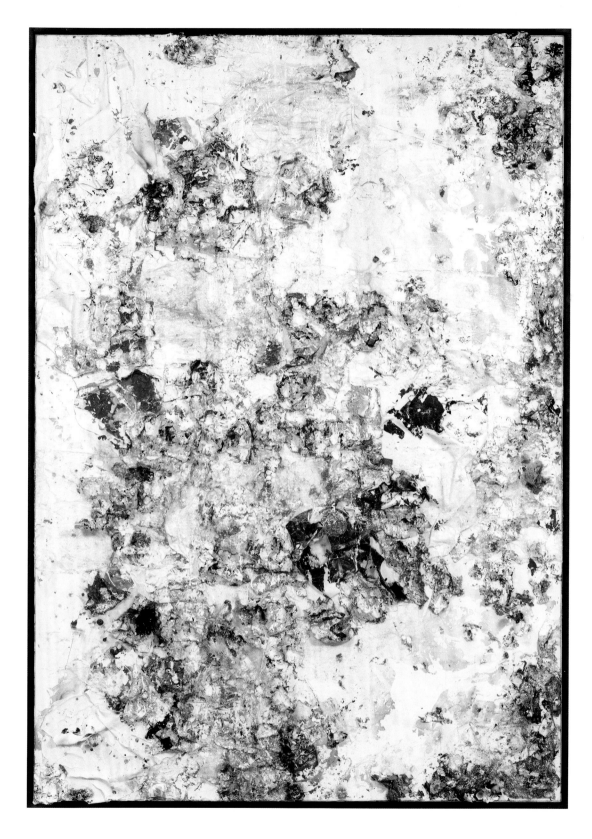

Four Seasons (Spring), 2013–14
147 × 105 × 8 inches (373 × 267 × 20 cm), framed

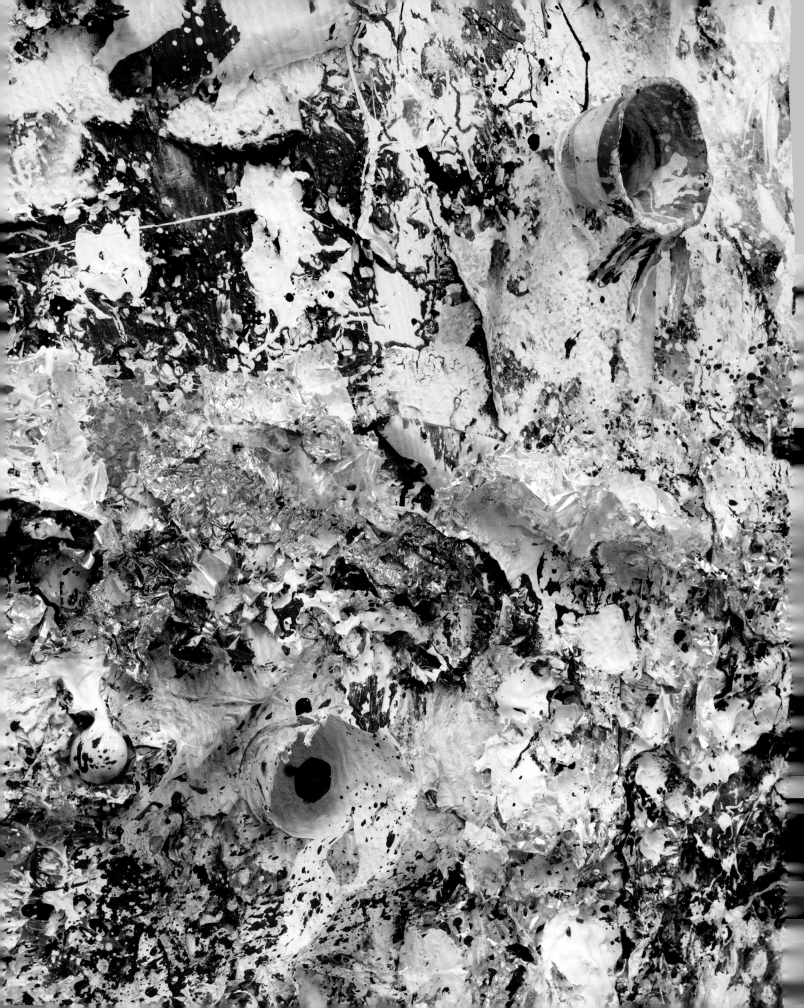

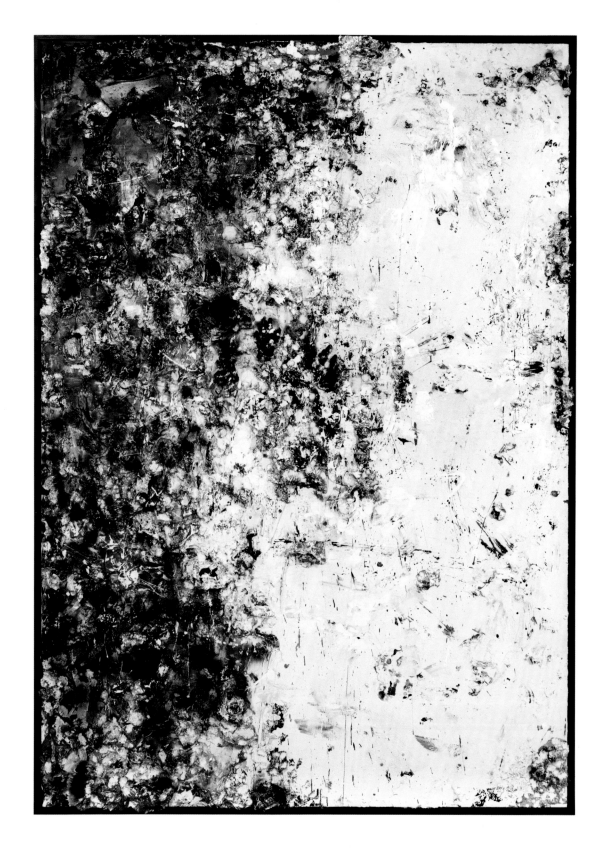

Four Seasons (Winter), 2013–14
147 × 105 × 8 inches (373 × 267 × 20 cm), framed

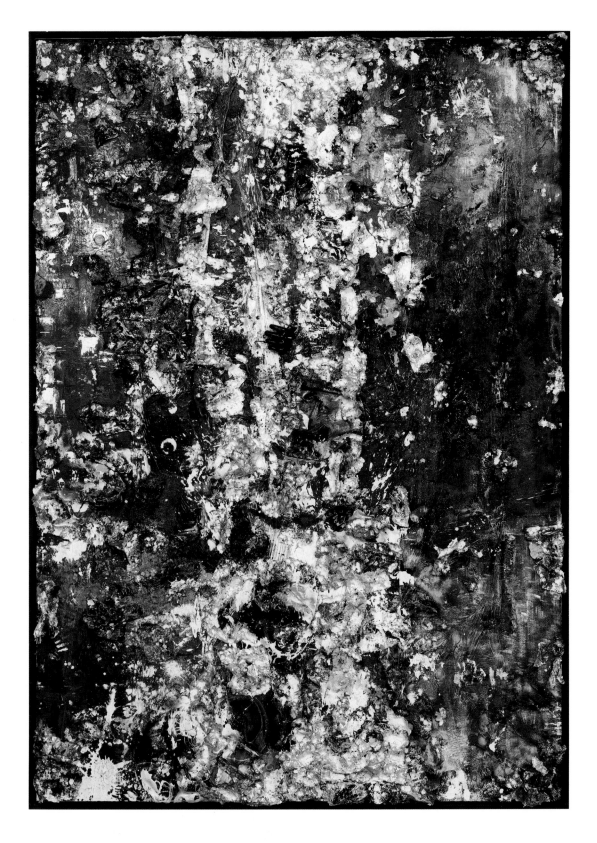

Four Seasons (Autumn), 2013–14
147 × 105 × 8 inches (373 × 267 × 20 cm), framed

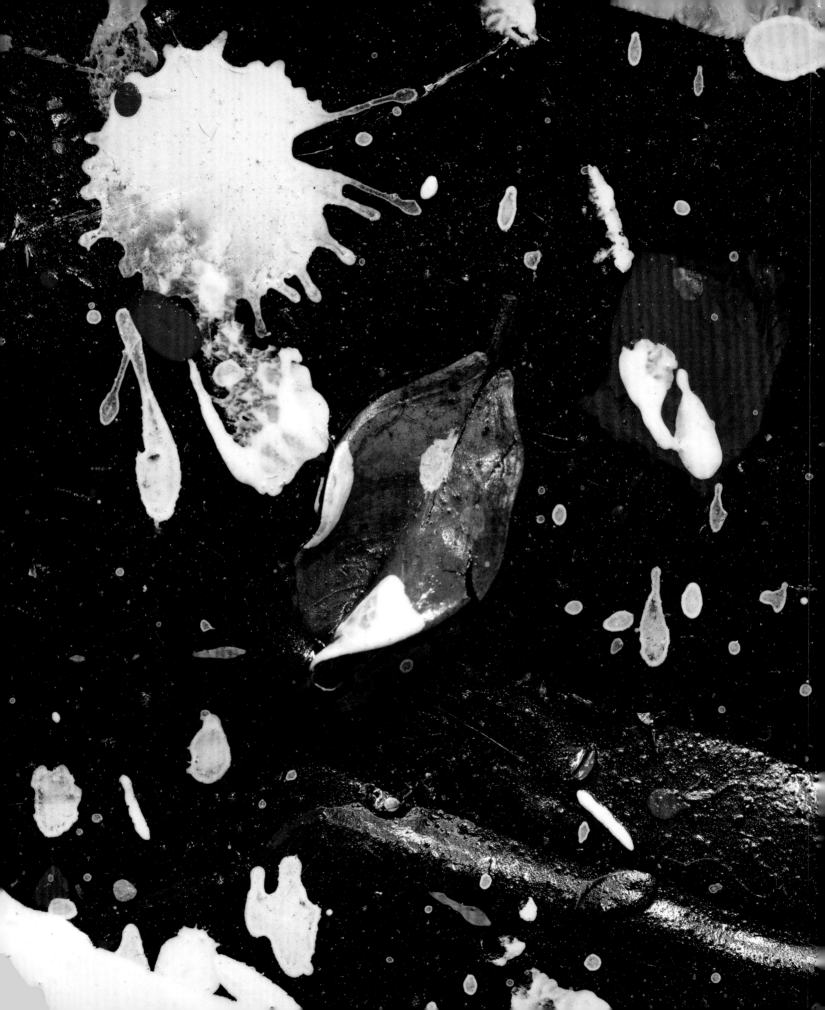

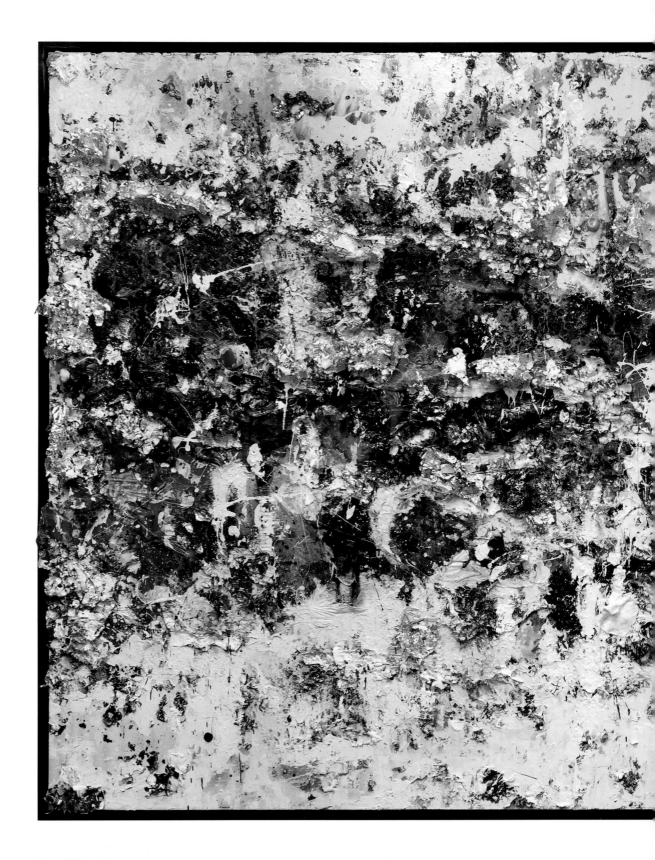

Beyond White Poles, 2014

105 × 291 × 8 inches (267 × 739 × 20 cm), framed

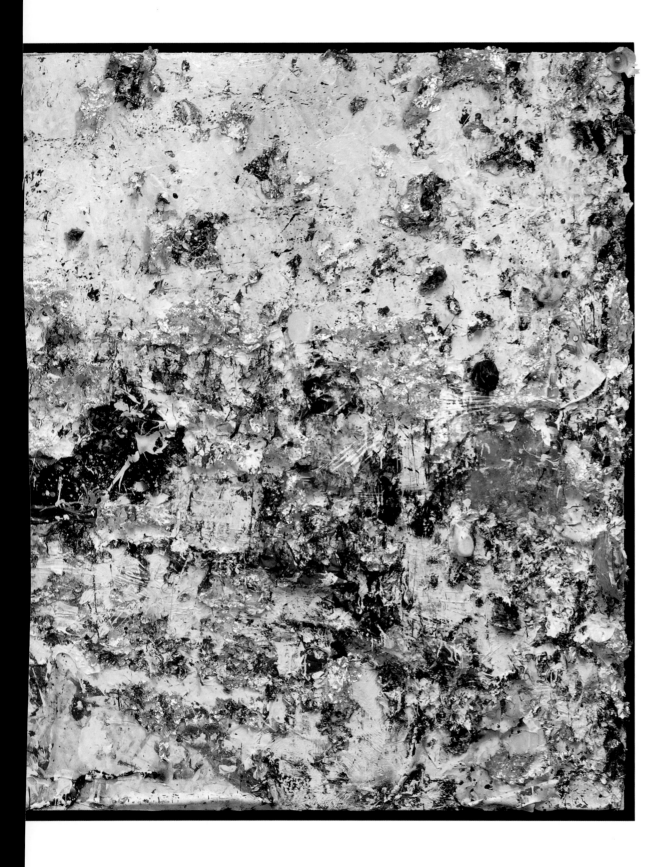

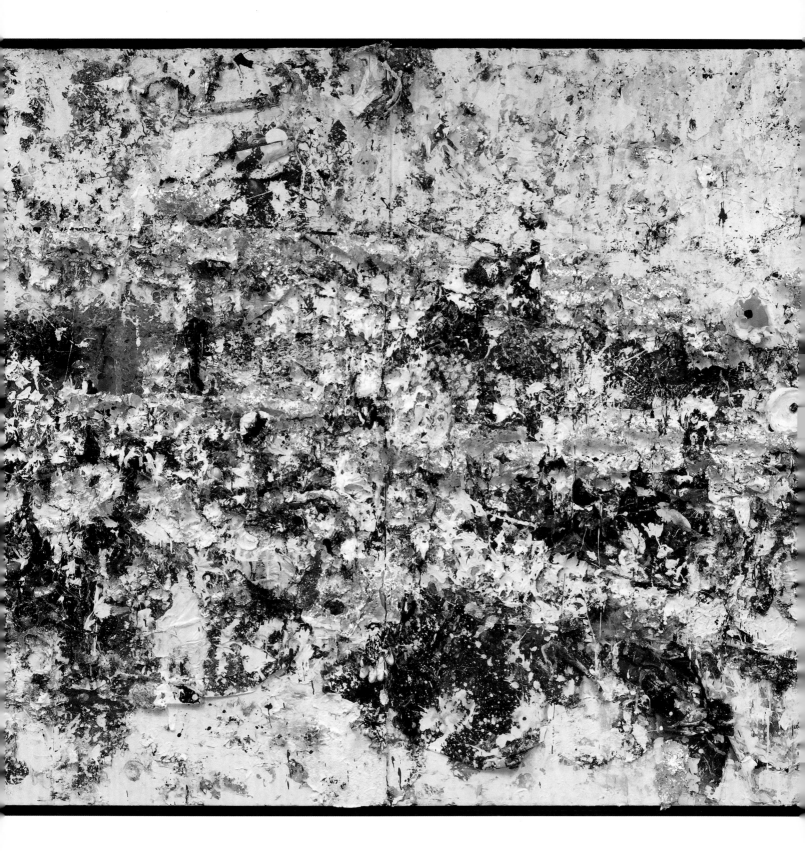

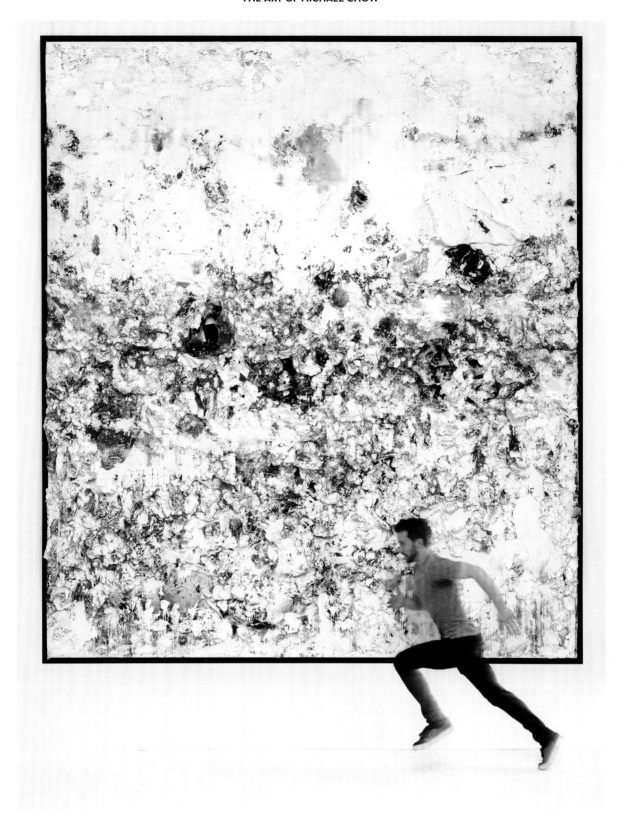

View of *Tell Them, the Phoenix Is Rising*, 2014

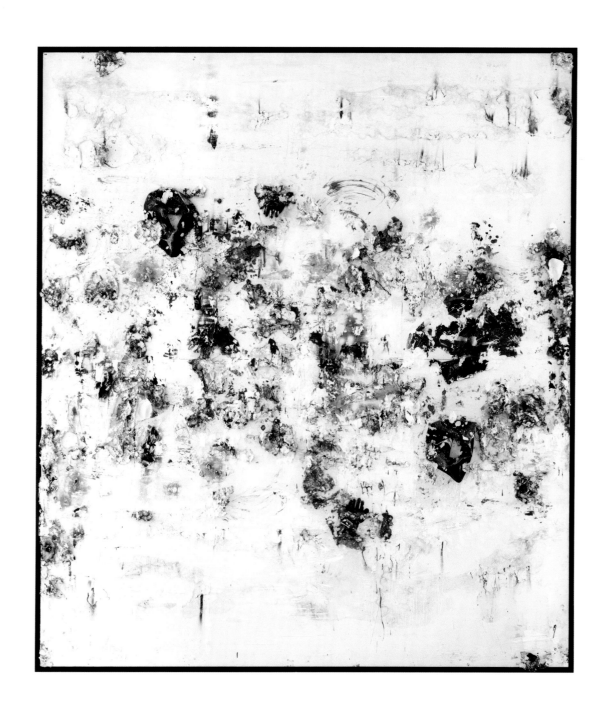

Asia's Island in the Sky, 2013–14
165 × 147 × 8 inches (419 × 373 × 20 cm), framed

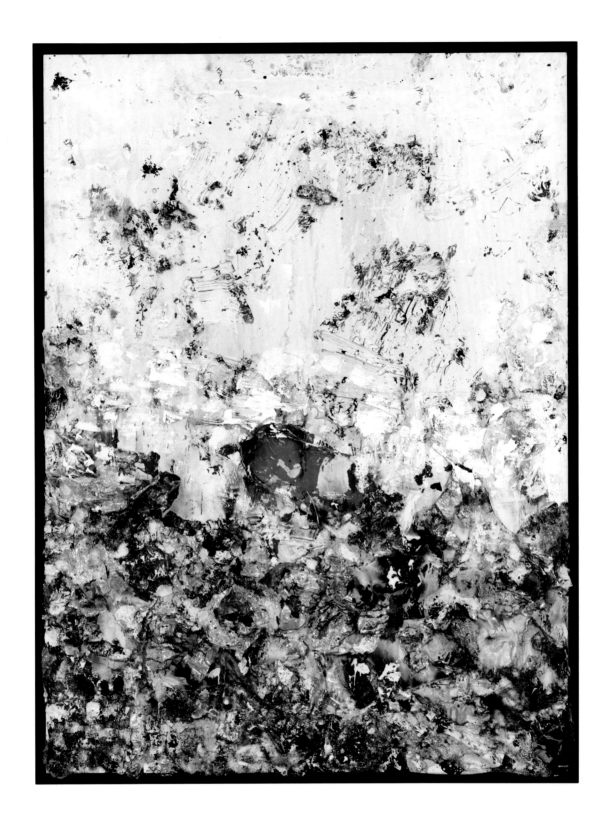

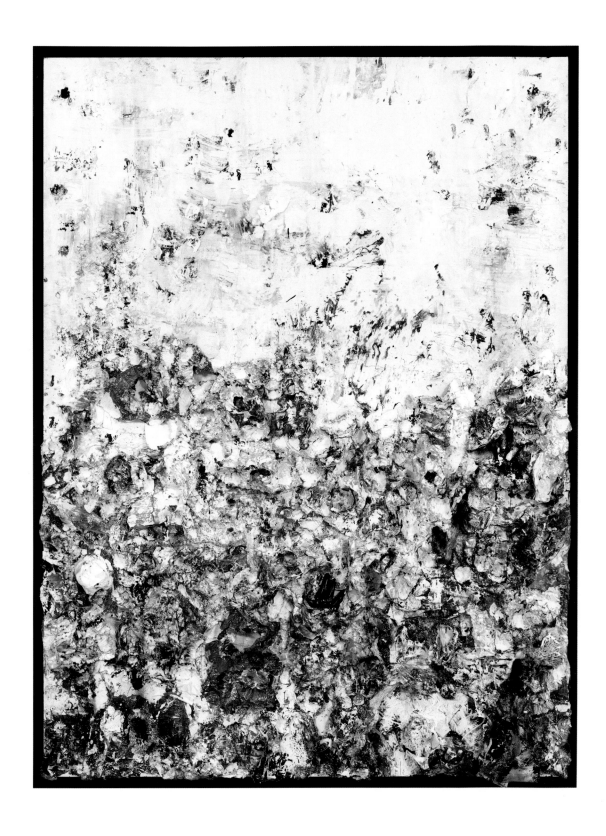

Sorrow for the Fall of the Ming (polyptych), 2013
99 × 75 × 8 inches (251 × 191 × 20 cm) each, framed

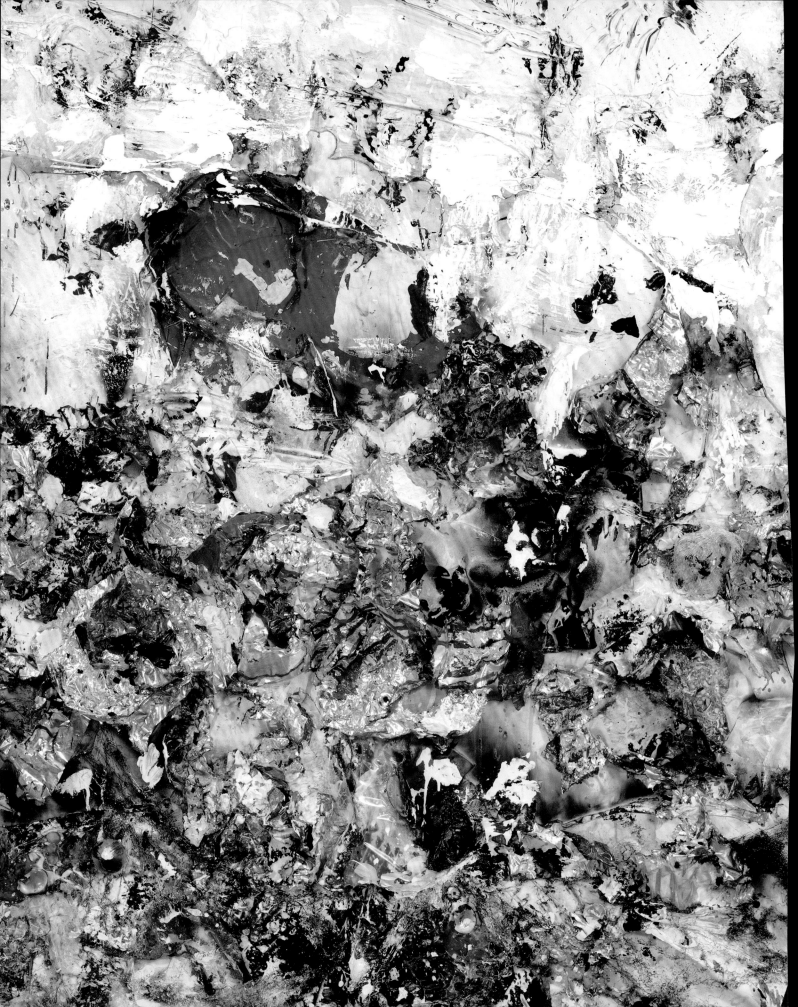

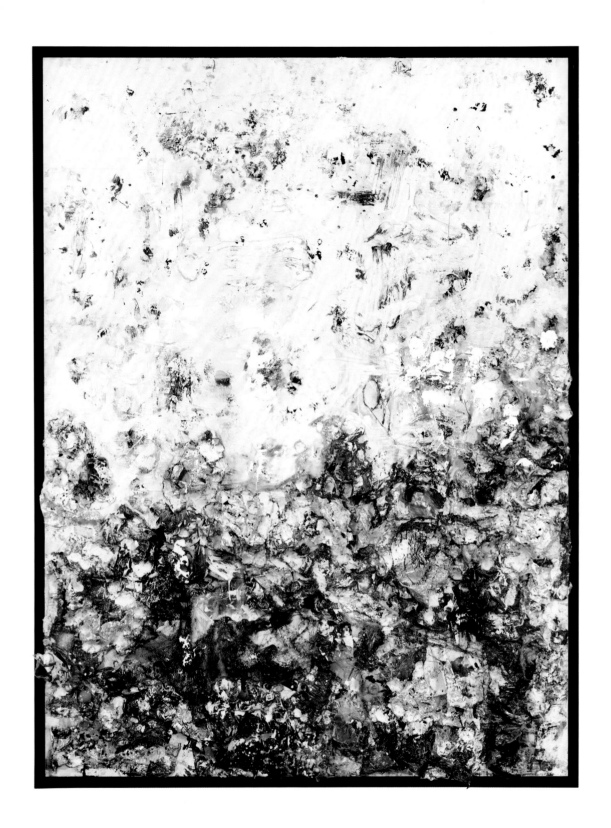

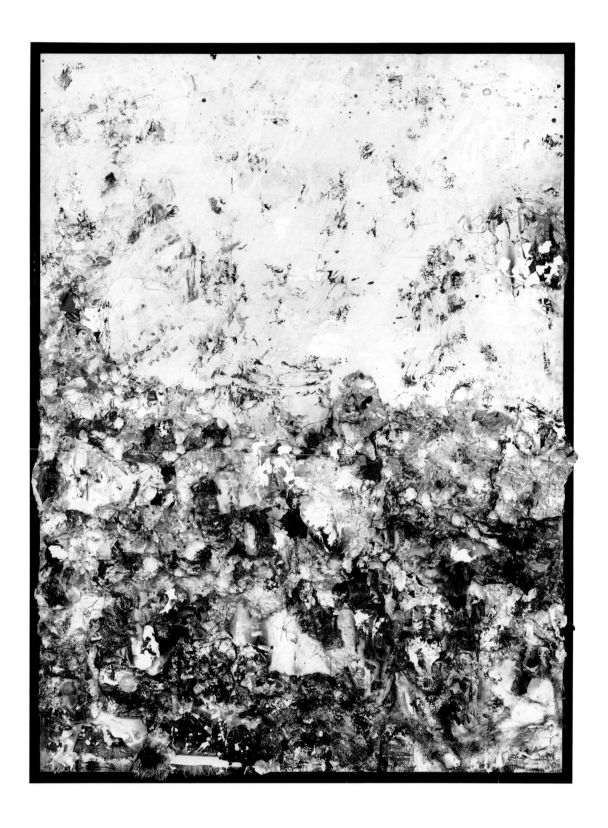

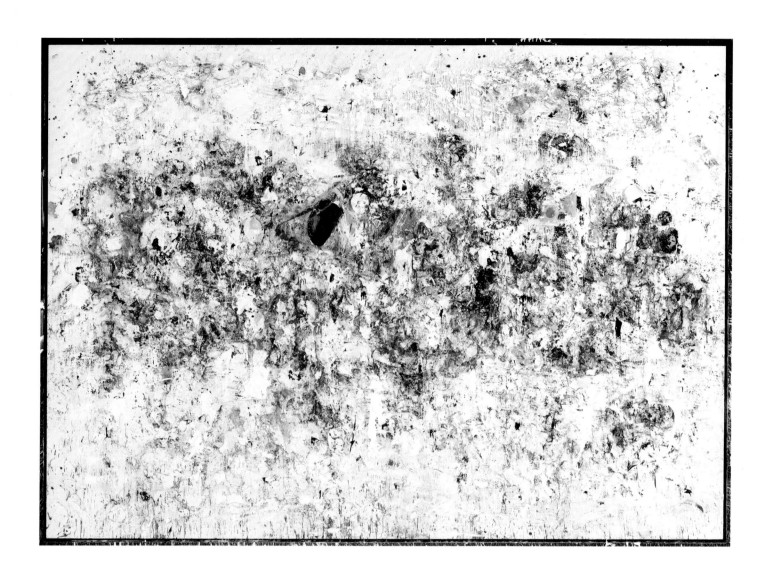

Shoot the Frame, 2014
105 × 147 × 8 inches (267 × 373 × 20 cm), framed

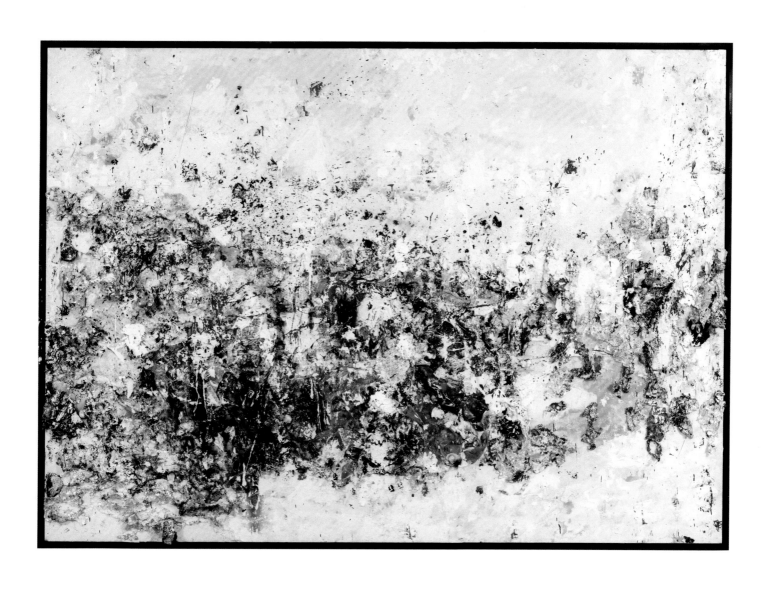

Remembering 1781 at Sea, 2014
105 × 147 × 8 inches (267 × 373 × 20 cm), framed

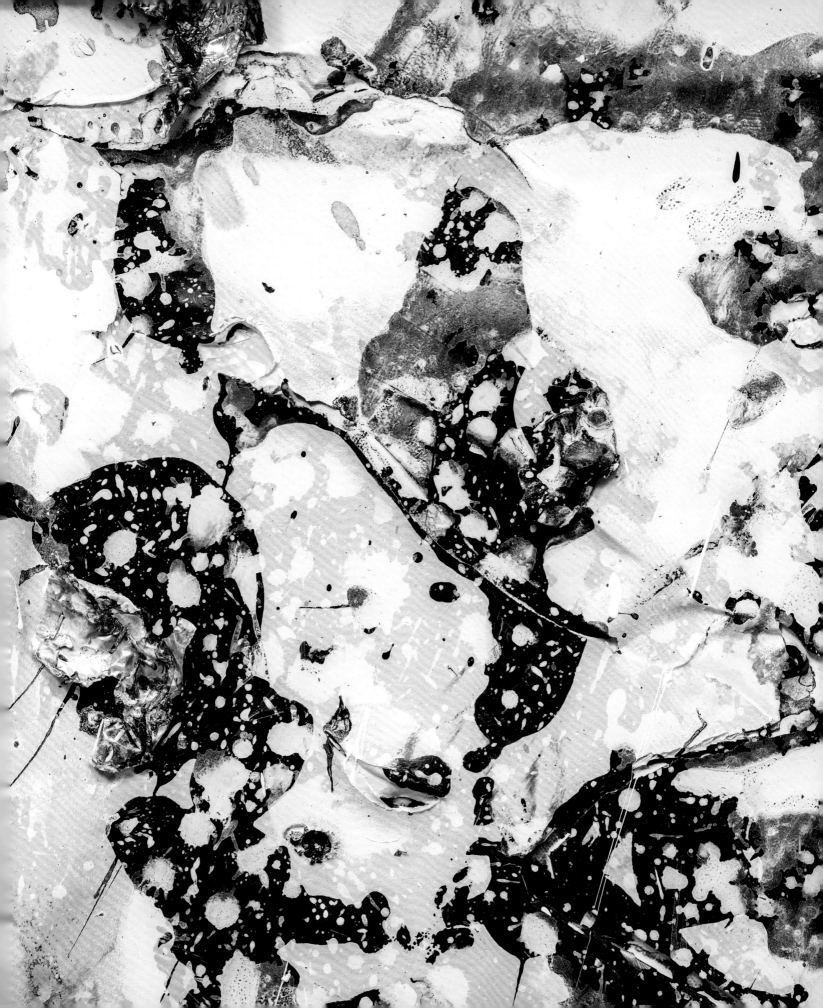

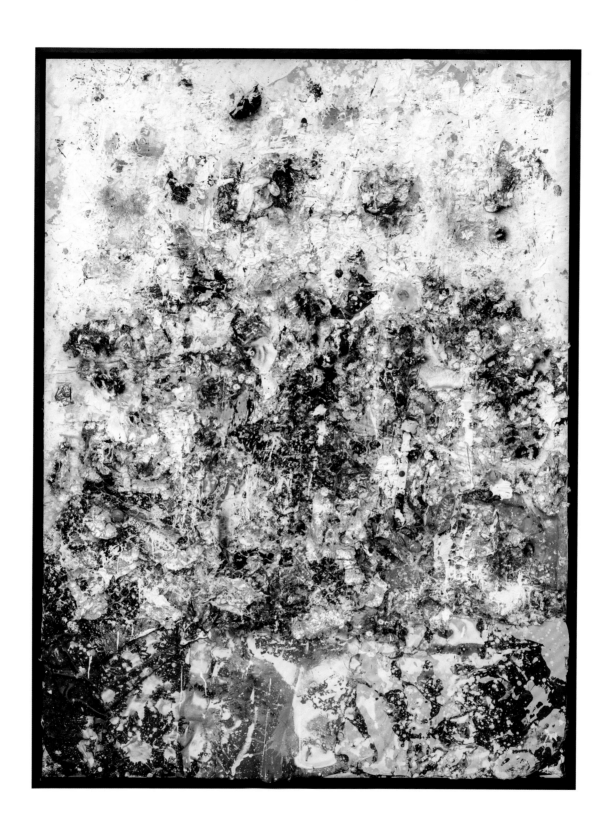

Under the Clear Sky, 2014
99 × 75 × 8 inches (251 × 191 × 20 cm), framed

PAGES 53–59 *Works on Fire,* 2013–14
36 × 24 inches (91 × 61 cm) each, framed

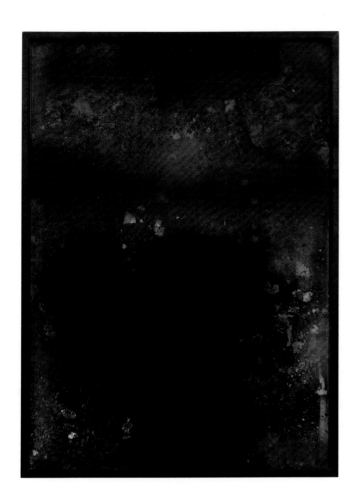
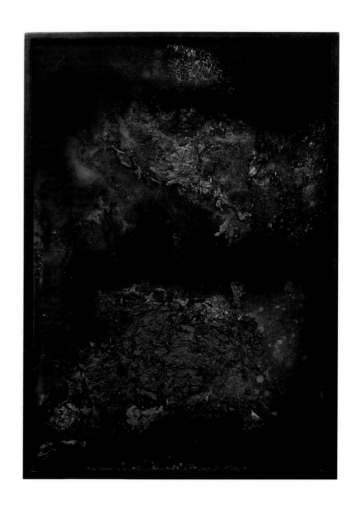

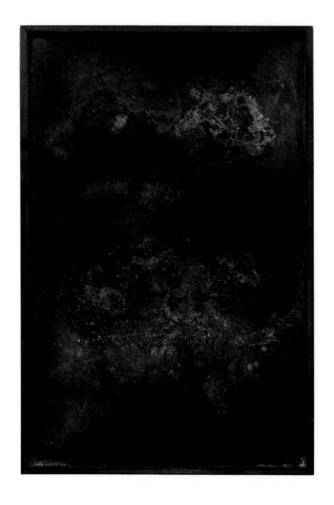

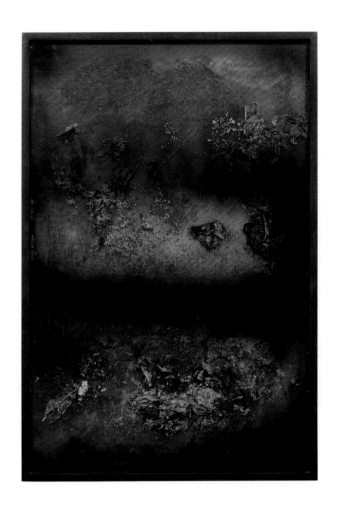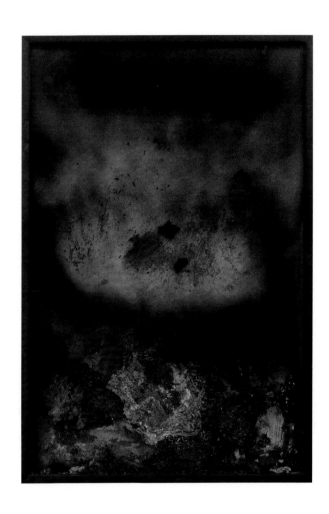

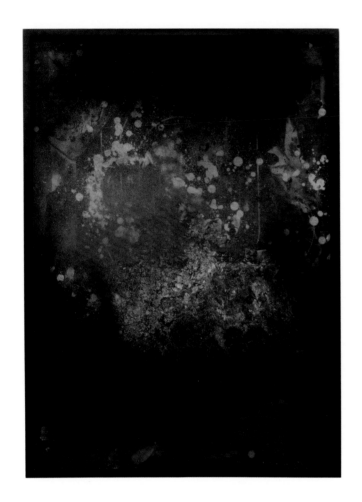
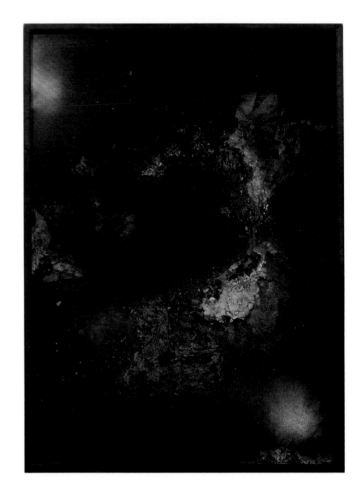

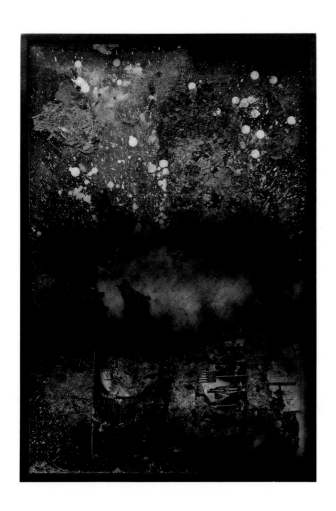
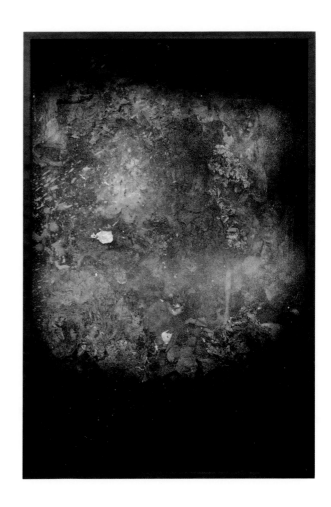

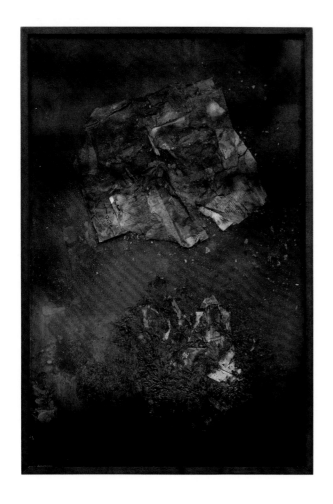
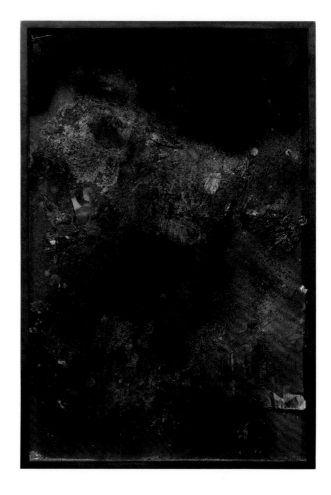

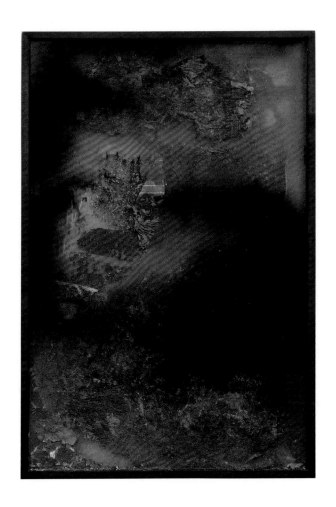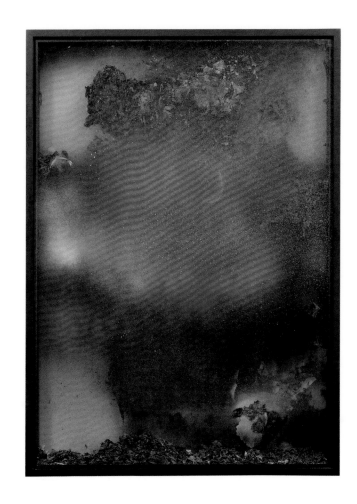

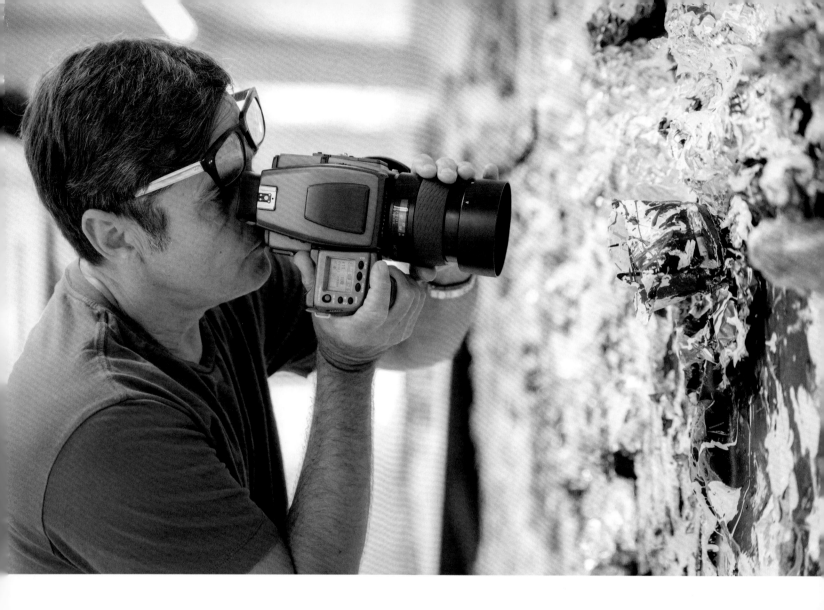

Photographer Fredrik Nilsen at work in Michael Chow's studio

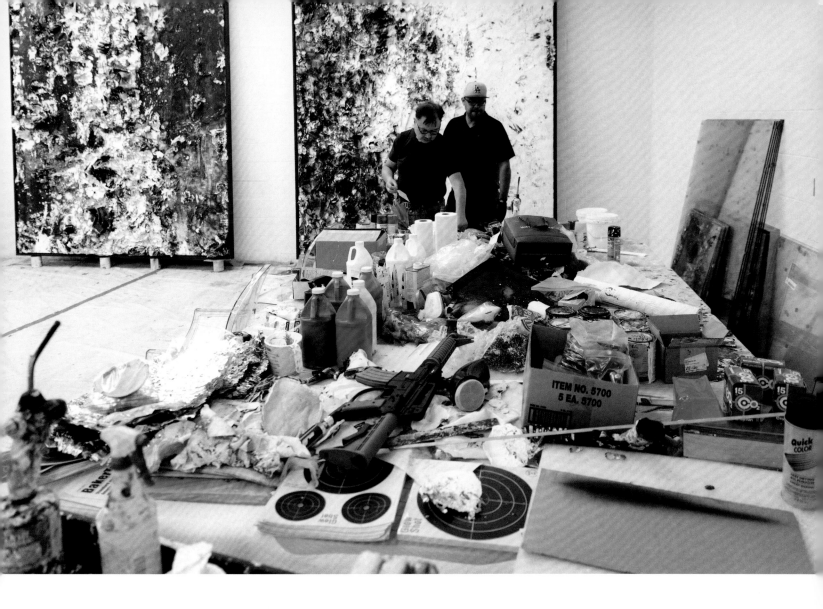

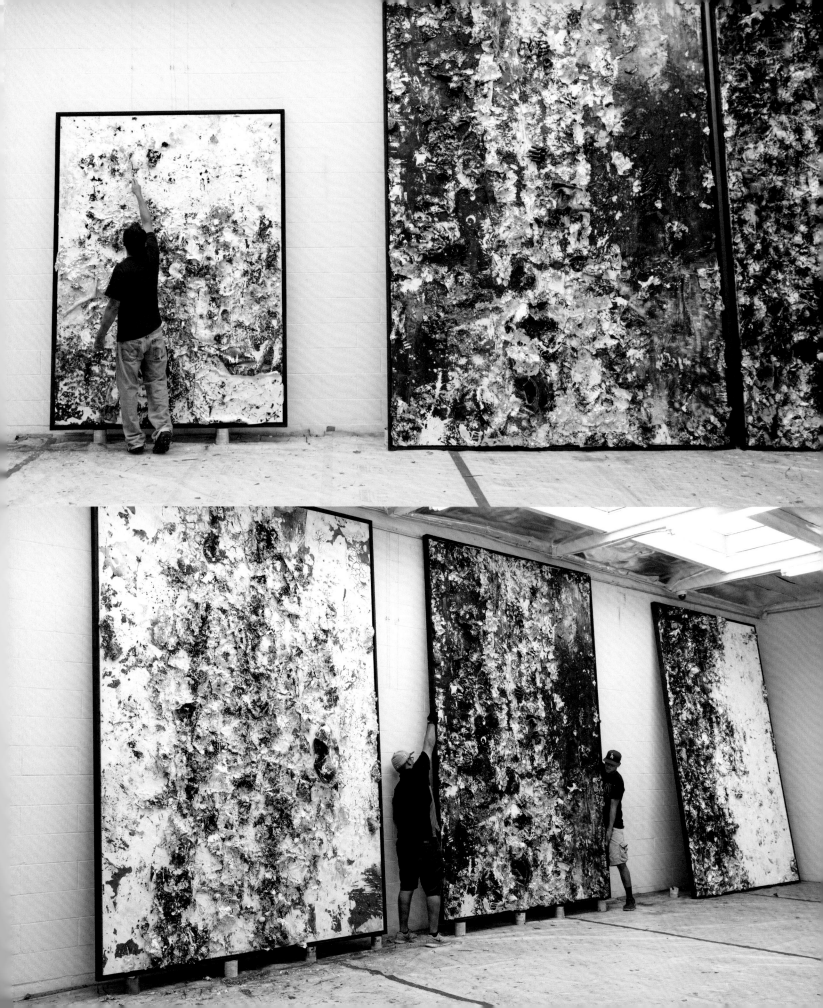

INGREDIENTS

1. Sea sponge
2. Bath sponge
3. Black plastic glove
4. Atlas glove
5. Tire inner tube
6. Fishing net
7. Steel wool
8. Plastic carpet shield
9. Bubble wrap
10. Paint sheet
11. Vase of paint
12. Antique nail
13. Wax candle
14. Espresso
15. Burnt paper ashes
16. Whole egg yolk
17. Egg shells
18. Tools
19. Paint stirrer
20. Paintball gun
21. Spray paint
22. Money
23. Ziploc bag
24. Ziploc container
25. Knee pads
26. Clothing
27. Leaves
28. Seeds
29. Accumulated paint layers
30. 24-carat gold
31. Gold leaf
32. Pure silver sheets
33. Lid of acrylic jar
34. House paint
35. Acrylic paint with tube
36. Oil
37. Lighter fluid
38. Staples

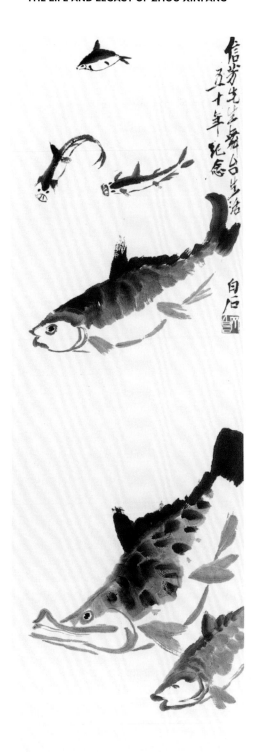

Qi Baishi, *Zhou Xinfang's 50 years of Stage Life Celebrations*, 1954
Chinese ink on scroll
41 × 13 inches (104 × 33 cm)

ZHOU XINFANG, QI MASTER

By Liu Housheng

ZHOU XINFANG WAS ONE OF THE MOST IMPORTANT CHINESE ACTORS OF THE TWENTIETH CENTURY. Known as the Unicorn Child (*Qi Lin Tong*), he was born on January 15, 1895, in Qingjiangpu (modern-day Huai'an), Jiangsu province, to a Beijing opera family, although his ancestral home was in Cixi, Zhejiang province. He first took to the stage at seven years old and, by the time he was thirty, was universally acknowledged as the most important figure in southern Beijing opera. The role he was best known for was the old gentleman character (*laosheng*), although he could also play the young man (*xiaosheng*) or painted face (*jing jiao*) roles. His most important characters included Song Shijie in *Four Scholars*, Xiao He in *Xiao He Chases Han Xin Under the Moonlight*, Song Jiang in *Oolong Courtyard*, Xiao En in *The Fisherman's Revenge*, Xu Ce in *When Minister Xu Ce Hears News of a Battlefield Victory*, Wu Han in *Murder in the Oratory*, Zhang Yuanxiu in *Gentle Breeze Pavilion*, Kou Zhun in *Chanyuan Alliance*, and Hai Rui in *Hai Rui Submits His Memorial*.

Zhou lived, studied, and performed primarily in Shanghai and the south of China, but during his youth traveled to Beijing's renowned Xiliancheng Opera School where he met and studied alongside Mei Lanfang—another famous actor in his day—who became a lifelong friend. His stage life lasted over sixty years. Between opera excerpts, individual pieces, and serialized plays, Zhou performed over six hundred different works of Beijing opera,

a record unmatched by any other Chinese performer. Also a director, screenwriter, and theater manager, he was considered a Renaissance man within Beijing opera. Of the traditional plays and new productions Zhou chose to perform, most depicted humanity's struggle between good and evil, and the pursuit of justice and harmony in society.

Employing Beijing opera's traditional tools of singing, dialogue, acting, and acrobatic fighting, Zhou introduced many innovations that resulted in a series of unique, vivid personas, each one bold, powerful, and vigorous in style, and exuding a virile grand temperament. His style of acting, called the Qi school (*qipai*), is one of the most influential in Beijing opera, having attracted a large number of followers and being greatly beloved by audiences. The Qi school is not simply a performing arts style, but a performance school of thought. For example, Zhou did not endorse the conventional opinion that the audience came to listen to the opera. He valued singing and acting equally, stating, "The 'acting' in 'playacting' encompasses everything . . . it refers to everything in the play, not just singing." He emphasized the holistic nature of the performance, a completeness that encompassed both singing and acting skills individually, as well as their coordination with screenwriting, directing, acting, sound, aesthetics—in short, with all the artistic elements of opera. Expressing his profound understanding of the aesthetic experience and social impact of theater, Zhou said, "To rouse the audience through the play's will: this is the true value of theater."

During the War of Resistance against Japan, Zhou wrote multiple patriotic historical plays to inspire audiences and often acted in supporting roles to young actors, helping troubled colleagues. He was deeply loved and respected by his colleagues, writing in defense of other actors humiliated by the warlords and gangsters of the old society. On the eve of the founding of the People's Republic of China, Zhou was one of four figures from the opera world—the others were Mei Lanfang, Cheng Yanqiu, and Yuan Xuefen—invited to attend the first Chinese People's Political Consultative Conference. He was elected as a representative to the first three terms of the National People's Congress and appointed deputy director of the Chinese Opera Research Institute, director of the East China Opera Research Institute, vice-chairman of the Chinese Dramatists Association, and chairman of the Shanghai Dramatists Association. At the first National Opera Observation and Performance Conference in 1952, Zhou was presented with an honorary award alongside Mei Lanfang, Cheng Yanqiu, Yuan Xuefen, Chang Xiangyu, Wang Yaoqing, and Gai Jiaotian. The Ministry of Culture, China Federation of Literary and Art Circles, Chinese Dramatists Association, and similar organizations in Shanghai held commemorative events for him. Despite these accolades he was imprisoned in 1968 during the Cultural Revolution and remained under house arrest until his death on March 8, 1975, in Shanghai. In 1978 a ceremony was held in Shanghai to rehabilitate his memory, for which Deng Xiaoping and other leaders sent wreaths.

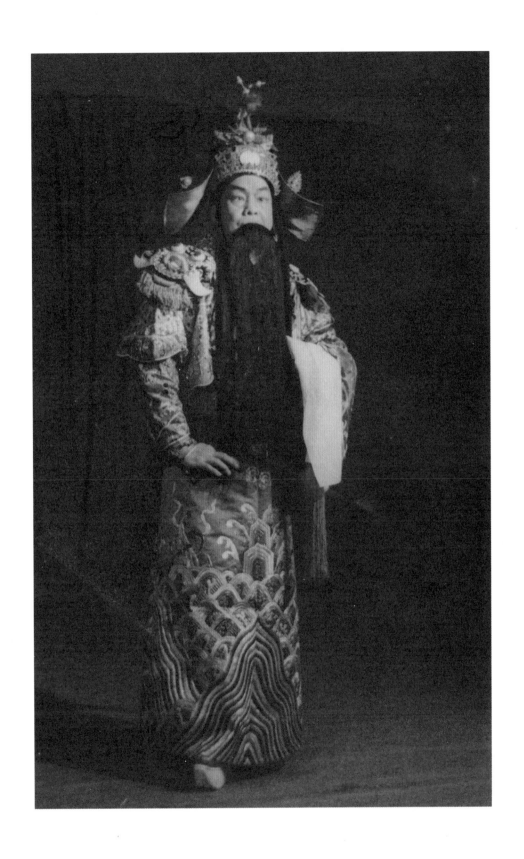

Wen Tianxiang, 1955

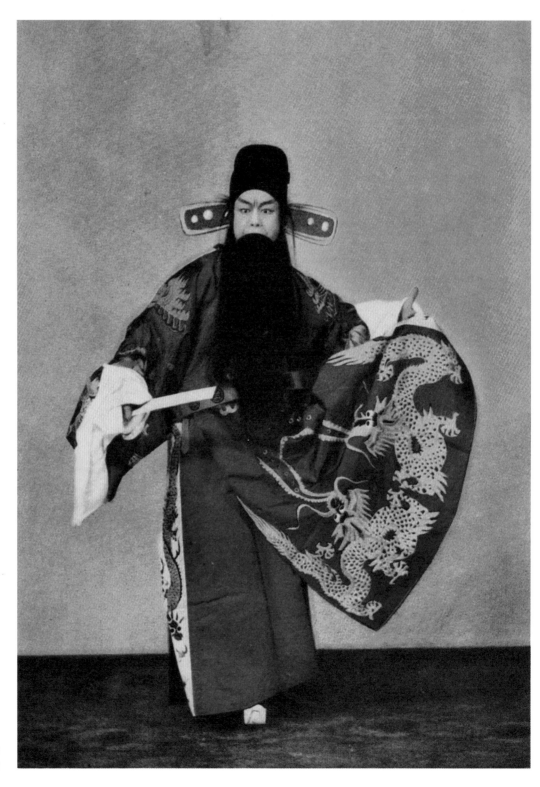

Postcard of Zhou Xinfang
Lincoln Center, New York, 1981

UNICORN CHILD

By Christopher R. Leighton

FOREBODING SIGNS DISMISSED, conspicuous coincidence met with calm credulity, and faith in happy endings: the characters in opera clearly do not go to the opera much themselves. They face their fate unarmed, unaware of history, and uninitiated in the conventions of genre that propel them to their ends. In the case of modern China, those who created and performed such roles had more hope; even as they lived the grand real-life drama of China's tumultuous twentieth-century history, their art gave them both perspective and power. They could structure the stories, shape the allegories, and write their own endings. How they did so mattered deeply because art mattered, and not just for its aesthetic merits. In late-nineteenth and twentieth-century China, the pressing debates of the day found primary expression there too, where both the wide urban public and attentive government censors turned to test, press, or defend ideas.

Nowhere was this more true than in the fraught case of Beijing opera (*jingju*), a syncretic style of performance pioneered in the late Qing period (1644–1911) and reformulated and rejuvenated in the Republican era (1912–49), when it combined special status as an avowedly national art with broad popularity. And for no one was this more true than Zhou Xinfang (1895–1975), one of the form's star practitioners, whose personal and artistic trajectory traced an arc as powerful as any of the characters he portrayed. His life, framed by cultural and political watersheds he both labored to make happen and through which he suffered, limns the tensions in the intersecting worlds of art and politics in China. His legacy, secured as an interpreter of and innovator in Beijing opera (by design the quintessentially Chinese art), extends to all those inspired by or in dialogue with the Chinese tradition, including his son, Michael Chow. Understanding Zhou Xinfang's history unlocks the artistic

and cultural milieu that informed and inspired both men. It sheds light too on the potential hopes and hazards for the present generation of Chinese artists, who, after so many years of conspicuous absence, are today returning to an international prominence that belies the precariousness of their position in China itself.

Born in 1895 in the modest prefectural town of Qingjiangpu (today Huai'an city in central Jiangsu province), Zhou Xinfang grew up in the final years of the Qing dynasty, China's last empire; its decline and fall, and the ways in which its broken heritage might be remade into a new and modern China, dominated his later life. His exposure to opera began early—his parents were both performers, and had sojourned north from his father's native Ningbo to work, when Zhou was born. Just five years later, he would go south with his father to Hangzhou and begin formal study of opera. His debut in 1901 as a loud-voiced boy (wawasheng), a standard role in local opera, earned him a first stage name that high-lighted his precociousness: Seven-Year-Old Wonder (Qi Ling Tong), which was his nominal age by Chinese reckoning.

He gained experience and exposure in children's roles over the next years, traveling through many cities with a new troupe, from Dalian in the northeast to the southern cities of Nanjing and Shanghai. He also gained new identities. While his father had bestowed both his childhood name (ming), Shichu, and courtesy name (zi), Xinfang, life as a performer demanded a stage name that allowed for experimentation and self-fashioning. Zhou changed his name first by altering the ideographic characters while retaining the sound of his original moniker to become the homophonous Seven-Spirit Boy (Qi Ling Tong); later, he discarded even that to be Evergreen (Wan Nian Qing) and others before finally settling in 1907 on Unicorn Child (Qi Lin Tong), a near phonetic echo of his debut billing but whose characters denoted the qilin, a mythical beast whose rare presence in the world was linked to the presence of a sagely ruler. He would be so known for the rest of his career. He was twelve years old.

The following years proved pivotal. He moved to Beijing, entered a new troupe, and met and befriended many of the greatest opera performers of the day, among them Mei Lanfang, who played the impersonated female roles (dansheng) opposite Zhou's eventual specialty in older male characters (laosheng). National mourning and a consequent ban on festivities following the deaths of the Guangxu emperor and the empress dowager Cixi sent him from Beijing. By 1912 he was in Shanghai, performing to positive reviews in the local papers as the dynasty finally fell and the Republic of China took its place. Like many, Zhou felt the promise of the new republic. The political transition, however, was troubled. When Song Jiaoren, a republican revolutionary who led the Nationalist party to victory in China's first elections, was assassinated on his way to take up power in 1913, Zhou channeled the

performative element: speech, mime, dance, acrobatics, and sometimes even staged combat (which might occur while the actors sang) all formed part of the show. A stylized vocabulary of physical gestures, musical cues, and the actors' distinctive and often arresting maquillage telegraphed more about the scene and characters than the sparse staging, few props, and a blank or absent backdrop. Categorization of performers was not by vocal range (e.g., tenor or soprano) but by the requirements of role type. The male (*sheng*), female (*dan*), painted (*jing*), and clown (*chou*) roles, with all of their many sub-types, required particular combinations of voice and singing as well as movement, makeup, and costume.

Though cloaked in the mantle of tradition, Beijing opera was thus a relatively recent creation defined by self-conscious attempts to fashion a national art; even from an early date, the idea of constant reform and change had become part of its history. Beijing opera had already entered a period of reinterpretation in the twentieth century as Zhou Xinfang and others experimented with it. Reformed Beijing opera emerged from the south, in the area around modern Shanghai, and stressed the interpretative role of individual actors, rather than the former emphasis on ensemble troupes, as well as more innovation in repertoire and performance. This brought the performer to the fore and encouraged the creation of its star system, a transition Zhou Xinfang both benefitted from and helped to make, and which allowed him to create some of the most famous and enduring operas, including Mei Lanfang's *Farewell My Concubine* (*Bawang bieji*) and Zhou's own *Four Scholars* (*Si jinshi*).

Though known first for his quality as an actor specializing in the standard older male roles, as Zhou reached artistic maturity he infused first his performances and then the operas themselves with new interpretive elements drawn from diverse sources: modern

Zhou Xinfang and Mei Lanfang
with other well-known figures

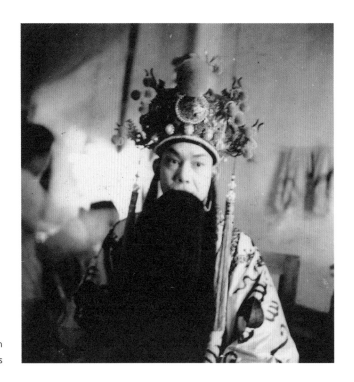

Zhou Xinfang as Chong Zhen
in *Sorrow for the Fall of the Ming*, 1940s

tragedy into a new-style contemporary opera in modern clothing, *Song Jiaoren Murdered* (*Song Jiaoren yuhai*), which captured popular feeling. Continuing turbulence in China's politics provided fuel for further experimentation that put Zhou in the political as well as artistic avant-garde. When Beijing students took to the streets in the epochal May Fourth Movement of 1919 to protest the inequitable treatment of China (and their government's complacent acceptance of it) in the postwar settlement at Versailles, Zhou lent support with another piece, *Learn Boxing to Beat the Warriors* (*Xuequan da jin'gang*).

Tackling the pressing questions in contemporary China through opera made perfect sense; Beijing opera was perhaps the most vital and popular performing art of the day, and many critics cite the early decades of the twentieth century as its creative peak. Yet the legions of fans who crowded venues to see their favorite stars and stories were enjoying an art form whose strong appeal belied a comparatively short history. Beijing opera emerged only in the nineteenth century as a blended urban theater that took in elements of regional traditions of opera, music, and theater, and recombined them in novel ways so that the resultant style might be familiar to audiences across the empire but not quite congruent with the style of any particular locale. Unlike Western opera, song was not its singular

plays, dances, and even Hollywood. By the 1930s he sought to balance and integrate the many roles in each piece with an eye toward their total effect, transforming them from a collection of more discrete performances by stereotyped characters into realistic characters whose interactions drove a coherent plot. In his masterwork, *Four Scholars*, Zhou revisited the old tale of four men, recently successful in the imperial examinations and awaiting official appointment to government, who take an oath to remain honest; a tangle of lies and greed leads all but one astray. As the upright official Song Shijie, Zhou pared away the traditional songs and dances in favor of plot and character development to highlight conflict among the men rather than their individual internal struggles. This style would eventually become the Qi school of Beijing opera, named for the first character in Zhou's stage name.

As he devised new operas, Zhou frequently returned to the wellspring of the Chinese tradition, but while his pieces often told tales of ancient days safely set in the distant past, they also reflected contemporary issues: official corruption, rebellion, and unjust government. Some of this surely derived not only from frustration with the fitful progress of the country under its new leaders but also from a sense of personal injustice. As he entered his thirties, Zhou began to write as an opera critic under his childhood name, Shichu, eventually widening his angle to become a social critic too. While his new operas addressed the largest possible questions, some of his essays turned inward to the plight of artists themselves. To be a Chinese performer, he thought, was the bitterest lot of all; disdain for their imagined associations with the demimonde dominated the celebration of their creativity, and discrimination lingered. Proposed Nationalist government regulations to register all "entertainers," which grouped opera stars like Zhou alongside prostitutes and dancing girls into a single class, further aggrieved him.

To a prominent critic dissatisfied with the governing Nationalists, alternative voices at the edge of the body politic made their case. China's communists, from their distant base in Yan'an, one thousand miles from the great urban centers of eastern China, had held romantic appeal among idealists, intellectuals, and young people, many of whom had undertaken the perilous journey across active frontlines to make a pilgrimage there since the 1930s. Zhou was of mature age before he showed sustained interest in the communists'

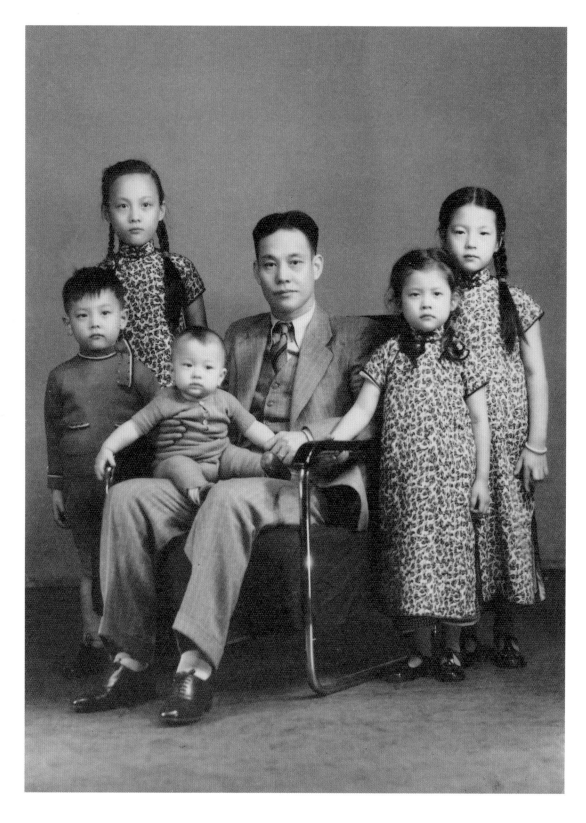

From left to right: Zhou Shaolin (William), Zhou Caizao
(Susan), Zhou Yinghua (Michael), Zhou Xinfang,
Zhou Tsai-chin (Irene), and Zhou Caiwen (Cecilia)

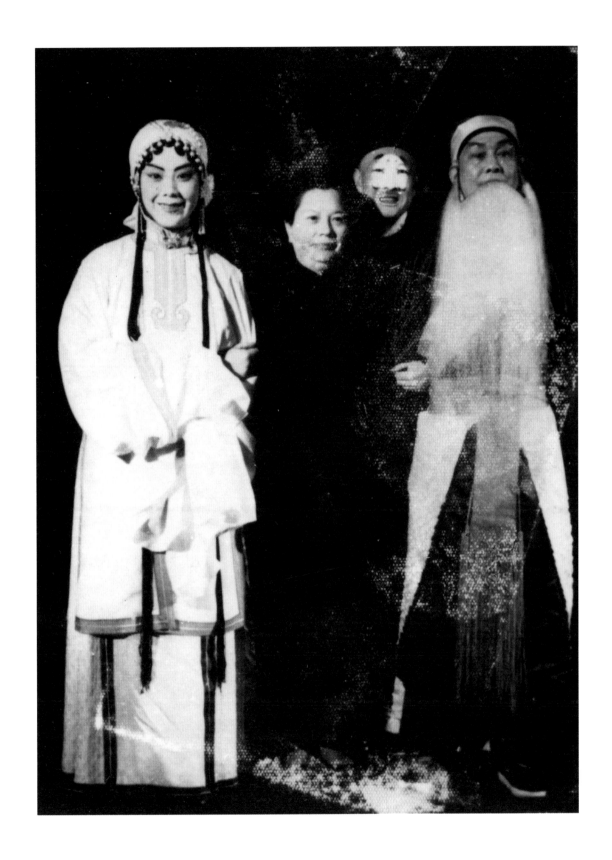

Zhou Xinfang with Li Yuru, Liu Binkun, and
Qiu Lilin after a performance of *Zhao Wuniang*

cause—perhaps a man whose art drew from China's classics and histories to portray life at the imperial court or among traditional scholars did not imagine much scope for accommodation with a militant party that aimed to wipe out China's feudal past. Nevertheless, in 1946, at fifty-one years old and around the same time he was protesting the Nationalist registration scheme, Zhou met with others from artistic circles and returnees from communist base areas to discuss Mao Zedong's *Talks on Art and Literature*, delivered at Yan'an in 1942, and Party policy on the arts. Mao spoke in an alien Marxist-Leninist vocabulary, but he blended that ideology with traditional Chinese social mores. Artists, he explained, would have to hew to the Party line, but they would have a critical role in the great cultural project of remaking China's heritage to speak to the masses and thus reform society. Their place was assured. Personal contacts developed too; perhaps most notably, Zhou met the communists' suave second-in-command, Zhou Enlai (no relation), at a banquet in 1946, when the latter Zhou arrived in Nationalist territory on a peace mission to find détente as the country lurched deeper into civil war.

By early 1949, Zhou Xinfang faced a defining choice. Battlefield victories had allowed communist armies to advance toward China's large cities against diminishing Nationalist resistance. Shanghai would fall in May. Should he follow the retreating Nationalists to the secure base they had prepared on the island of Taiwan? Many among the urban elite did. Zhou, despite his frictions with the regime, could easily have done so; he was not just a prominent member of society, but, as a star of Beijing opera, a valuable cultural property—like the country's gold reserves and its imperial art collections, another piece of the national patrimony that the Nationalists sought to carry with them to Taiwan. Or should he remain to see the arrival of the communists and the "liberation" that they promised to bring? Dark rumors circulated through the winter and spring of 1949 about the excesses of the advancing People's Liberation Army (PLA), which was said to be completely communizing everything it conquered, sharing out all land, property, and even women. Both sides made appeals for his allegiance. Most surprisingly, the Chinese Communist Party (CCP), in the midst of the immense tasks of waging war and learning to govern half the country, deployed scarce resources to cultivate Zhou. Underground members in Shanghai urged him to stay and welcome the new China that was to arrive along with their troops.

He did. At fifty-four years old, he chose to remain in a familiar place even if the future there seemed uncertain. His decision would shape the evolving history of Beijing opera through the People's Republic of China (PRC) up to the present, as well as the final tragic

act of Zhou's own life. As he stood to watch the founding of the PRC in Tiananmen Square on October 1, 1949, Zhou was not just an honored guest of the CCP but already part of its project to revive and reform culture. In the shambles of a country destroyed by war, a great effort of rebuilding launched that extended from economics to society and culture. Opera would play a central role in reimagining the Chinese tradition and translating its elite arts into mass culture for the country's new masters. Beijing opera might retain its painted face, but it had to have a socialist heart.

Zhou Xinfang was an ideal candidate for the mammoth task of reworking the entire repertoire of Beijing opera. He had himself performed hundreds of pieces, including the most canonical works, and had turns at directing and choreography as well as film. His early experiments in modern drama and indeed a career made from reinterpreting classic pieces prepared him for the project. The CCP tapped him to lead. In quick succession and often concurrently he served as head or deputy of research institutes into opera at the national and regional levels, national and local professional associations for opera performers and artists, and several performing academies and troupes, including the prestigious amalgamated Shanghai Beijing Opera Troupe. Organizational leadership in China's increasingly centralized but also now lavishly state-supported arts system gave him influence over a generation of new performers even as he revised the underlying repertory to make it congruent with socialist morality. He still performed, often to an appreciative audience of the country's highest Party cadres in Beijing, and even took his companies on tour to exhibit Chinese culture to socialist brother countries such as North Korea and the Soviet Union.

By 1956, at the age of sixty-one, Zhou had reached even greater heights of acclaim than during his heyday in the 1930s. Compilations of his scripts and writings on opera were issued as model works, he remained in the public eye as a central figure in China's most iconic performing art, and the state honored the occasion of his fifty years performing with a great celebration. Contrary to the expectations of many in the opera world, the CCP seemed a devoted if demanding patron. If other aspects of his life hinted at lingering doubts—most of his children, including Michael Chow, had gone abroad and remained expatriated—they remained behind the surface of his public persona. The ultimate imprimatur arrived in 1959, when he became a member of the Chinese Communist Party. The stage had been set for Zhou Xinfang's greatest role.

It was a tragedy, and he was to write his own part. As reward and recognition for his political reliability and artistic stature, Party officials asked Zhou to create a new piece in celebration of the tenth anniversary of the founding of the PRC. Its set subject, the upright Ming dynasty (1368–1644) official, Hai Rui, who dared to speak out against even the emperor when righteousness required it, was a popular historical tale, but this retelling would be fraught with contemporary political significance. With the Qing dynasty long overthrown and its last incumbent interned for war crimes, the only evident emperor in the 1950s was Mao Zedong himself. Mao's own obvious harsh suppression of his critics colored how audiences would interpret Hai Rui's story. Zhou grasped this from the beginning. His version, *Hai Rui Submits a Memorial (Hai Rui shangben)*, drew strong analogies between past and present, and strengthened the message with sharp scripting and provocative staging. Just as the historical Hai Rui was said to have readied his own coffin before speaking out, Zhou's version called for a real coffin on stage to accompany his performance of the critical allegory. Performed directly to the face of Mao and the regime elite at what amounted to the communists' court (the Huairentang Hall in the cloistered leadership compound of Zhongnanhai in Beijing), the show itself was the equivalent of Hai Rui's courageous memorial. It spoke truth to power in the tradition of loyal remonstrance. It was a brave thing to do.

The best hopes, that the play might temper China's politics through criticism, would not be fulfilled during Zhou's own life. *Hai Rui* and Zhou himself came under withering criticism from leftist cultural critics. Denounced by name in national papers for undermining Mao's authority, Zhou became a focal point in a widening controversy that sparked worsening rounds of factional discord and power struggle—the opening salvos of what would become China's Cultural Revolution (1966–76), a time of devastating strife when conflict cascaded from the art world to society at large. As the center of this greater storm, Zhou was not spared. Years of beatings, harassment, and imprisonment followed. Zhou, known for portraying heroes who sought justice for the people, would live out the allegory of what became his most famous work.

Yet even as the country embarked on a wholesale rejection and destruction of traditional culture, Zhou's influence remained etched into the idiom of the remade revolutionary art of his persecutors. While traditional opera performances ceased from 1965 and Zhou himself was jailed in 1968, Jiang Qing, Mao's wife and a champion of the radical left in the arts, spearheaded her own great effort to reform culture. Eight model operas produced

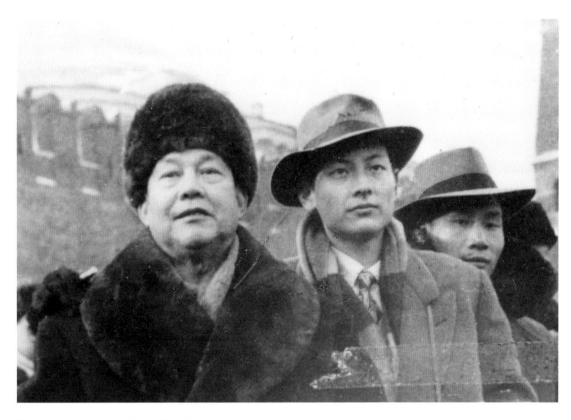

Zhou Xinfang and his son William (Zhou Shaolin)

under her auspices formed the core of this project, and, as the proud culmination of China's revolutionary culture, they became showcases for the world: US president Richard Nixon was treated to *The Red Detachment of Women* on his 1972 visit. Certainly the tough female soldiers pirouetting rifle drills before Nixon looked different than the heroes from Zhou's older repertoire; the techniques of their performance, however, were borrowed wholesale from his innovations, even if peasants and common soldiers substituted for emperors and officials, and the story itself was transposed from past to present. In a sense, the model operas were hardly as revolutionary as they claimed—they continued Zhou's own work of updating the form. Whether Zhou could have come to appreciate the revolutionary operas either for their unacknowledged debt to him or even as a source of inspiration is unknown. He died unredeemed in 1975.

The coda to the story of course is that, like Hai Rui, the character he played, Zhou Xinfang would be remembered by posterity with greater esteem than that accorded to his detractors. Today Zhou's Qi style survives and exerts influence at home and abroad. Official rehabilitation began in 1978 with a memorial service as a public honor and interment

in Longhua Martyrs' Cemetery. Commemoration centered not just on Zhou's artistic merits, but his fate as a real-life Hai Rui. The communist political establishment that denounced and persecuted him in the 1970s launched a full revival in the 1980s, celebrating the ninetieth anniversary of his birth in 1985 with admiring public declarations. Deng Yingchao, a veteran leader then the chair of the Chinese People's Political Consultative Congress, wrote that, "in memory of the ninetieth anniversary of the birth of Zhou Xinfang, we should learn his revolutionary will and his spirit of artistic innovation"; an admission, perhaps, or an appreciation of his multiple roles. And this year, in 2015, Shanghai celebrates Zhou Xinfang's posthumous 120th birthday.

The promotion of Chinese culture and its influences surround us today. The greatness of China's contributions and the depths of its traditions across many fields—from the fine arts to crafts, literature to opera, and even in food—are now assumed rather than dismissed. Chinese artists likewise enjoy international audiences and acclaim. Viewed through the lens of Zhou Xinfang's legacy, does this offer a final vindication or cause for caution? From a life built through reversals and reinventions, clear conclusions are difficult to draw; Zhou's very career as a Shanghai-centered southerner who built from those roots "Beijing" opera should alert us to the basic contradictions of the Chinese art world. If nothing else, Zhou's example highlights the formative role of artists over the great traditions in which they worked: the latter provided a dynamic and changing inspiration to be extended rather than a static inheritance to be conserved. In this sense, Zhou himself, or his process of making meaning by shaping tradition to speak to the present, should claim our attention as much as his body of work. His finest moments were made not just from his mastery of technique but drew from his weaknesses too: a helpless Hai Rui, better armed by his vulnerabilities. As China rejoins the world on the cosmopolitan tide, Zhou's heirs might hope or fear for as much.

WORKS CONSULTED

Goldstein, Joshua. *Drama Kings: Players and Publics in the Re-creation of Peking Opera, 1870–1937*. Berkeley: University of California Press, 2007.

Li, Ruru. *The Soul of Beijing Opera: Theatrical Creativity and Continuity in the Changing World*. Hong Kong: Hong Kong University Press, 2010.

Shen Hongxin. *Jingju da shi Zhou Xinfang*. Shanghai: Dongfang chuban zhongxin, 2009.

Wagner, Rudolf G. *The Contemporary Chinese Historical Drama: Four Studies*. Berkeley: University of California Press, 1990.

Zhongguo xiju chubanshe, *Shuo Zhou Xinfang*. Beijing: Zhongguo xiju, 2011.

Zhou Xinfang. *Zhou Xinfang wenji*. Beijing: Zhongguo xiju, 1982.

TRADITION AND MODERNITY

By Shan Yuejin

WHEN DID THE NAME ZHOU XINFANG FIRST ENTER MY CONSCIOUSNESS? It's hard to say. When I was young I often heard the older generation speak of Zhou Xinfang. My understanding was that he excelled at "making plays" or *zuo xi*, which in Shanghainese means performing. To these urbanites, Zhou Xinfang was a truly exceptional performer. At that time, if a person from Shanghai wanted to describe someone as a good actor, they would often hyperbolically say, "Wow, he's doing a Zhou Xinfang," just like in the United States when people say, "You are doing a Hollywood." Like me, many people first became acquainted with Zhou Xinfang through this kind of common lore. By the time I joined the Shanghai Peking Opera Academy, Zhou Xinfang had long since passed away, but I often came across materials and documents about him. The legend gradually became real in my mind: I understood that this was an extraordinary man.

Certain information is shocking to hear said aloud. This is certainly the case with regard to Zhou Xinfang's career. He played over six hundred different roles in his lifetime. His performances, only counting those advertised in *Shanghai News*, numbered 11,500— a number unmatched by any other performer. It is impossible for people today to imagine how influential his performances were. Wu Hufan, a painter of the same generation as Zhou Xinfang, once wrote the following couplet to describe the spectacle of his performances: "A hundred voices singing with Prime Minister Xiao / Ten thousand people

crowding to see General Xue." This couplet spread like wildfire. Audiences were enthralled by his stage presence, taking delight in discussing the school of performance he created—the Qi school. However, this is not what made Zhou Xinfang so important. What made him so illustrious is the new course that he initiated.

Derived from the traditional art forms of the agricultural civilization, traditional Chinese theater (opera) has always functioned as a form of aesthetic inspiration and moral education, especially during the long feudal period before the modern education system had been established. The classical aesthetic temperament inspired admiration and contemplation, but when Chinese society entered the modern era, the art form seemed like a one-dimensional institution that was closed off and restricted by its traditions. Its biggest drawback was that it had fallen out of step with the times and was unfit for modernity. History had run its course until one day 120 years ago: this overly static, one-dimensional structure was about to change.

In the year 1895 Zhou Xinfang was born. Who could have known that this child would have such a monumental influence on traditional Chinese theater? After a few years, in the Tianxian Tea Garden on the outskirts of Hangzhou, seven-year-old Zhou Xinfang would begin to perform Beijing opera under the stage name Seven-Year-Old Wonder (*Qi Ling Tong*). Soon the moniker Seven-Year-Old Wonder no longer described his age or his talent. The prodigy Zhou Xinfang earned the favor of many older artists. He was exceptionally earnest in his study of traditional theater techniques, gradually becoming a much sought-after Beijing opera actor. It was then that he was crowned with the stage name Unicorn Child (*Qi Lin Tong*), a homophone in Chinese for a seven year old. In Chinese culture the unicorn is a gentle and auspicious mythical beast and is often used as a metaphor for singularly talented people.

It was during this time that a theater reform movement was taking hold, especially in large metropolises like Shanghai where, alongside revolutions in poetry and literature, it was part of the bustling cultural reform of the early twentieth century. A new cultural frame of reference was introduced, inciting changes in thought as well as new popular demands. Underpinning this reform was the introduction of Western values, which aggravated the acute clash between Chinese and Western cultures, and exposed the many internal contradictions within Chinese society. The reform movement was actually a quixotic attack that questioned the traditional theater system. The theater reform movement,

however, was unable to shake the foundations of the colossus that is traditional Chinese theater. It very quickly returned to stasis. At that time Zhou Xinfang was not an advocate for theater reform. However, he was active on the Shanghai stage and studied with some of the figures of the movement, collaborating with them and in turn being influenced by them.

In Zhou Xinfang's mature works and performances, with their completeness and richness of plot, their tight structure, and the individuality of their characters, a modern sense of theater began to take shape. One can also see the emergence of changes in its spiritual character and form. For example, the serialized opera *Wen Suchen*, which Zhou Xinfang acted in and directed, is fresh and original in form with its winding plot and profound emotional sensibility. He even incorporated film techniques, endowing his performance with a contemporary feel. The first round of performances lasted for three full months, truly a wonderful spectacle. The following year brought performances of several of the later operas. Audiences flocked to attend and the box office continued to boom. *Wen Suchen* inspired imitations in film, Shanghai opera, and *tanci*.

In the aforementioned couplet, "Prime Minister Xiao" and "General Xue" refer to roles Zhou Xinfang played in *Xiao He Chases Han Xin Under the Moonlight* and *Xue Pinggui Leaves His Home* respectively. These two roles were notable for the development of character in performance, inviting widespread praise. During this time Zhou Xinfang also created and acted in a large number of theater works about the fate of the nation which portrayed ordinary life and human nature, such as *Sorrow for the Fall of the Ming*, *Wen Suchen*, *Gentle Breeze Pavilion*, and numerous others. In addition he pursued a stylized form of performance that was profoundly self-aware. After puberty his voice became hoarse; however, he deployed a unique method that emphasized the sincerity and subjectivity of his emotional expression, and wisely chose roles that evinced a masculine strength and simple vivacity, establishing his own style of singing, dialogue, acting, and acrobatic fighting. He had an immediately recognizable stage demeanor and opera aesthetic.

In a school that extolled a sweet and mellow style, Zhou Xinfang's voice was like a shout that pierced the sky, penetrating the hazy, lovely mist and undermining audiences' aesthetic expectations. He imbued the characters he created with a profound sense of human warmth. His performances were not just technically spectacular but emotionally rich. His training stressed the spiritual over the formal. He never put on airs to flaunt his high standards or prominence, yet many Beijing opera elites felt only sincere admiration for his

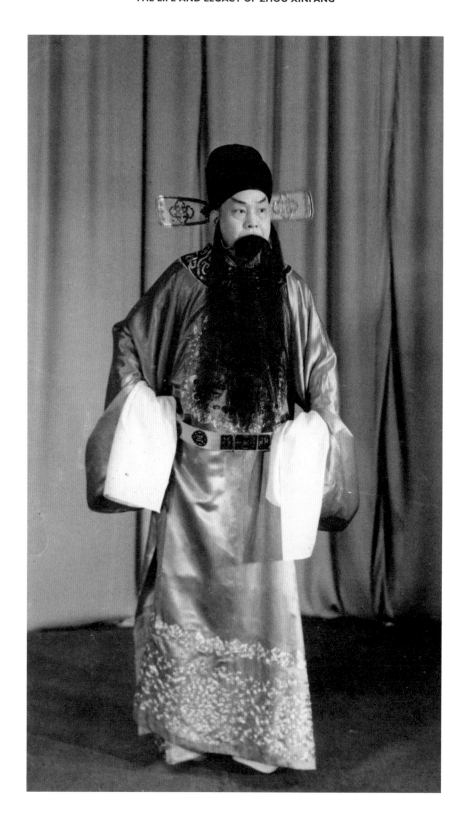

As Kuang Zhong in *Fifteen Strings of Cash*, 1956

art. If we say that the theater reform movement was a revolutionary fervor guided by ideas, then Zhou Xinfang's impact on traditional Chinese theater was a whirlwind propelled by popular desire and market demand.

Today, as we brush away the dust of history, we quickly see that, in the first half of the twentieth century, the classicist aesthetic position within traditional Chinese theater had already reached its zenith. Zhou Xinfang, a figure who was once deeply immersed in traditional theater, opened the door to the spirit of the modern era. From that point on, Beijing opera split into two camps, "classical aesthetics" and "combining tradition with contemporaneity," forming an aesthetic opposition. The Chinese theater world still oscillates within this dialectic. Equally matched, the two inclinations nourish each other. And because of this dynamic, contemporary Chinese opera is variegated and diverse. This diversity is entirely due to Zhou Xinfang. This is what makes him so illustrious, so valuable and significant.

In his late years Zhou Xinfang served as director of the Shanghai Peking Opera Academy. He established the company as an artistic enterprise. As we commemorate the 120th anniversary of his birth, we cannot help but reflect on the significance of his life as both an inheritance and a creation. Zhou Xinfang's significance has transcended his natural life. His artistic attainment, his observation, insight, exploration, and creation of art—all are still inspiring to us today.

While preparing for this commemorative event, I was fortunate enough to meet my predecessor's son Michael Chow and learn about his artistic accomplishments. The interesting thing is that one can vaguely discern a certain connection between the artistic intuition and values of father and son. Michael Chow's paintings have a loose, flowing sense of rhythm. They are free and bold, drawing vitality from a feeling of ease and contentment. His unrestrained use of materials and understanding of light and shadow evince a sense of lightness and desire oriented around the expression of inner subjectivity. Is this not the essence of Zhou Xinfang's Qi school? Michael Chow is a painter of the Qi school of Expressionism. I believe that, from Zhou Xinfang to Michael Chow, the legacy of artistic vivacity is truly indisputable.

A CELEBRATION OF ZHOU XINFANG

For six days in January 2015, the 120th anniversary of the birth of Zhou Xinfang was commemorated by Shanghai Peking Opera Academy with a series of events in Shanghai and Beijing.

PROGRAM

Opening Ceremony and Gala
Tianchan Peking Opera Centre Yifu Theatre
January 12, 2015

Inauguration of Zhou Xinfang Theater Space
Organized by Shanghai Peking Opera Academy
Garden of National Quintessence
January 12, 2015

Conference
Promoting the spirit of the Qi school, advancing the development of art
Shanghai International Convention Center
January 13, 2015

Book Launch
The Complete Works of Zhou Xinfang includes three volumes: scripts, literary works, and musical scores
Shanghai Library
January 14, 2015

Painting the Qi School of Theater
Famous painters and calligraphers paint classic characters and scenes
Organized by the Chinese Opera Character Painting Seminar
Shanghai Library
January 9–15, 2015

Commemorative Performances by Shanghai Peking Opera Academy
The Marriage of Dragon and Phoenix, Famen Temple, Qin Xianglian, Opera Excerpts from Young Qi School Performers, Spring and Autumn of Chu and Han (Peking Opera Theater of Hubei Province)
Tianchan Peking Opera Centre Yifu Theatre
January 13–18, 2015

Commemorative Performances, Beijing
Classic Opera Excerpts from the Qi School, Ballad of Golden Threads (new Beijing opera)
National Center for the Performing Arts
January 30–31, 2015

Xiao He Chases Han Xin Under the Moonlight Premiere
Production of the Peking Opera Film Program
January 2015

A LIFE
IN
PICTURES

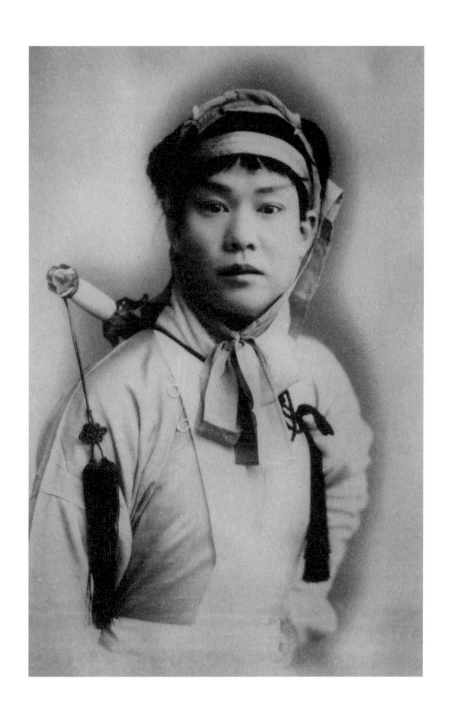

As Zhang Liang in *Liu Bang of Han*

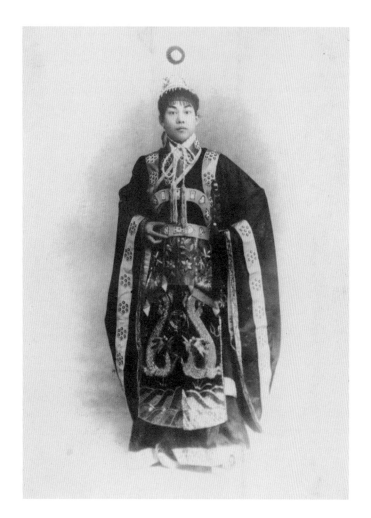

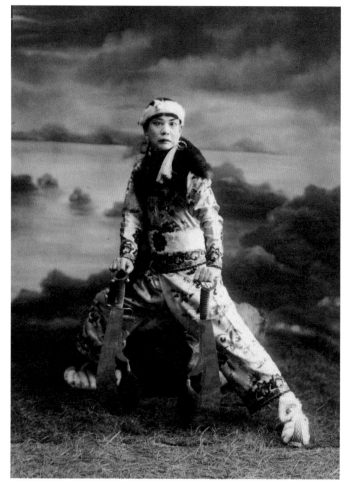

As Liu Bang in *Liu Bang of Han*, 1920s

Three Hundred Years of the Manchu Qing, 1937

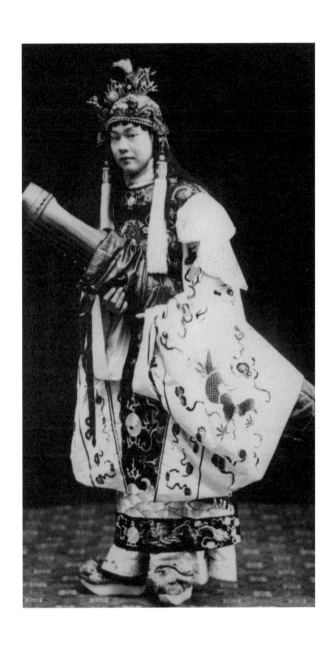

As Bo Yikao in *The Investiture of the Gods*

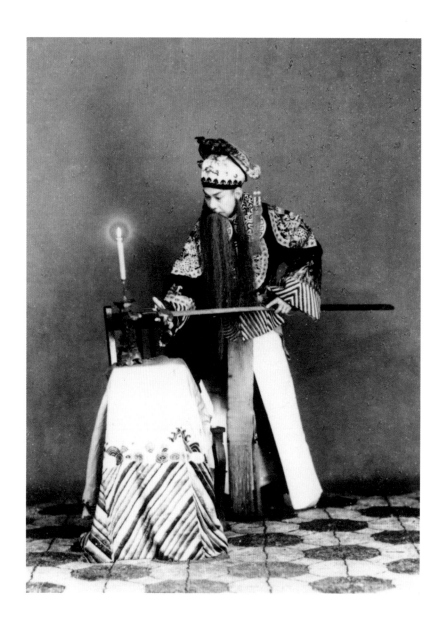

As Wu Zixu in *Wu Zixu*

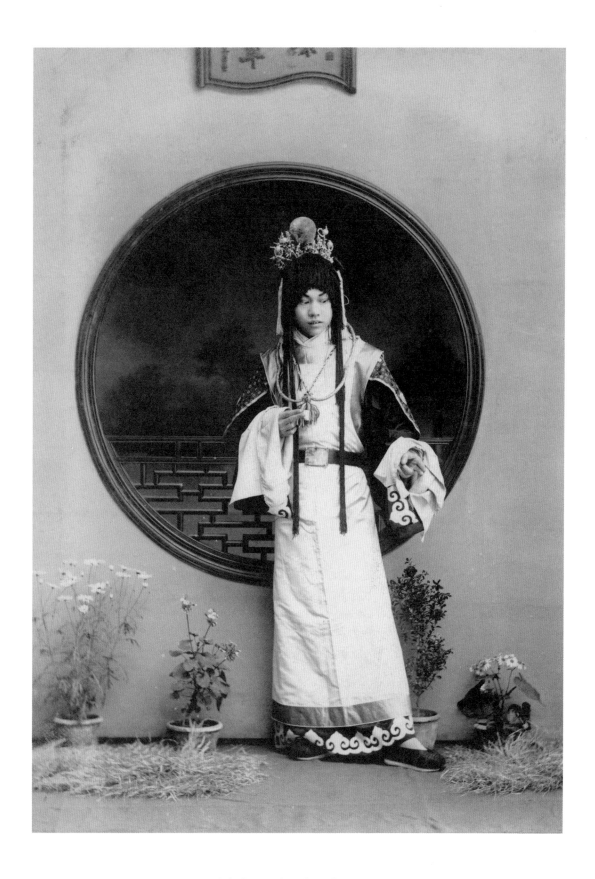

As Jia Baoyu in *Daiyu Buries Flowers*, 1914

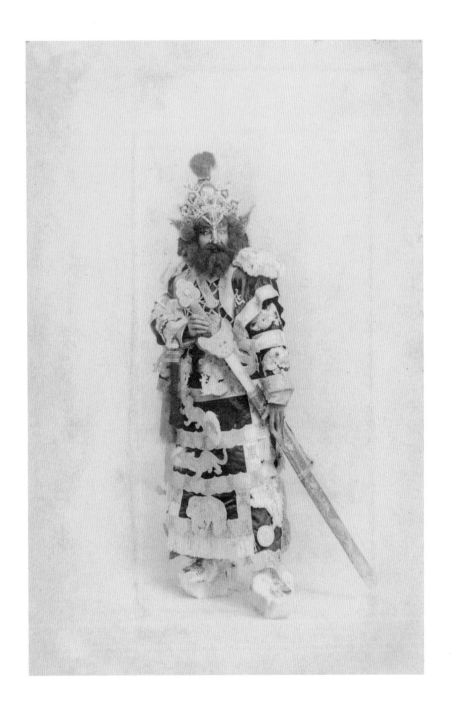

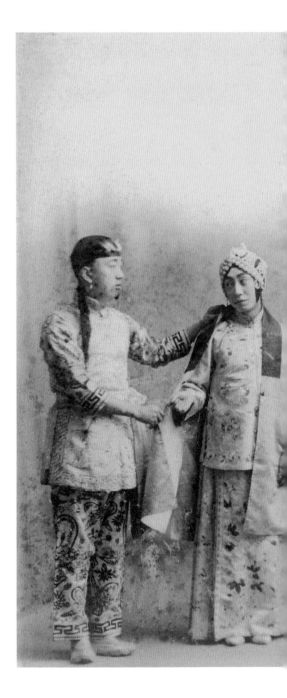

As Xiang Yu in *Liu Bang of Han*, 1930s

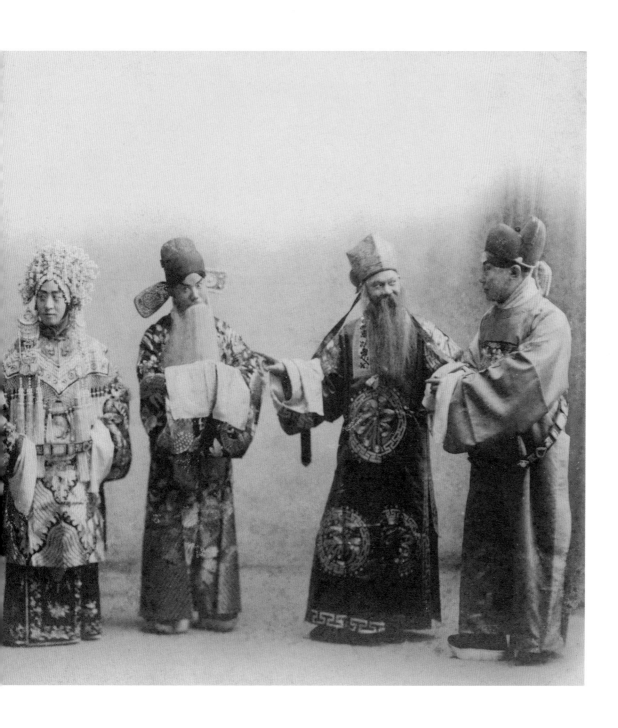

As Cui Wenyuan in *The Riverside Posthouse*, 1924

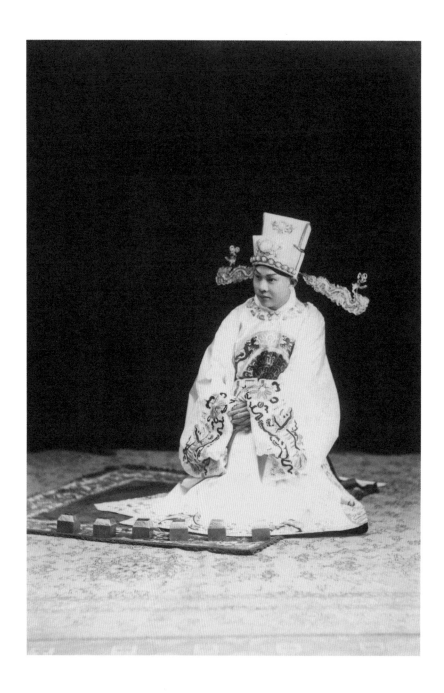

Magnificent Destiny

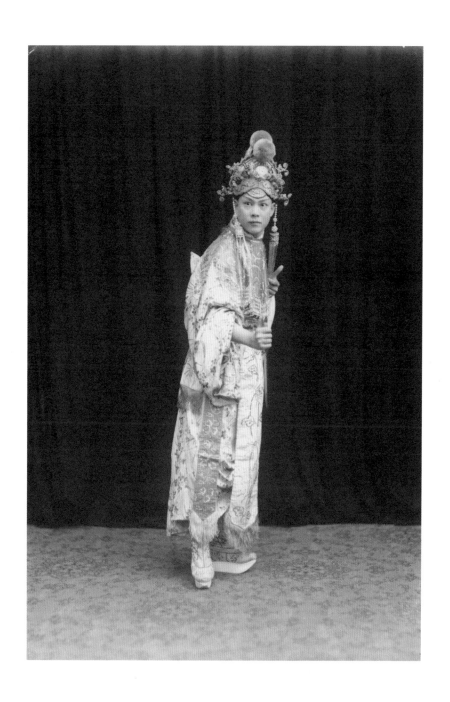

As Zhang Kui in *Dragon and Phoenix*, 1928

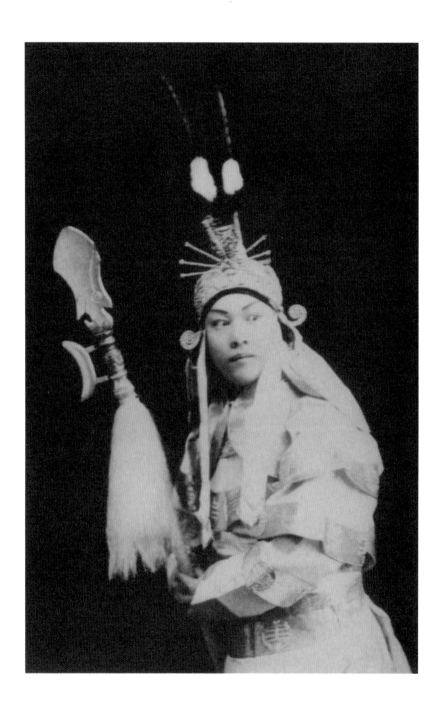

As Huangfu Shaohua in *Magnificent Destiny*, 1928

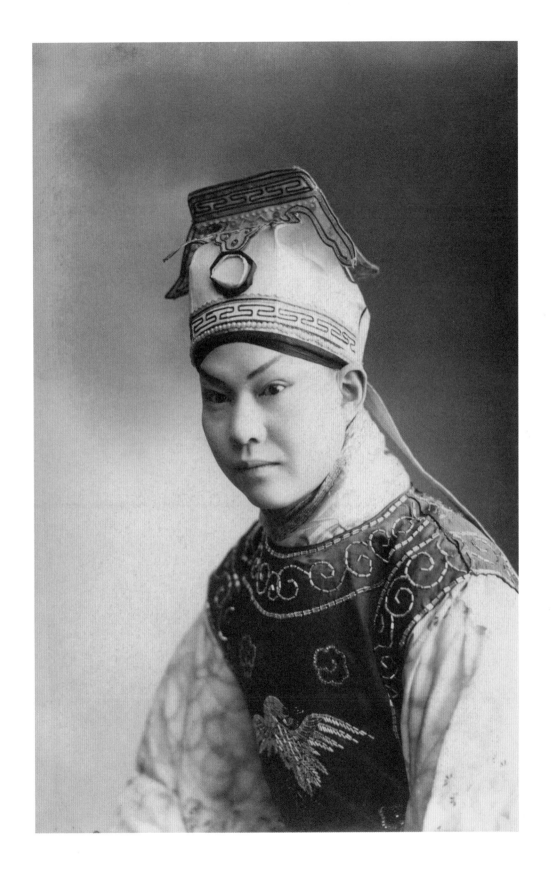

As Huangfu Shaohua in *Magnificent Destiny*, 1928

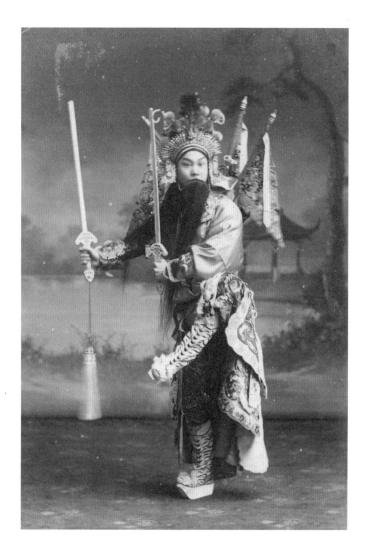

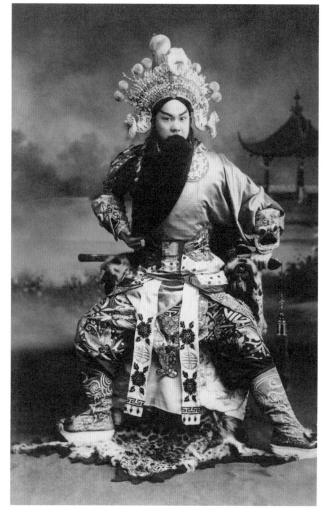

As Liu Bei in *A Deer Hunt in Xutian*, 1915

As Deng Ai in *Crossing the Yinping River*, 1915

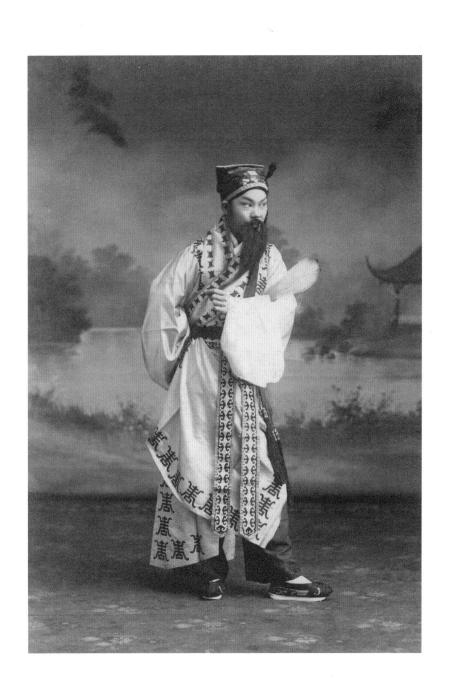

As Lü Chunyang in *Three Tricks on White Peony*, 1920

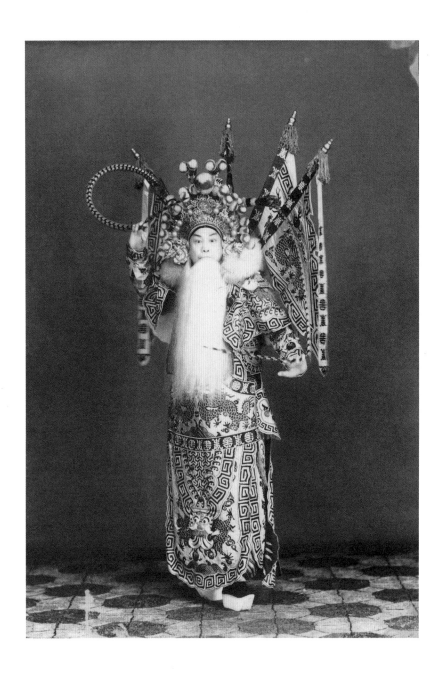

As Huang Zhong in *Battle at Changsha*

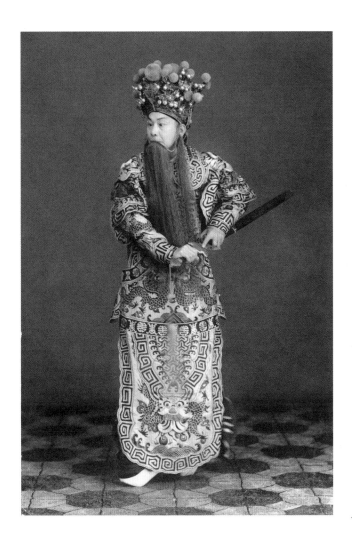

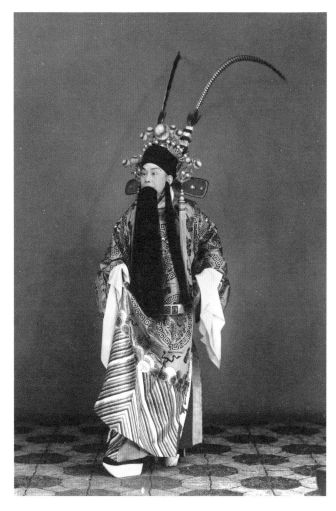

As Yang Jiye in *Generals of the Yang Family*, 1930s

As Yang Yanhui in *Silang Visits His Mother*, 1940s

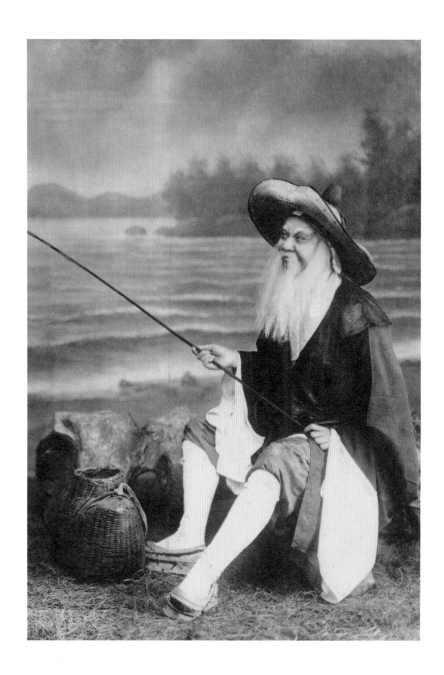

As Jiang Shang in *The Investiture of the Gods*, 1930s

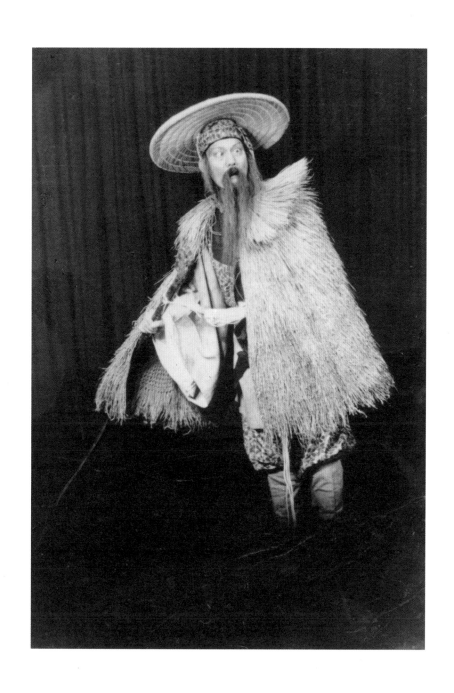

As Cui Wenyuan in *The Riverside Posthouse*

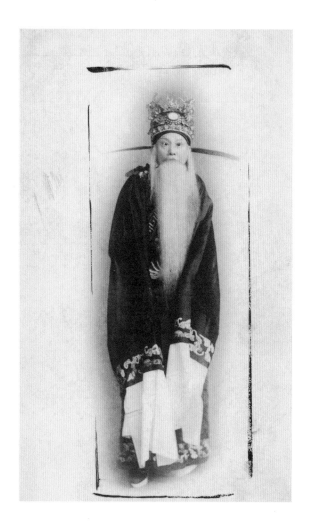

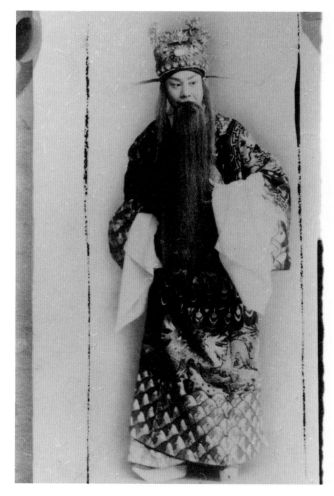

As Xu Ce in *When Minister Xu Ce Hears News*
of a Battlefield Victory, 1920s

As Han Xin in *Xiao He Chases Han Xin*
Under the Moonlight

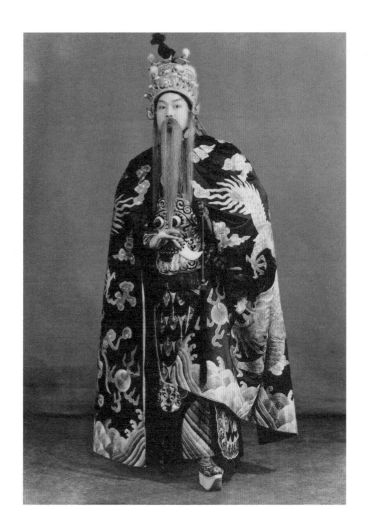

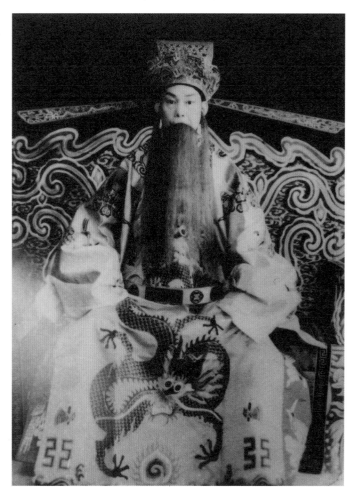

As Yang Ren in *The Investiture of the Gods*, 1935

As Emperor Huizong in *The Two Emperors Hui and Qin*, 1930s

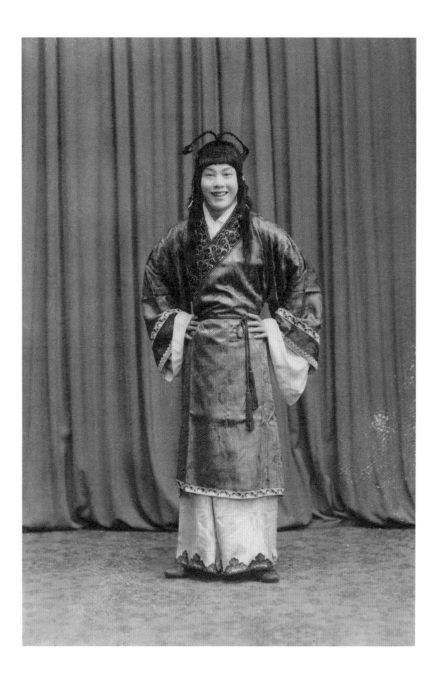

As Prince Ciyun in *Dragon and Phoenix*, 1920s

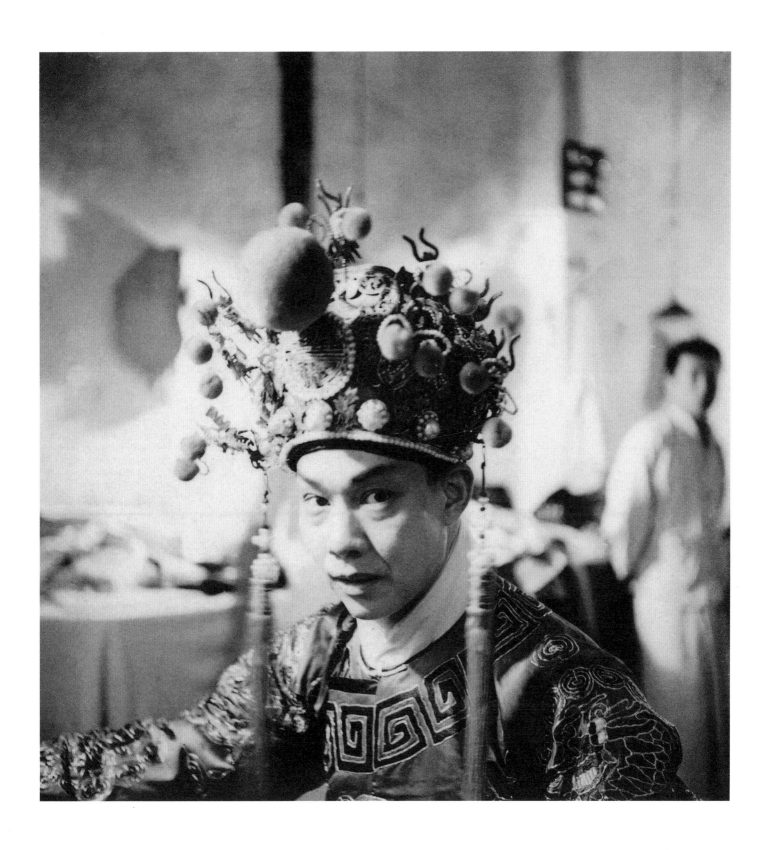

Sorrow for the Fall of the Ming, 1940s

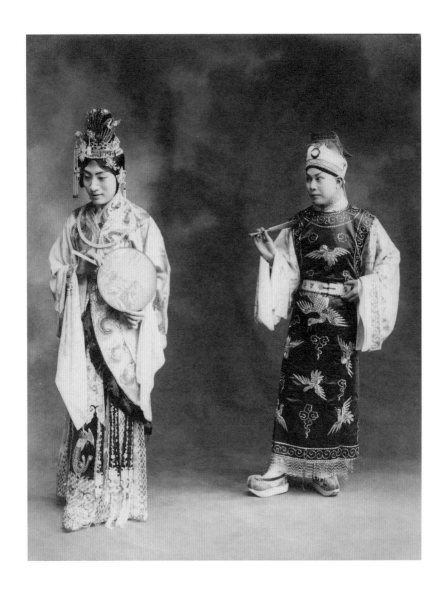

As Huangfu Shaohua in *Magnificent Destiny*, 1928

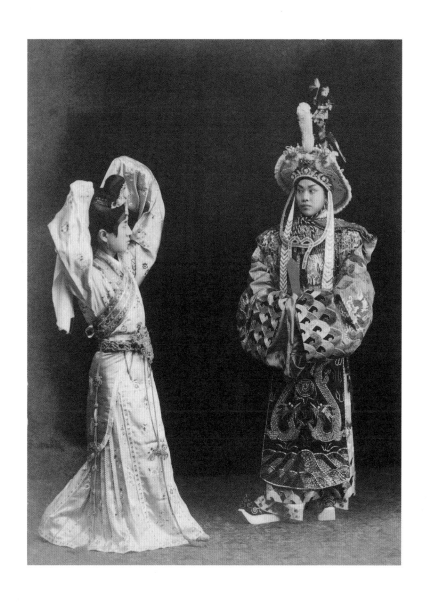

As Liu Bang in *Contest Between Chu and Han*

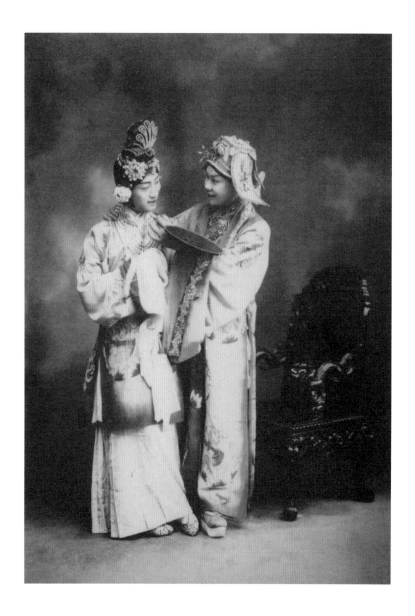

As Huangfu Shaohua in *Magnificent Destiny*, 1928

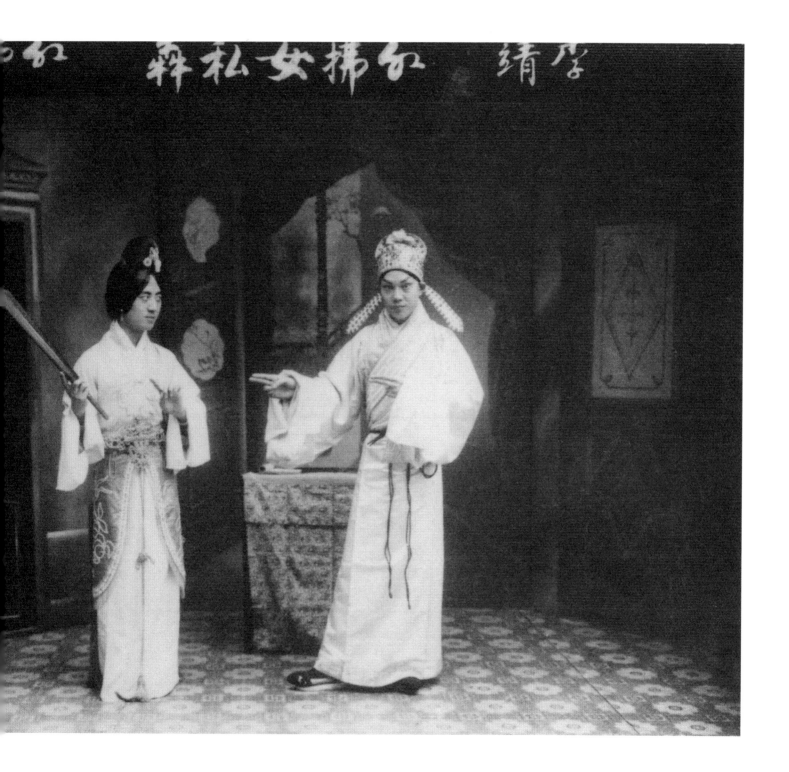

As Li Jing in *The Legend of Hong Fu*

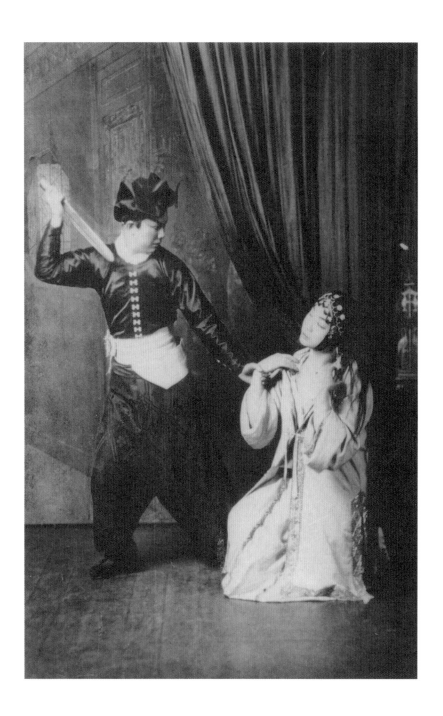

With Ouyang Yuqian in *Wu Song and Pan Jinlian*, 1929

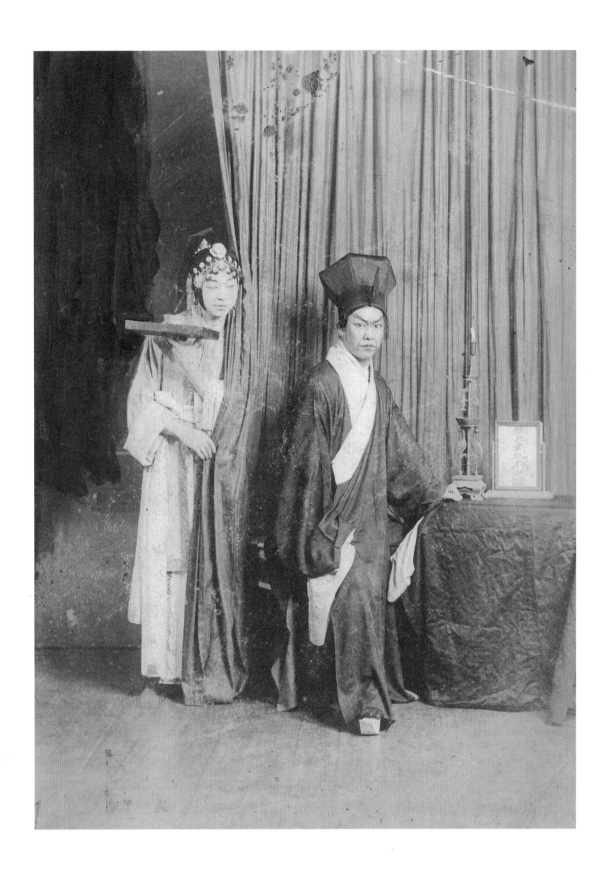

With Ouyang Yuqian in *Wu Song and Pan Jinlian*

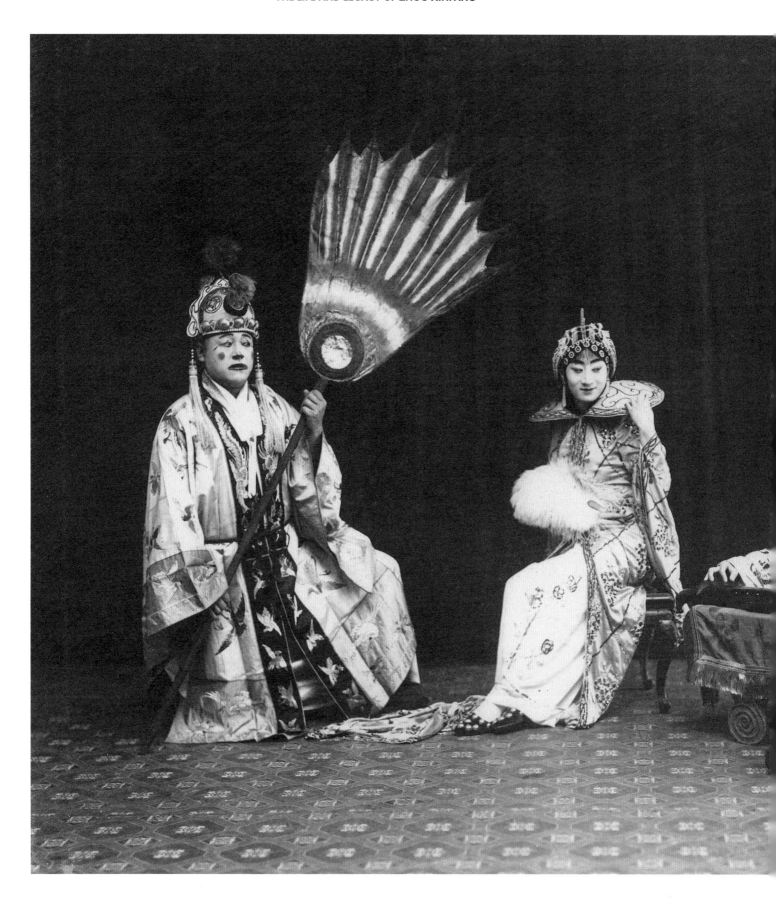

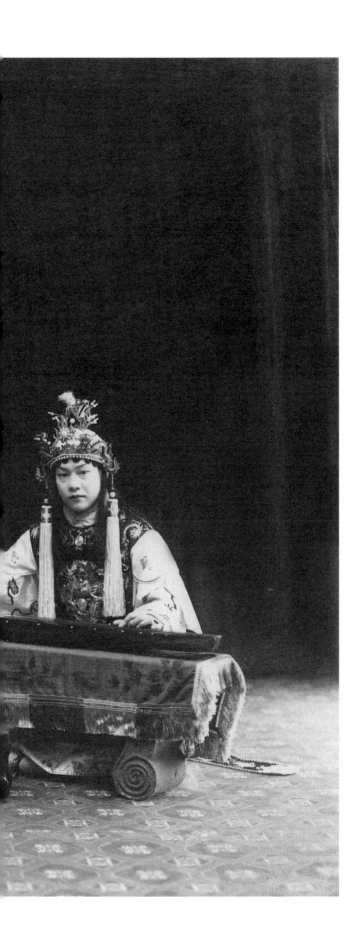

As Bo Yikao in *The Investiture of the Gods*, 1930s

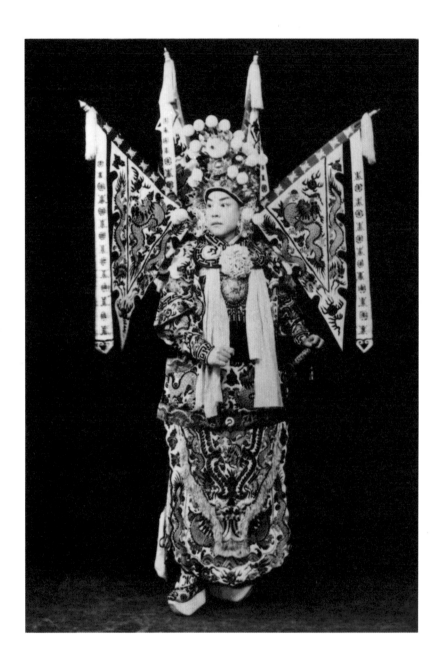

As Xue Pinggui in *Leaving Home to Join the Army*

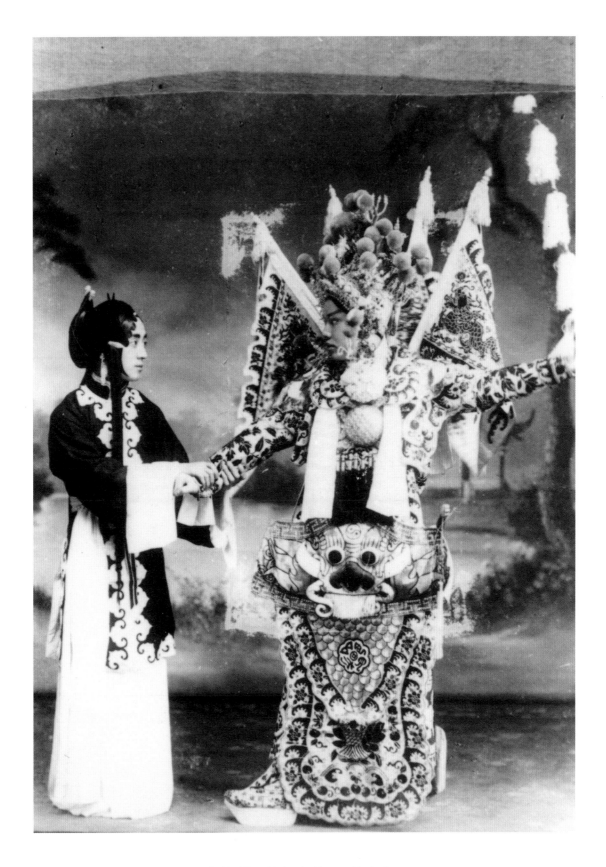

As Xue Pinggui in *Leaving Home to Join the Army*

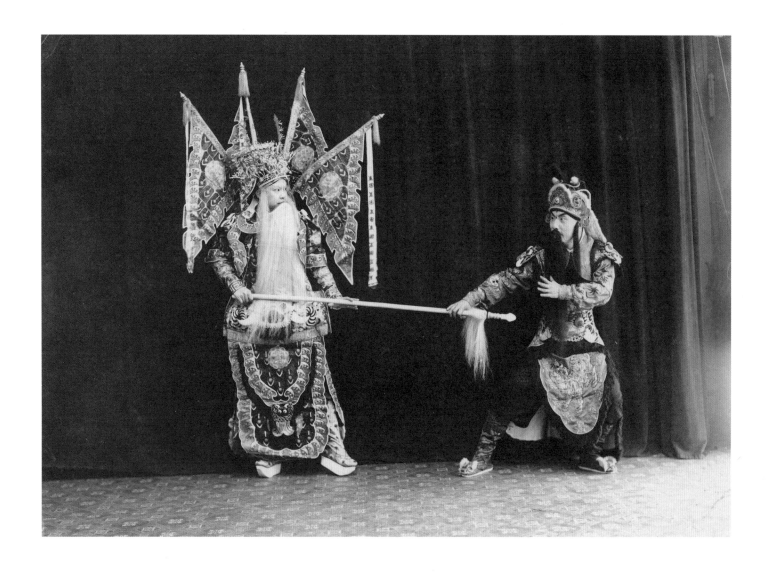

As Huang Gun in *The Investiture of the Gods*, 1930s

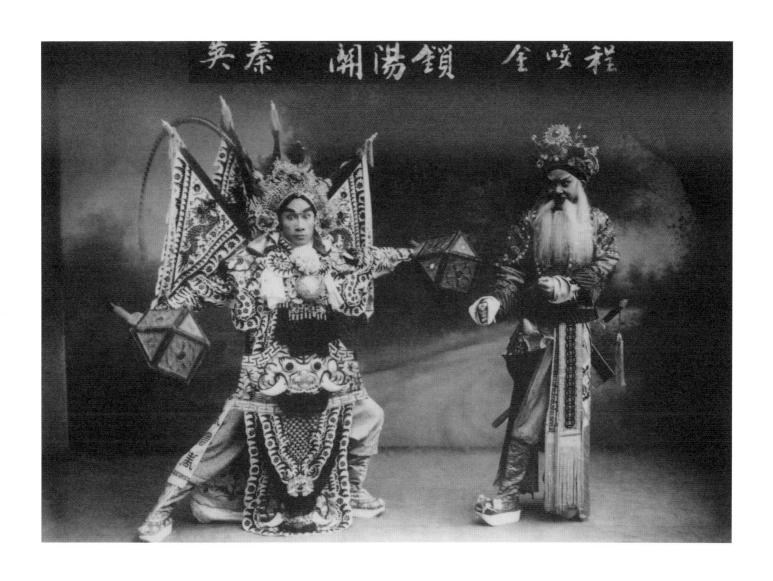

As Cheng Yaojin in *Suoyang Pass*, 1924

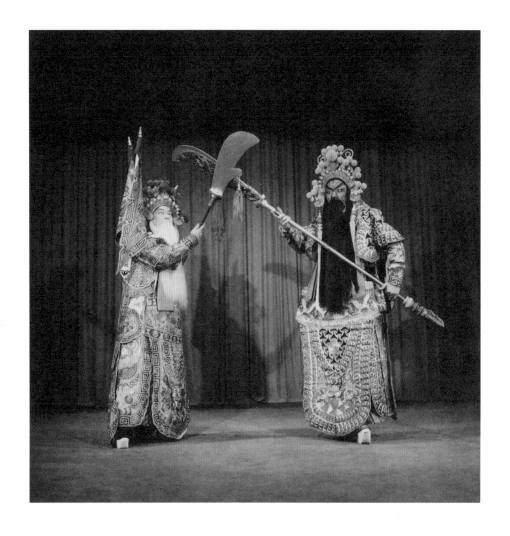

With Zhou Shaoqi in *Battle at Changsha*, 1961

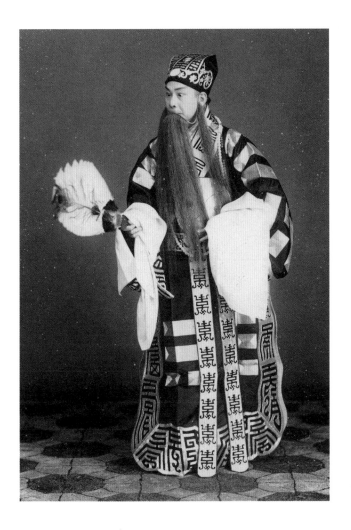

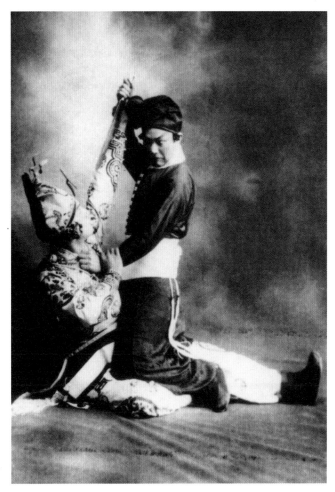

As Kong Ming in *Capturing Meng Huo Seven Times*, 1930

As Wu Song in *Wu Song and Pan Jinlian*

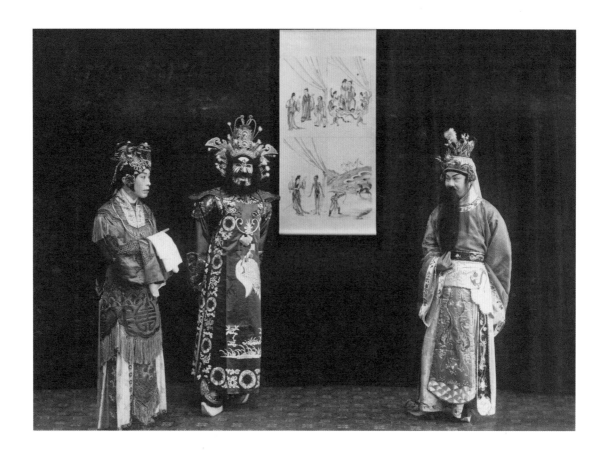

As Yang Ren in *The Investiture of the Gods*, 1930s

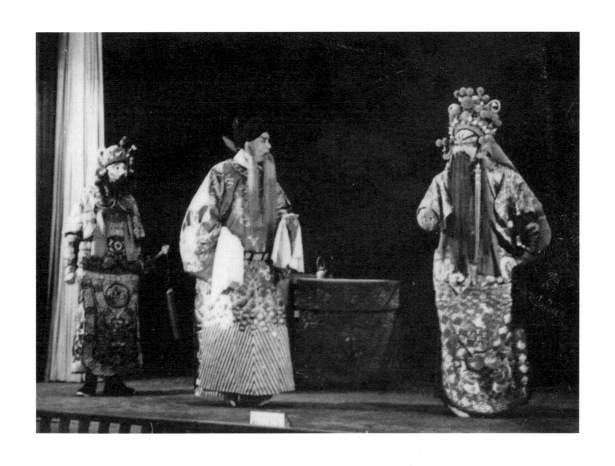

Lord Guan Goes to the Feast, 1958

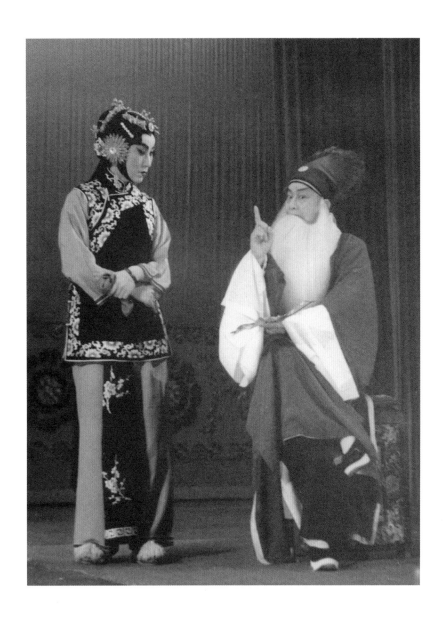

With Tong Zhiling and Li Yuru in *Four Scholars*, 1956

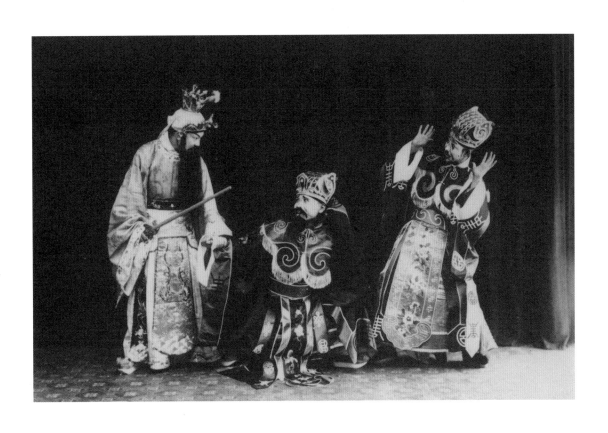

As Yang Ren in *The Investiture of the Gods*, 1930s

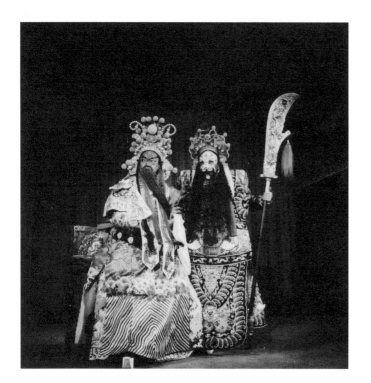 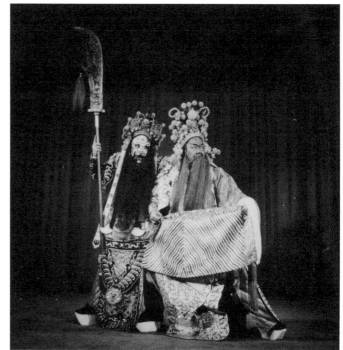

With Wang Shiping in *Lord Guan Goes to the Feast*, 1958

Lord Guan Goes to the Feast, 1958

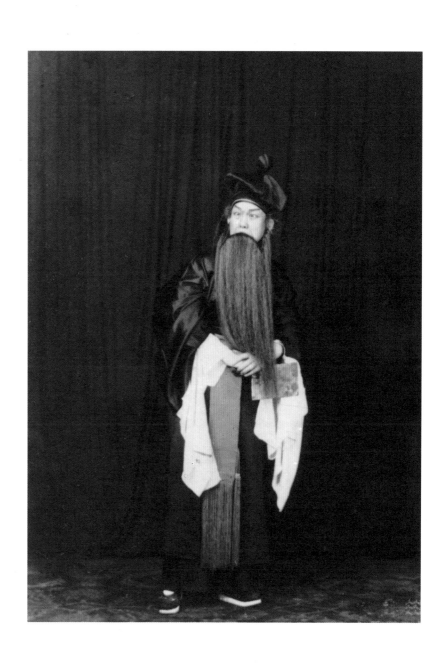

As Mo Cheng in *A Handful of Snow*

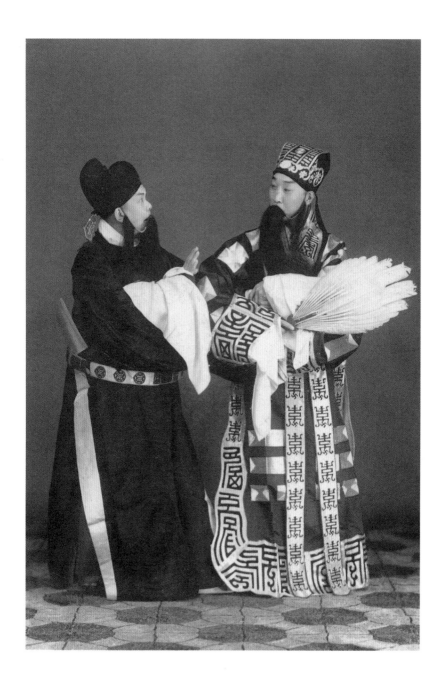

As Lu Su in *A Gathering of Heroes*, 1930s

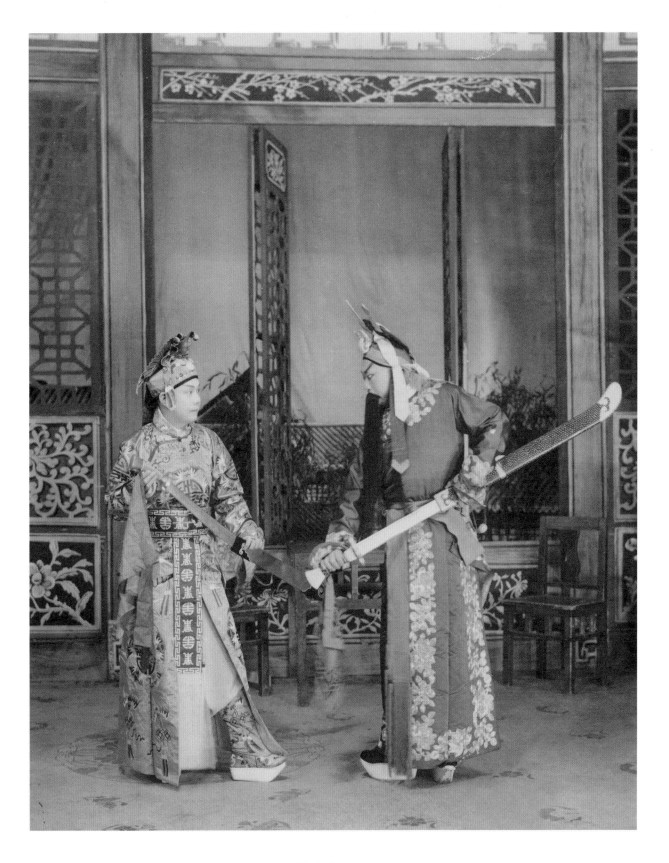

Wen Suchen, 1940s

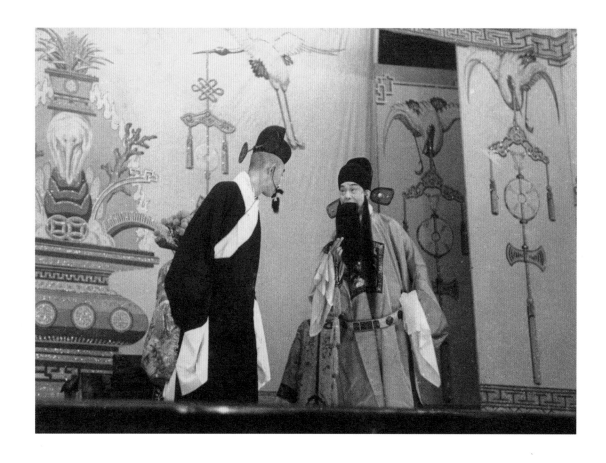

As Zou Yinglong in *Beating Yan Song*

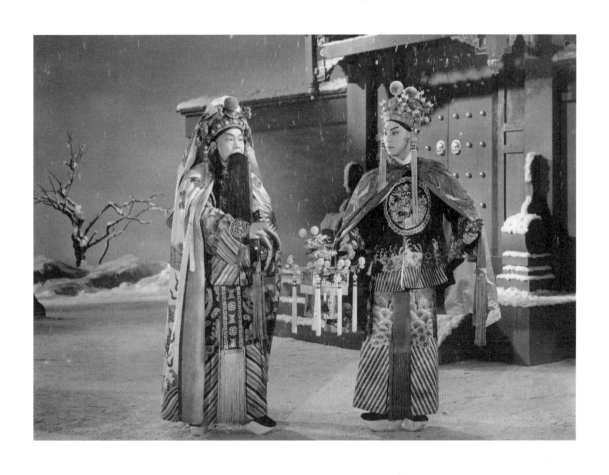

Sorrow for the Fall of the Ming (film)

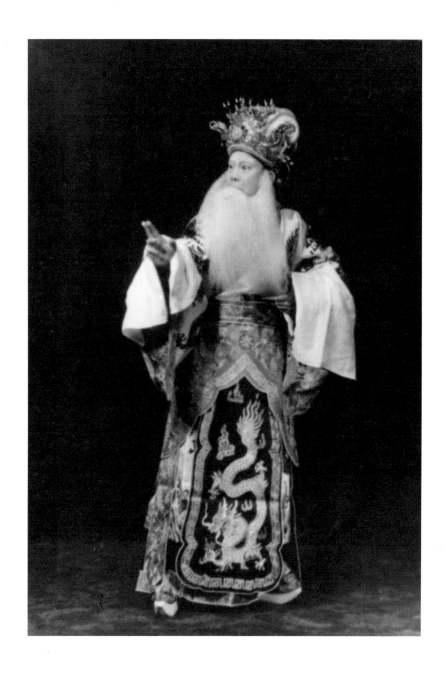

As Bi Gan in *Hatred at Deer Terrace*

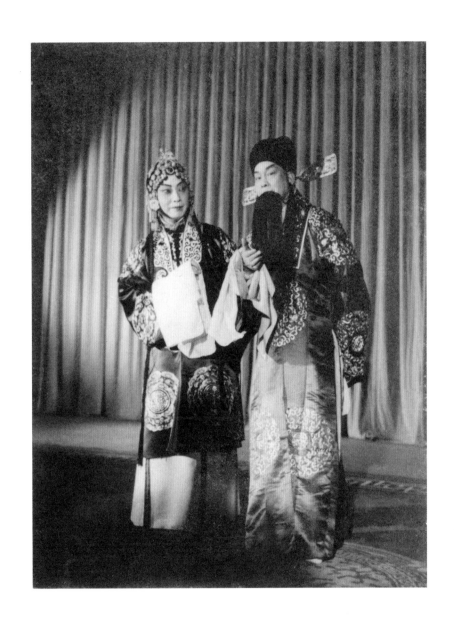

With Mei Lanfang in *The Magic Lotus Lantern*, 1952

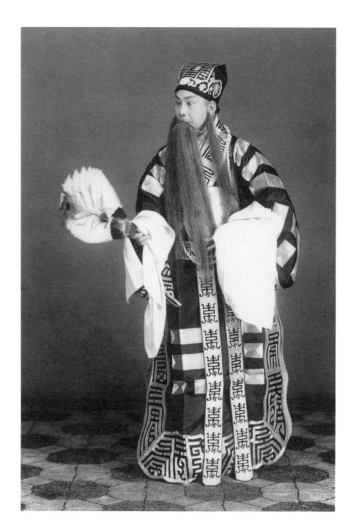

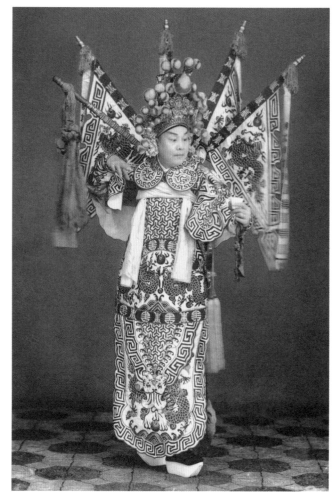

As Zhuge Liang in *Borrowing the East Wind*

As Xue Pinggui in *Leaving Home to Join the Army*

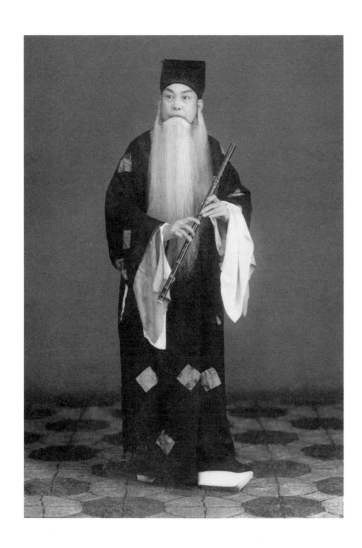

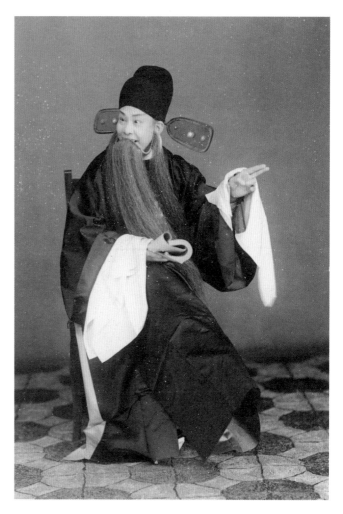

As Wu Zixu in *Wu Zixu*

As Zhang Cang in *Stealing the Ancestral Scroll*, 1930s

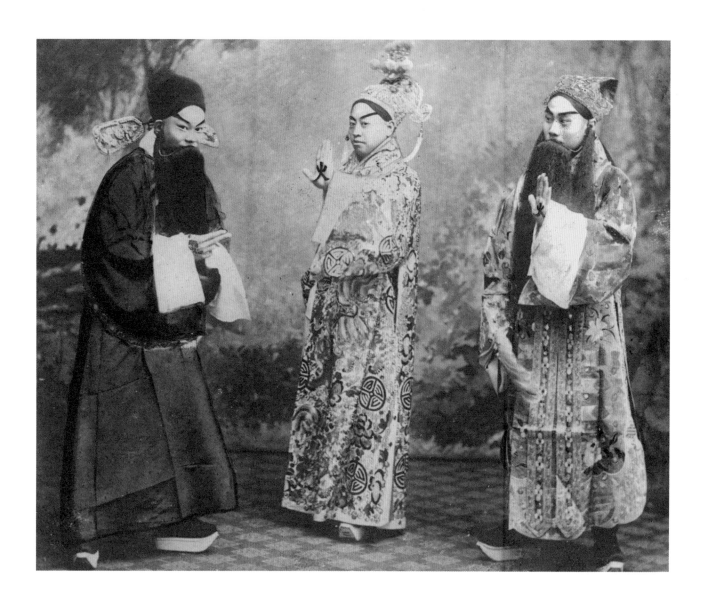

As Lu Su in *A Gathering of Heroes*,
alongside Miao Shengchun as Kong Ming
and Li Manyun as Zhou Yu, 1911

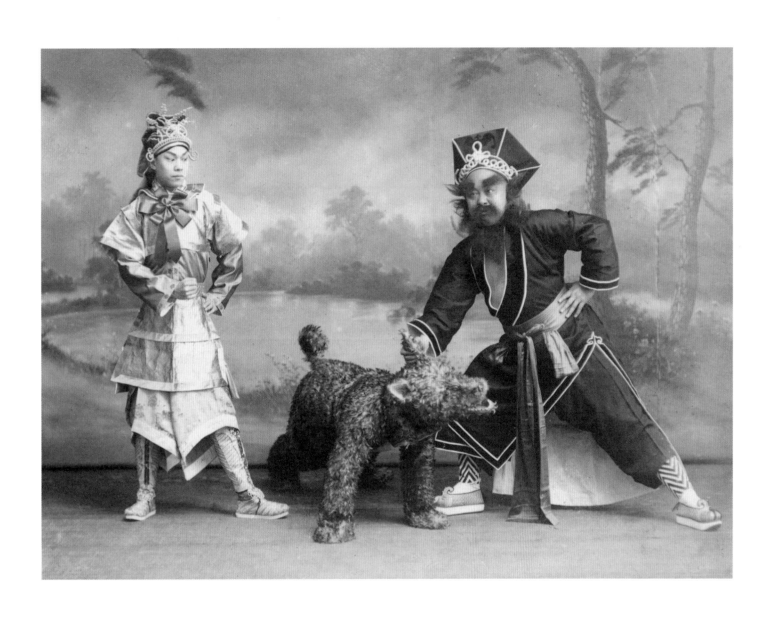

As Liu Bang in *Liu Bang of Han*, 1925

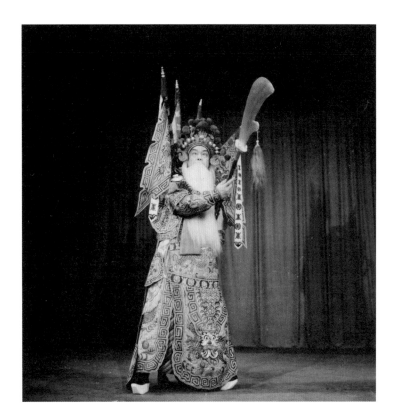

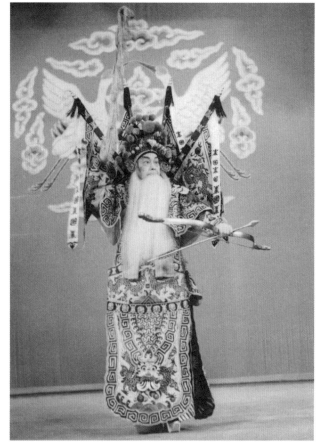

Battle at Changsha, 1961

As Huang Zhong in *Battle at Changsha*, 1960s

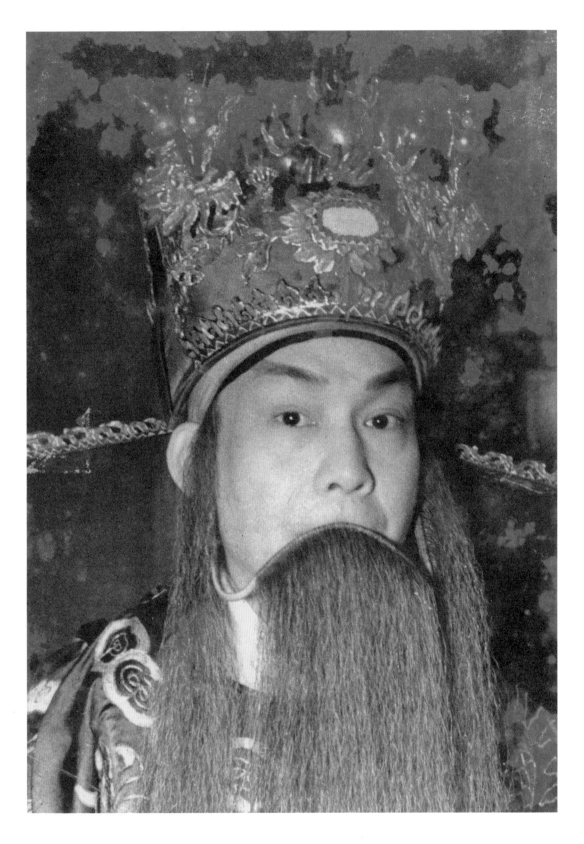

As Xiao He in *Xiao He Chases Han Xin*
Under the Moonlight

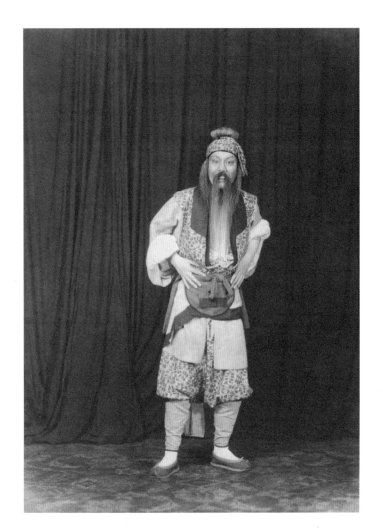

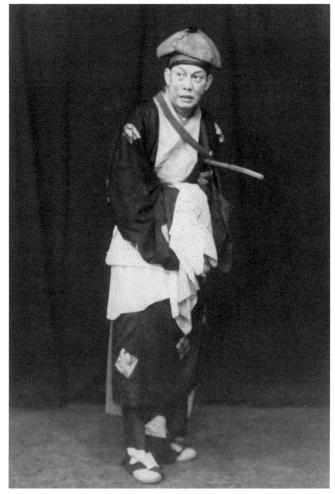

The Riverside Posthouse, 1930s

As Mo Ji in *The Servant of Gold and Jade*

As Zhou Puyuan in *Thunderstorm*, 1930s

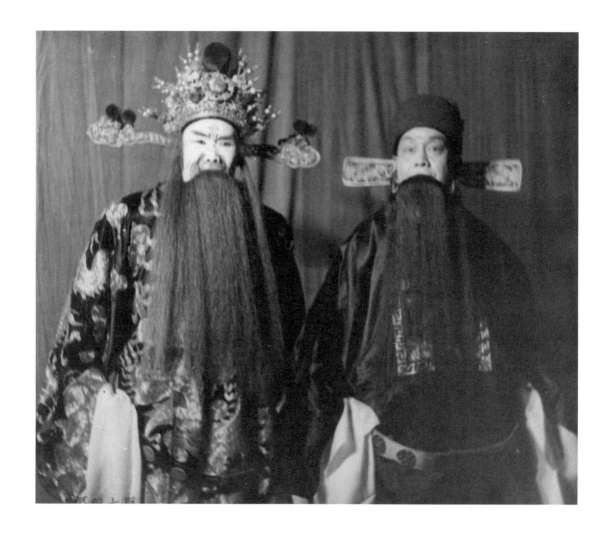

With Qiu Shengrong in *Beating Yan Song*, 1961

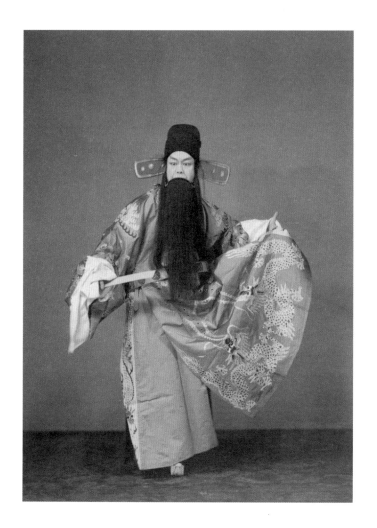

As Mei Bo in *The Burning of Mei Bo*, 1920s

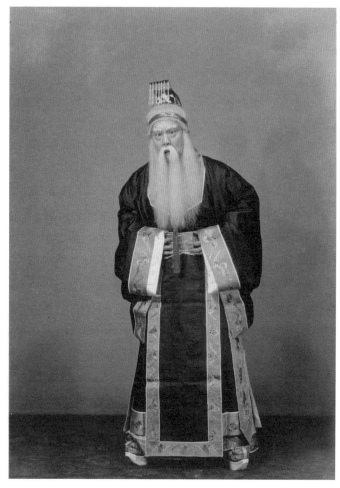

As Bi Gan in *Hatred at Deer Terrace*

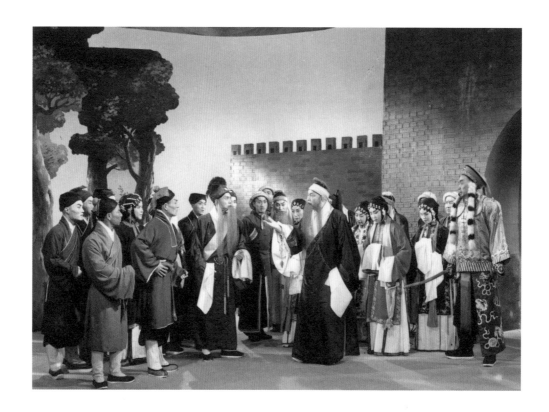

TOP *The Two Emperors Hui and Qin* (film), 1955
BOTTOM *Wen Suchen*, 1940s

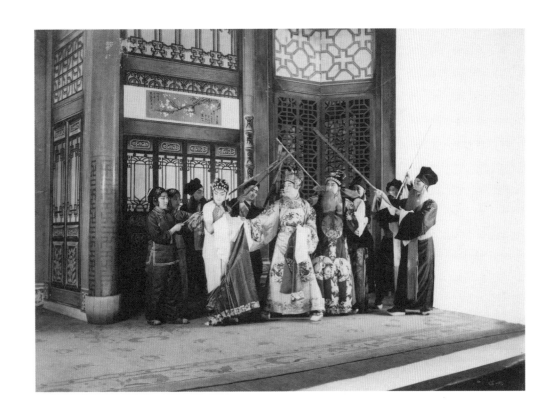

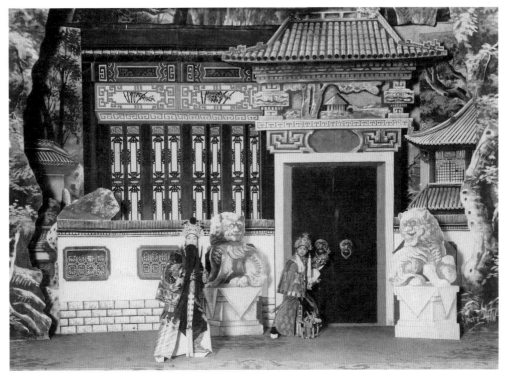

TOP *Wen Suchen*, 1940s
BOTTOM *Sorrow for the Fall of the Ming*, 1940s

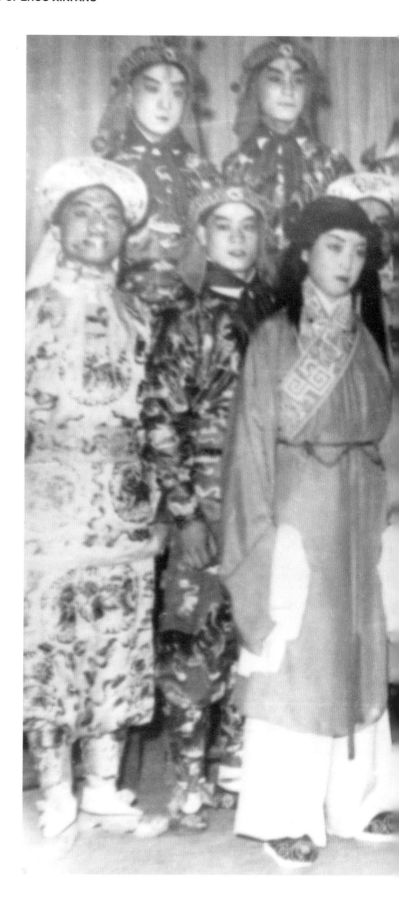

After a performance of *Giving Up Her Son*
in the Second Hall

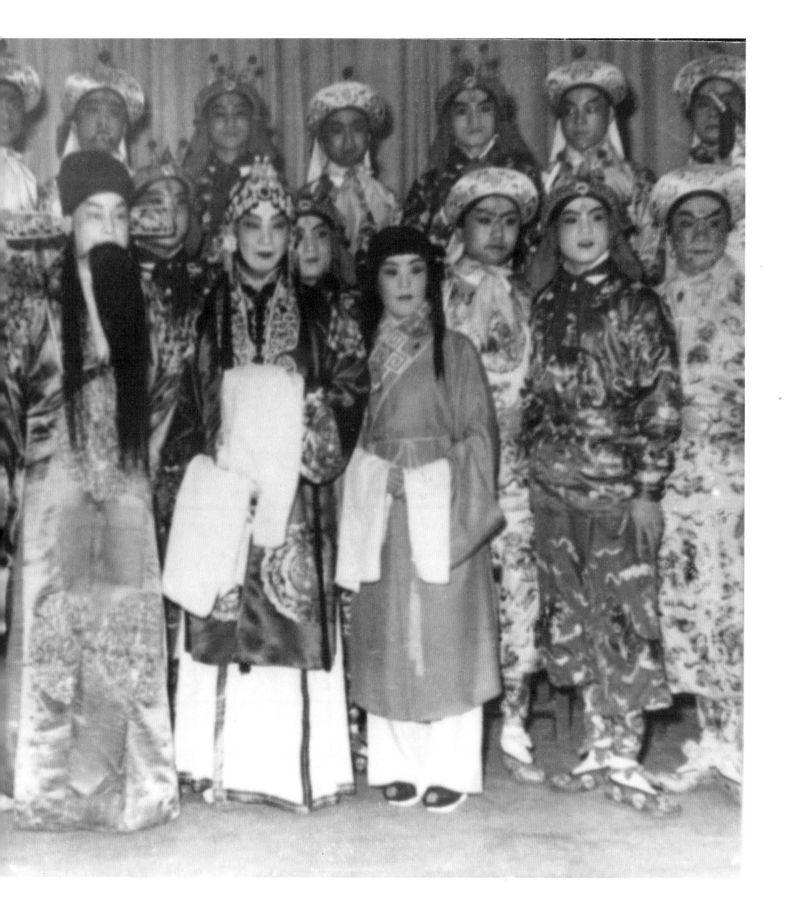

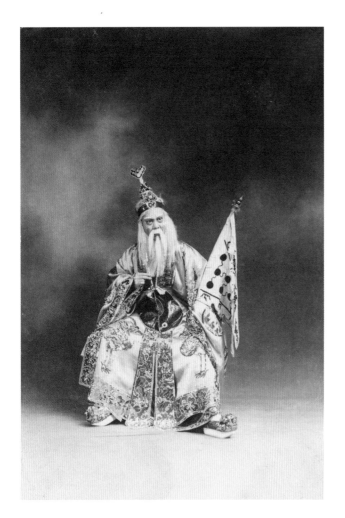

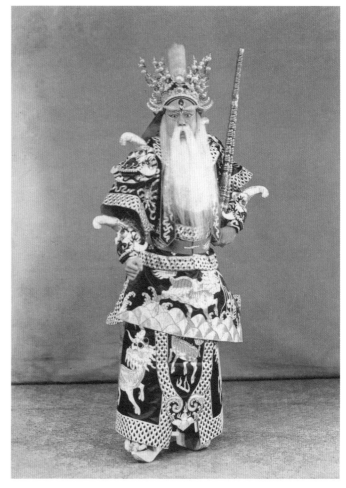

As Jiang Shang in *The Investiture of the Gods*, 1920s

As Wen Zhong in *The Investiture of the Gods*, 1920s

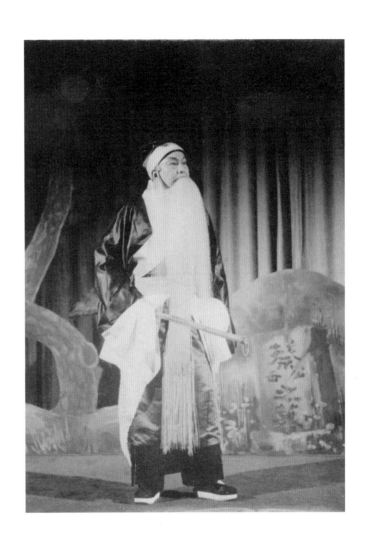

As Zhang Dagong in *Sweeping the Pine Needles*, 1950s

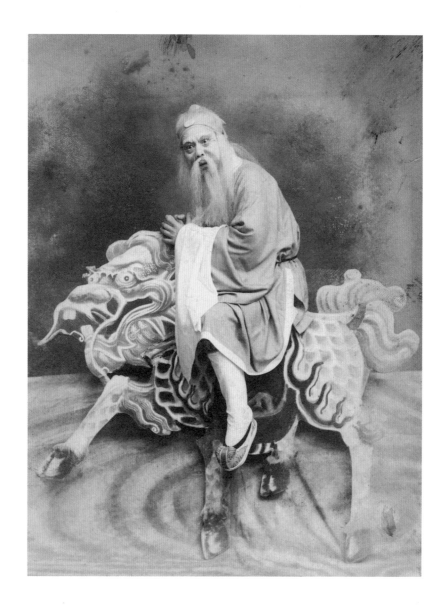

As Jiang Shang in *The Investiture of the Gods*

STAGING THE SELF

by Philippe Garner

A BOY LEAVES HIS COUNTRY, HIS CULTURE, HIS FAMILY, HIS HOME, AND ALL HE HOLDS DEAR. He arrives, an exile, a stranger in a distant new land. He must discover who he is and carve a place for himself in an unfamiliar environment. He must ascertain and express his true identity after the trauma of rupture from his own past. There is a void that must be filled. He must be strong, and sensitive; he must be fearless, yet wise; he must use his innate resources—his eye, his intelligence, his instincts, and the precious traces and memory of who he was—to shape how he will grow.

The key to Michael Chow's fundamental philosophy of living might be expressed as a simple truism—that life and art are inseparable. For him, creativity is all; emotions, experiences, and aesthetics are inextricably intertwined in a rich and intense engagement with the world. His constant pursuit, a perpetual act in every waking moment, in every gesture, every word, every choice, and every human contact, is the ideal of harmony as an expression of rightness.

In 1959, Michael Chow staged a striking black-and-white self-portrait. In the photograph, Chow is frozen in mid-gesture as he hurls water toward the camera—the water caught in flight. Here is an echo of his past and the harbinger of much that is to follow. The idea of stylized performance, of a stage, of assuming a part, a role, a character, is boldly manifested in this early image as if it were a primary link in Chow's DNA. And surely it is—we see him instinctively asserting himself as the son and heir of his father, the great stage artist, Zhou

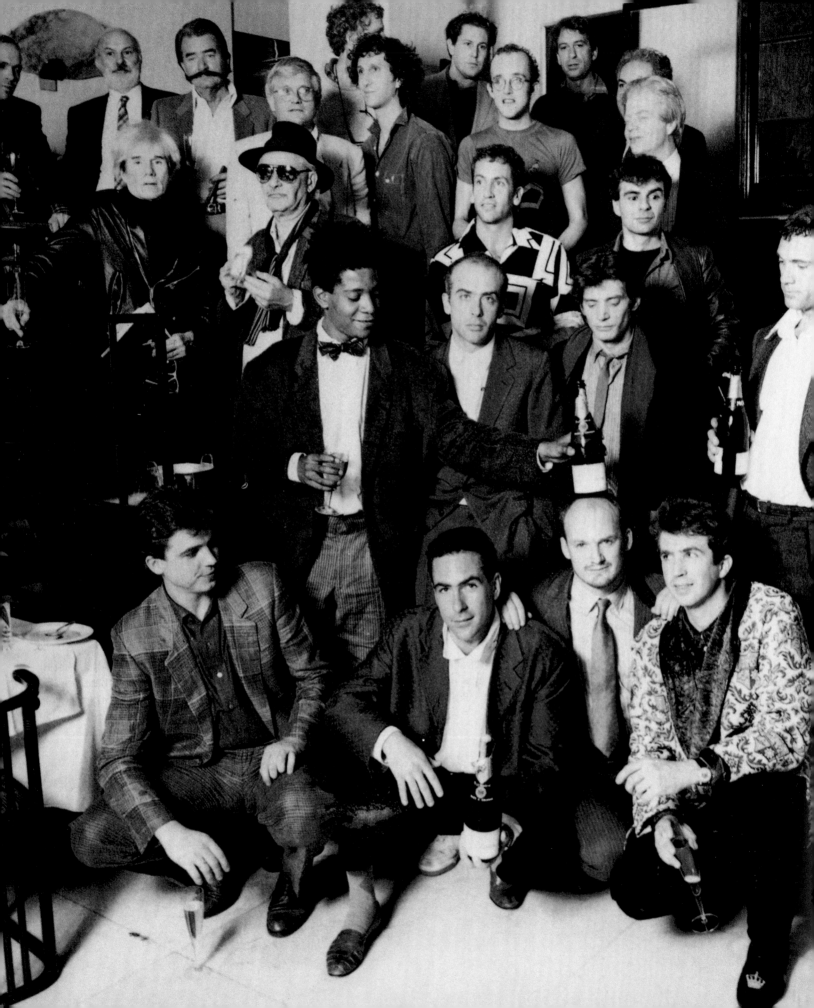

Xinfang. This scenario is resonant for the particular role in which Chow casts himself—as a performance artist and action painter whose medium is the dynamic temporal statement, at a moment when this approach to art is truly avant-garde. This early self-portrait can be seen as emblematic of the way in which he was to live as one with the cutting edge of experimental art, and was to engage collaboratively with so many artists in constructing his extensive, highly innovative, kaleidoscopic collection of portraits of himself. This remarkable collection gives definitive form to the role or roles that he has performed ever since; it deftly illustrates the different mantles that he has assumed—as a figure of style, as a social and creative catalyst, as a sophisticated, philosophical connoisseur of art and of life, and as an artist in his own right, whose most extraordinary creation is surely himself, holding court as an impresario on the global stages that he has constructed through his skills and finesse as an architect of environments.

For more than half a century, Michael Chow has built a striking collection of portraits of himself—portraits in various media, portraits large and small. They are the work of numerous notable artists, many of them friends. Vanity? Not at all. Arrogance? No. He is not an arrogant person. These portraits are not about self-aggrandisement; they are not conventional status portraits; they reveal humanity, and humor; they have their own logic as one facet of a multilayered process of inquiry, an existential inquiry that has defined his life story.

He arrived in Britain at the age of thirteen. Eventually, settling in London as a student of architecture with the ambition to be an artist, he started to make contact with kindred spirits, among them young artists still little known but destined to establish themselves as the shapers of a new British art scene constructed on the twin foundations of Pop and abstraction. Among the very first friendships was the one struck up with painter Peter Blake, often cited as one of the key founding figures of British Pop. In 1966, Chow asked Blake to make a portrait of him. This was the first, and remains one of the most witty and idiosyncratic. Chow is depicted, his face collaged onto an older man's suited body, as the manager of a pair of wrestlers, part Chinese, part Italian; the work incorporates Pop-folk-art lettering and is festooned with deliberately kitsch chinoiserie. It is a clever, tongue-in-cheek spoof of racial stereotyping.

MR CHOW New York, ca. 1983.
FROM TOP TO BOTTOM (LEFT TO RIGHT) Michael Heizer,
Arman, LeRoy Neiman, Dennis Oppenheim, Julian Schnabel,
William Wegman, David Hockney, Alex Katz, Keith Haring, Tony
Shafrazi, Red Grooms, Andy Warhol, John Chamberlain, Kenny
Scharf, Ronnie Cutrone, Jean-Michel Basquiat, Francesco Clemente,
Robert Mapplethorpe, Sandro Chia, Chris Goode, Darius Azari,
Shawn Hausman, and Eric Goode

Michael Chow, *Self-Portrait*, 1959

Within two years, Chow had opened his first restaurant, its interior a masterful mix of classic European Modernism, Italian terrazzo-tiled floors, smoky mirrors, artful lighting, and contemporary works commissioned from artist friends, including Clive Barker's chromium-plated sculpture *The Three Peking Ducks* (1969)—obliquely referencing Chow's persona. In 1967, high-profile British artist David Hockney made a sensitive, naturalistic color pencil drawing that Chow used on the restaurant's matchboxes, underlining the very personal touch he brought to his business. In creating his London restaurant—along with subsequent restaurants in Los Angeles, New York, and Miami—Chow, the exile, was creating his own universe, to his exacting standards and reflecting his refined sensibility. He has created settings that speak of elegance and glamour, with specific visual triggers that evoke a nostalgia for lost eras of high style—the Art Deco years, and the Hollywood film noir that he loves, with its suave tuxedoed leads, polished temptresses, and melodramatic lighting. Rita Hayworth as Gilda in the eponymous 1946 film remained a defining image for Chow.

The MR CHOW restaurants are his translation of his dreams into a reality. He has called them his "embassies" and these sophisticated spaces demand a level of performance from their clientele. They are designed to ensure that the diners feel like stars, and have attracted generations of luminaries from the worlds of fashion, film, and, of course, the arts. And ever present is the master of ceremonies, the director, set designer, and choreographer of this spectacle—either in person, his watchful eye ensuring every detail is in order, welcoming diners into his world, or in spirit, through the portraits that hang in the restaurants

and underscore the identity of the man who plays the lead role in this highly styled universe. Central to the design of the Miami restaurant and emphasizing the grandeur of the elongated room is a long, straight river of carpet, like the red carpet of a film premiere; yet this is Chow's space, and it is blue—Yves Klein blue—in homage to the artist.

For the restaurant Chow opened in 1974 in Beverly Hills, he invited West Coast artist Ed Ruscha to make a portrait of him. The result was surprising—like a giant calling card, purely typographical, spelling out *Mr. Chow L.A.* using egg yolk, red cabbage, soy bean paste, red bean paste, and a secret ingredient, rather than paint. Other Ruscha typographical works followed over the years, including one to celebrate Chow's thirtieth anniversary as a restaurateur.

The New York restaurant, opened in 1979, situated Chow at the epicentre of the city's art community, at a time when the art scene was making an international impact. In his apartment above the restaurant, he installed his museum-quality collection of furniture and objects by the two masters of Art Deco—furniture designer Emile-Jacques Ruhlmann and lacquer artist Jean Dunand—whose alignments of modernity and tradition in refined works of faultless proportion and exquisite execution have served as a touchstone for Chow's own design practice. Diners entered the restaurant through magnificent double doors with cast glass panels by René Lalique. Chow appreciates their magical provenance—they were made for Jacques Doucet, arguably the most important art patron and collector in the first quarter of the twentieth century.

Chow was in his element as the 57th Street restaurant became a meeting place for the New York art crowd. Andy Warhol—the most visible artist of his generation—lapped up the spectacle. The young, brilliant, mercurial Jean-Michel Basquiat entered the charmed Chow circle. New portraits followed. From Warhol, in 1984, came an imposing double screen-print, one image in black on white, the other with partial tonal reversal in black and graphite

Michael Chow, photographed
by Andy Warhol, early 1980s

163

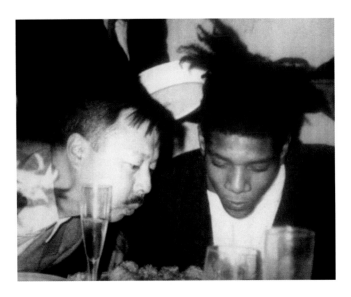

Michael Chow and Jean-Michel Basquiat,
photographed by Rene Ricard, ca. 1983

and subtle sparkles, corresponding to Chow's request for "lots of sparkling, glittering stuff and hold the color." The following year, Basquiat painted an ambitiously scaled portrait, notable for the subject's looping, symbolically all-embracing arms. And in 1996, when Julian Schnabel—who made portraits of Michael in 1986, and of his wife, *Eva Holding a Miniature Amulet of Michael*, in 1998—turned his hand to directing with his biopic on the short, meteoric life of Basquiat, the New York MR CHOW featured as an authentic location, and of course there was only one person to play the part of the restaurateur—Michael Chow himself.

Recent commissions from younger contemporary artists remind us that Chow's project is open-ended. A portrait sculpture executed in wax by neo-Dadaist Urs Fischer was acquired through exchange, this time with Chow trading one of his own paintings rather than restaurant credits, a peer-to-peer barter that gave him particular satisfaction. Chow's video interview with multimedia artist Alex Israel is the Proust Questionnaire reinterpreted for the YouTube generation.

Chow has, on numerous occasions, posed for the camera. In the sixties he was photographed by such highly fashionable London names as David Bailey and Barry Lategan. Warhol made an intriguing photo-portrait of Chow in the early 1980s. Himself a keen collector of Art Deco, he would have appreciated the spectacular early 1920s jewel by Georges Fouquet that Chow had recently acquired as a stellar addition to his collection, a piece he eventually gifted to the Metropolitan Museum of Art in New York. In the eighties and nineties he was perhaps most tellingly portrayed by Helmut Newton, with whom he had developed a close friendship. Newton understood and respected Chow's obsessive pursuit of his goals, just as he surely related to the psychology of the émigré needing to reconstitute his universe, for he too had been forced to dramatically sever links with his

family and culture when he fled Germany in 1938. And Chow admired Newton's ability to elaborate his richly layered pictorial inventions so convincingly by setting them in real-life contexts that gave them the authentic flavor of documentary photographs.

Alongside all these specific portrait commissions and projects, Chow has, for many years now, invited artists to contribute to his Guest Book, his reinvention of the traditional guest book signed by visitors. His idea was to offer each artist a blank page or double page on which they might inscribe or sketch a tribute of their own devising. Today, the list of contributors constitutes a roll call of many of the most influential artists of their day. We find Francis Bacon expressing his "deep admiration." Cy Twombly writes a few words in a script that is unmistakable, like the traces that constitute his enigmatic paintings. Allen Jones sketches, in 1978, a leg ending in a signature high-heeled shoe; on another page, Jim Dine draws a heart, a 1996 echo of the series of hearts he had painted for the Valentine's Day opening of the first London restaurant. Elsewhere, we find a sensitive head-and-shoulders colored drawing of Chow by Larry Rivers, a cartoonlike image by Keith Haring, playful additions by Anthony Caro, Patrick Caulfield, John Chamberlain, Isamu Noguchi, Robert Rauschenberg, and James Rosenquist, among others. On facing pages, Julian Schnabel and Francesco Clemente draw delicate portraits of each other; Basquiat, meanwhile, like a mischievous child, runs riot over numerous pages.

The Guest Book is a vivid testament to Chow's ability to communicate and share his vision of a world in which creativity and aspiration can conspire fruitfully, a world in which primacy is given to the pursuit of ideals of beauty and of grace. The Guest Book and the portraits in all media that Michael Chow has commissioned are a revealing mirror of this exceptional man. Each image is a clue to the nature of his quest, an insight into the identity of the man depicted in this never-ending self-portrait.

Dan Flavin, *Untitled*, 1982
Ink on paper, 5 x 3 inches (13 x 8 cm)

Ed Ruscha, *MR. CHOW L.A.*, 1973

Peter Blake, *Frisco and Lorenzo Wong
and Wildman Michael Chow*, 1966

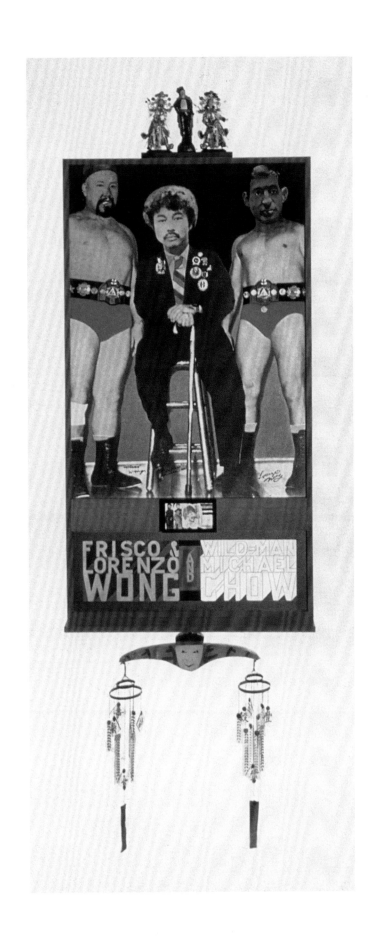

Ed Ruscha, *ZHOU XINFANG*, 1982

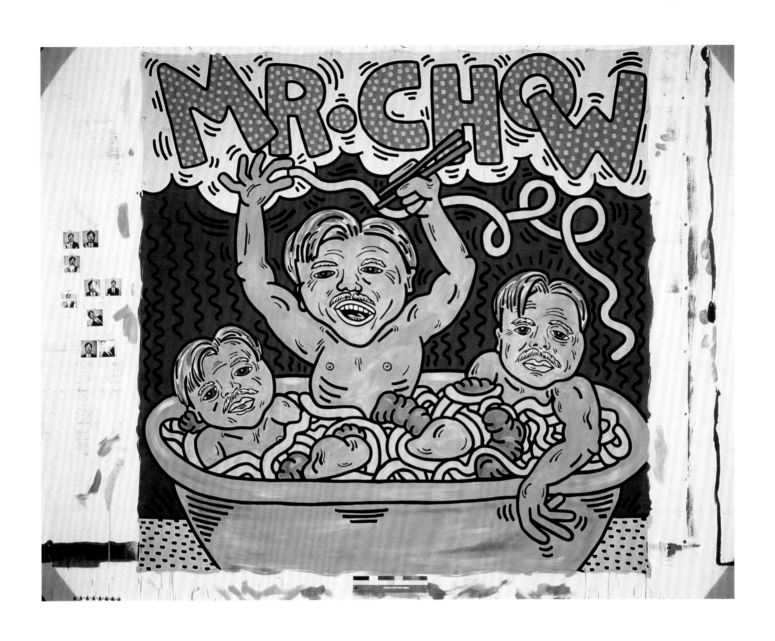

Keith Haring, *Mr. Chow as Green Prawns in a Bowl of Noodles*, 1986

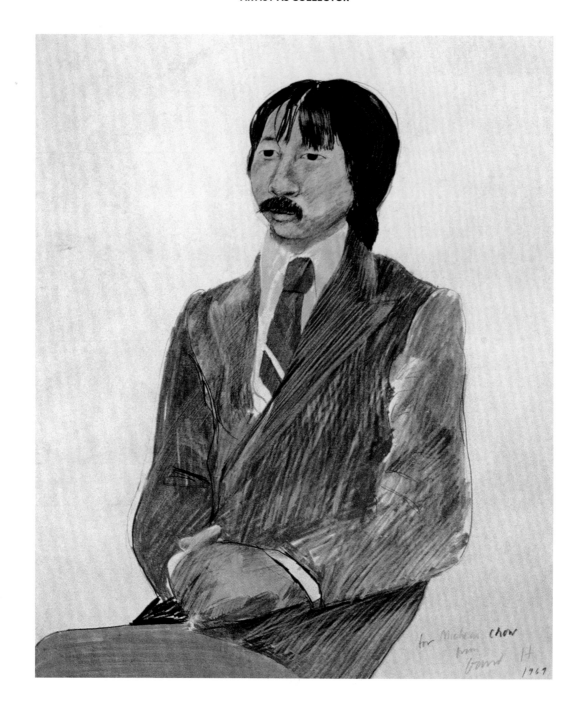

David Hockney, *Untitled*, 1967
Crayon on paper, 17 × 14 inches (43 × 36 cm)

Andy Warhol, *Untitled* (diptych), 1984

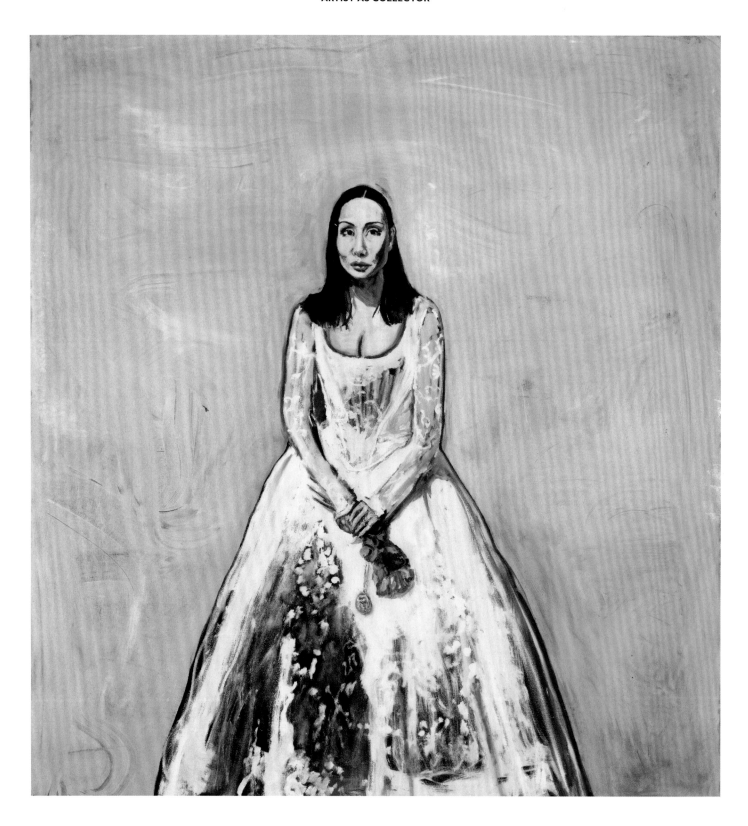

Julian Schnabel, *Eva Holding a Miniature Amulet of Michael*, 1998

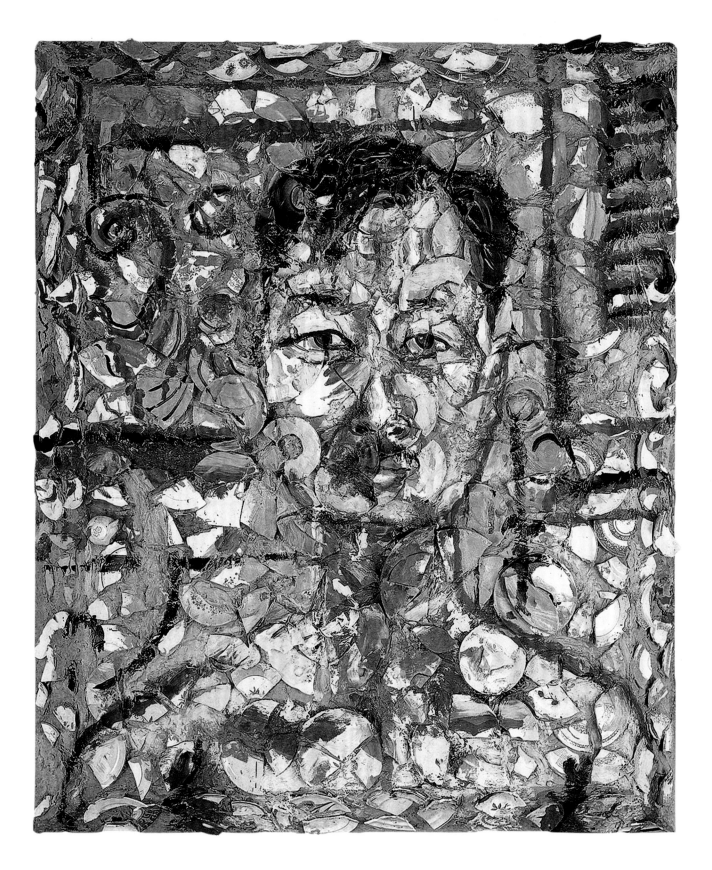

Julian Schnabel, *Untitled*, 1985

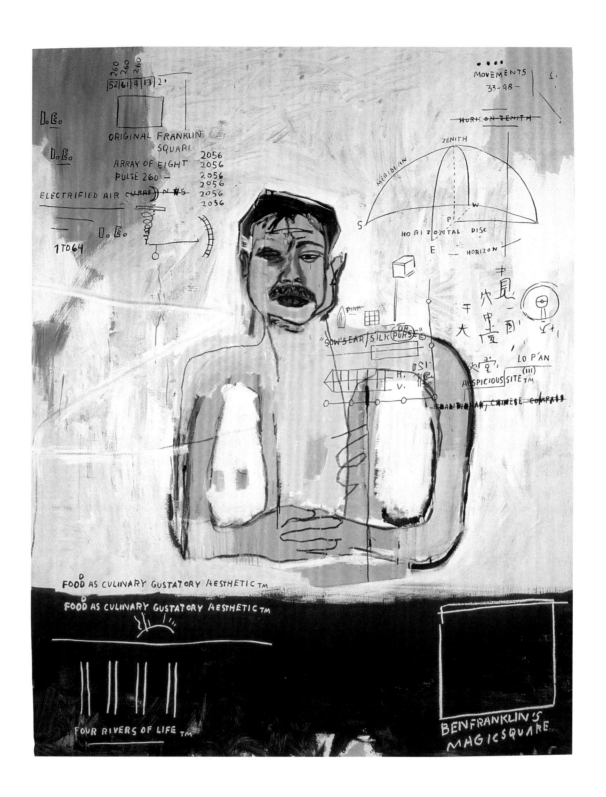

Jean-Michel Basquiat, *Untitled*, 1985

Roy Lichtenstein, *Sunrise*, 1977–78
Felt pen on paper, 12 × 9 inches (29 × 22 cm)

Alex Israel, *As It LAys – Michael Chow*, 2012

Urs Fischer, *Untitled*, 2014

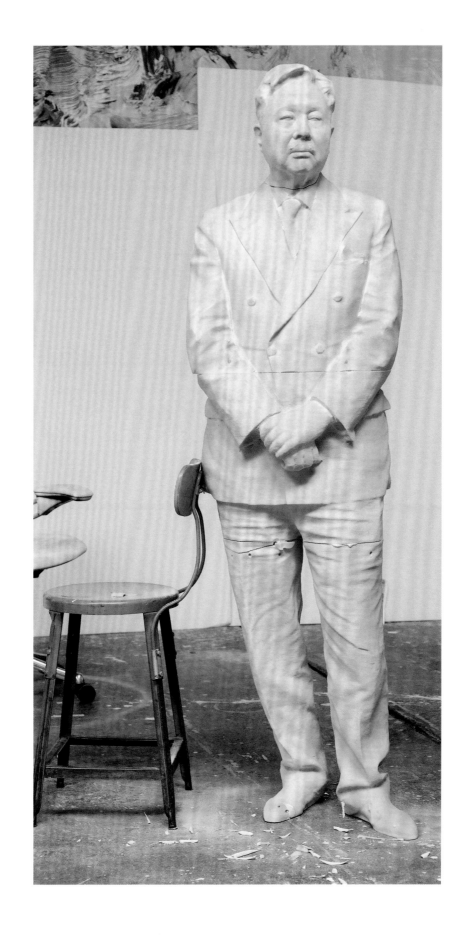

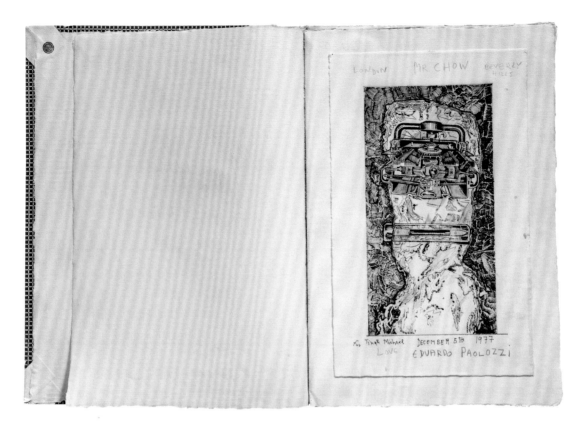

Eduardo Paolozzi

Richard Hamilton/
Dieter Roth

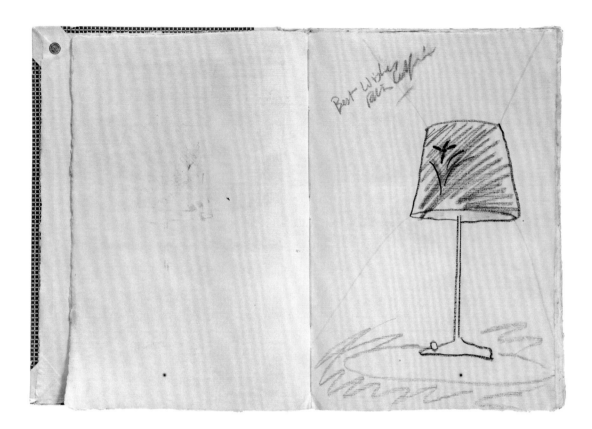

Patrick Caulfield

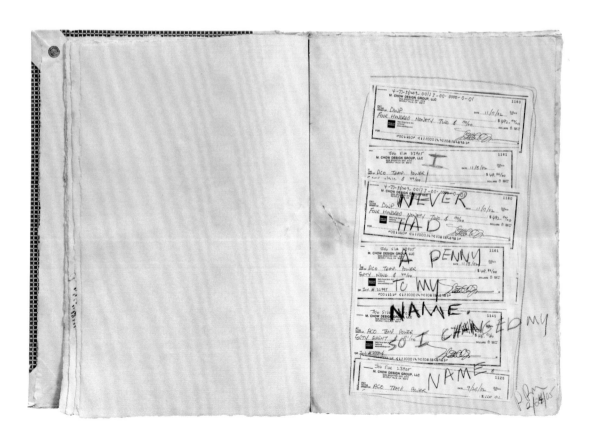

Richard Prince

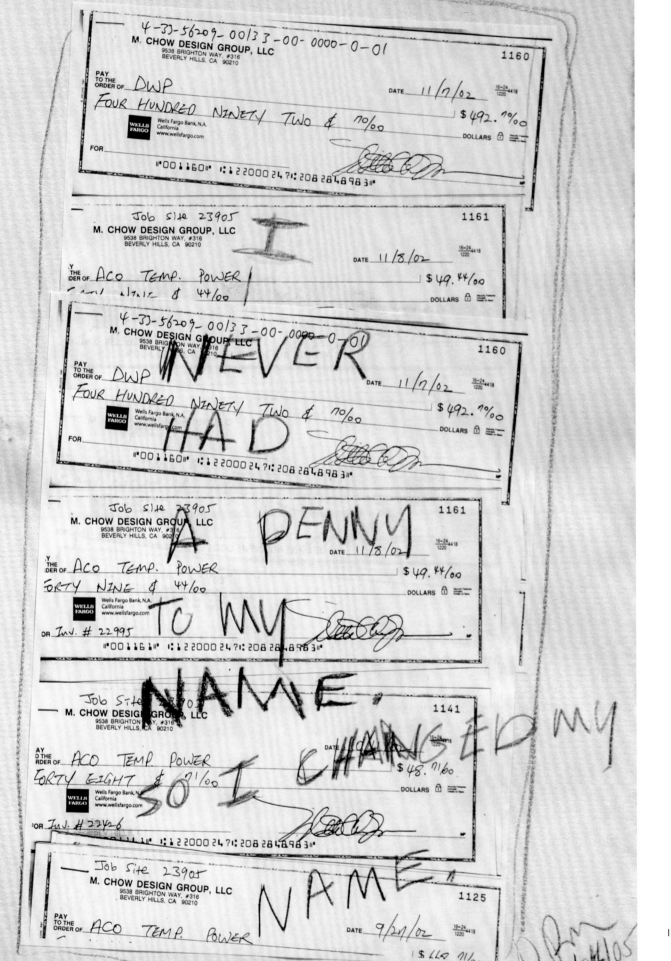

185

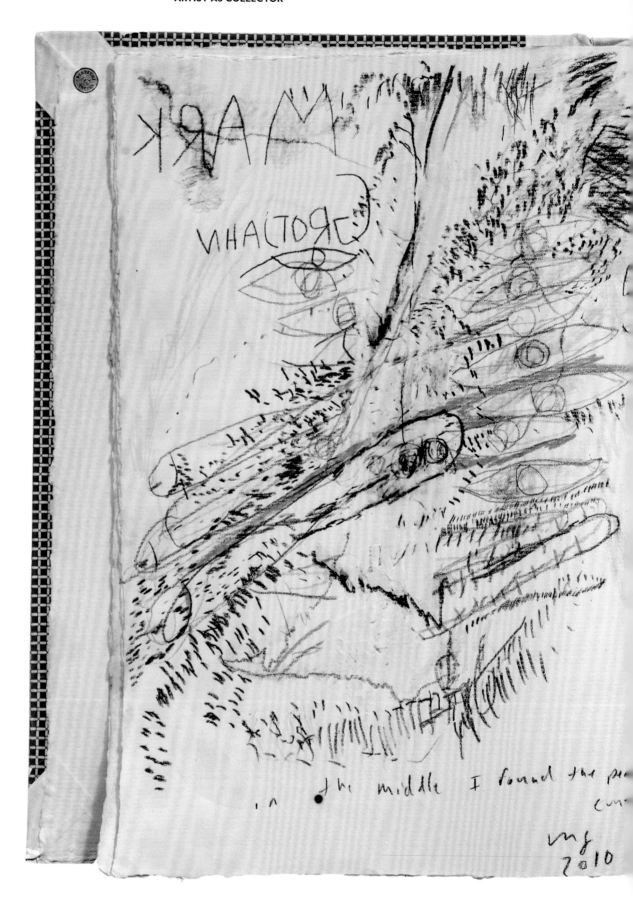

Mark Grotjahn

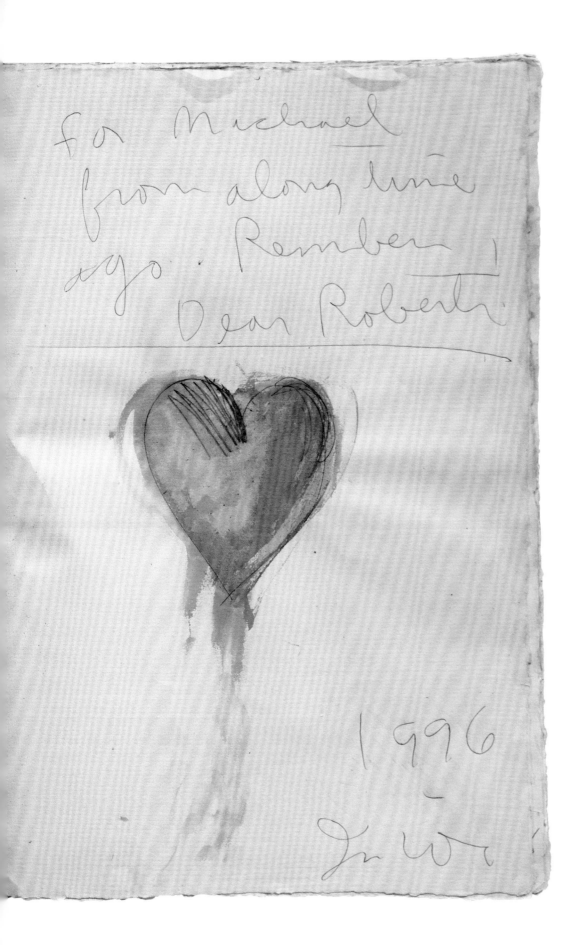

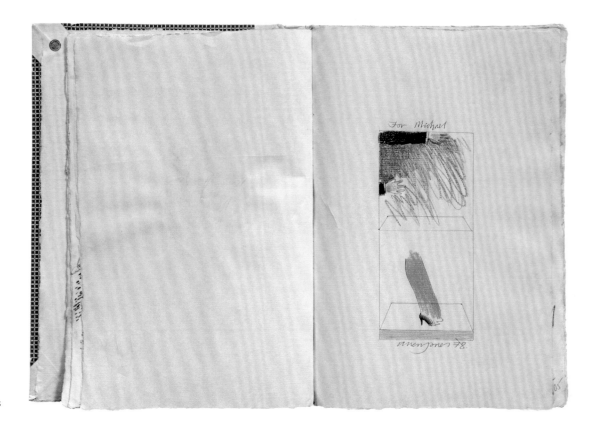

Allen Jones

Joe Tilson

Richard Smith

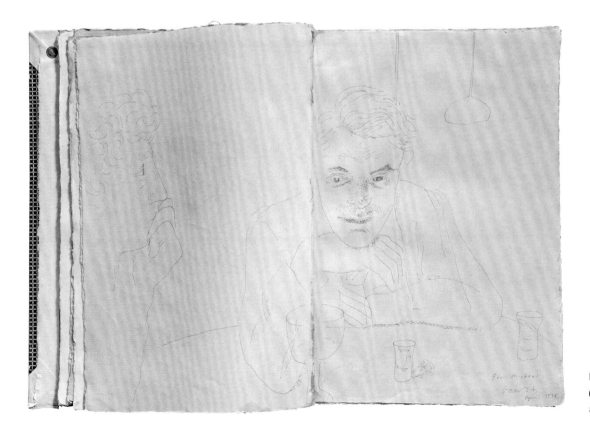

David Hockney
(of Manolo Blahnik
and Patrick Procktor)

James Rosenquist

James Rosenquist

Anthony Caro

Jeff Koons

Damien Hirst

Howard Hodgkin

Red Grooms

Peter Blake & Ian Dury

Tony Shafrazi

Urs Fischer

Francis Bacon

Ed Ruscha

Jasper Johns

Anthony Caro

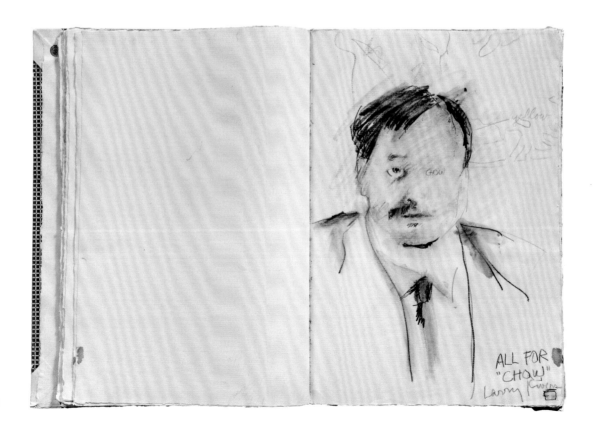

Larry Rivers

With best
wishes

Anthony Caro

6 October
1980

Isamu Noguchi

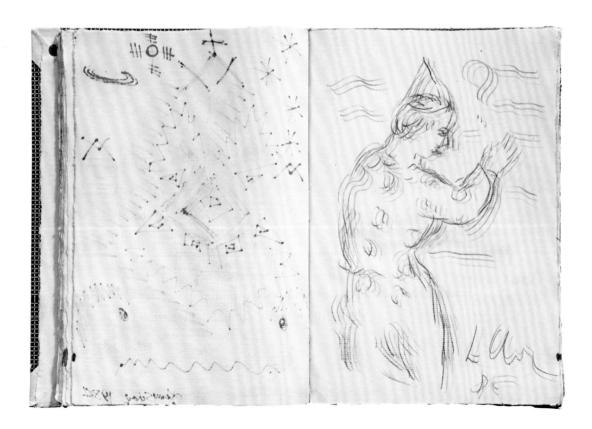

Sandro Chia

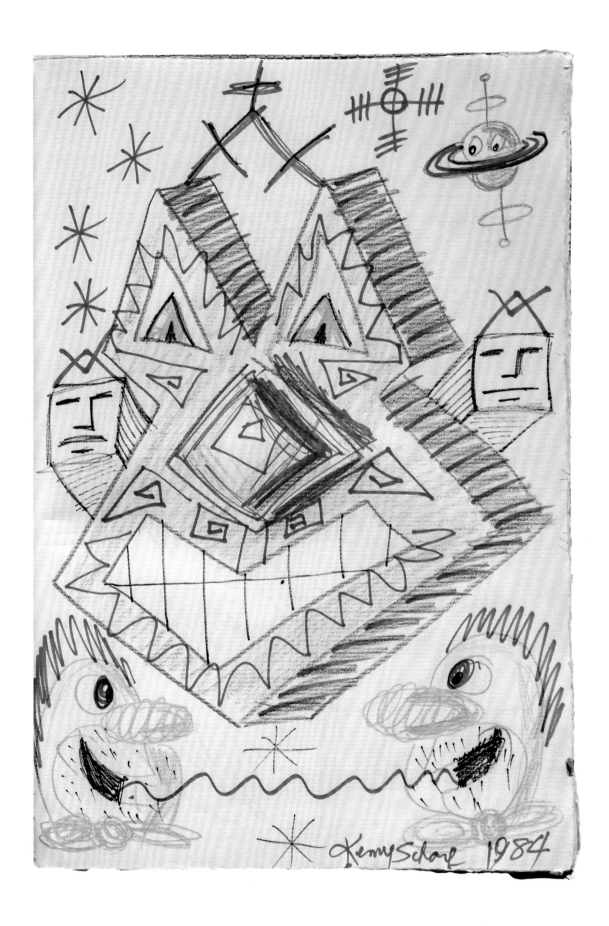

Kenny Scharf

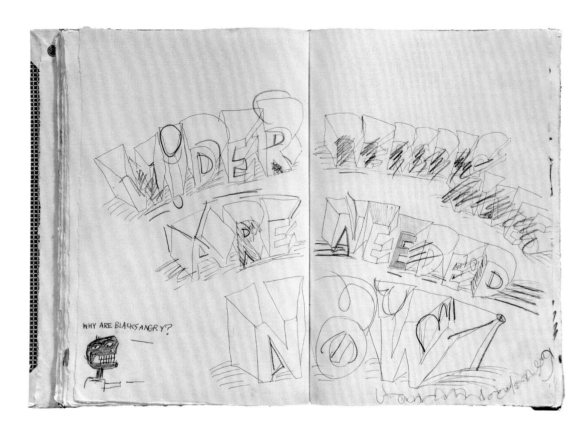

Jean-Michel Basquiat

Louise Nevelson

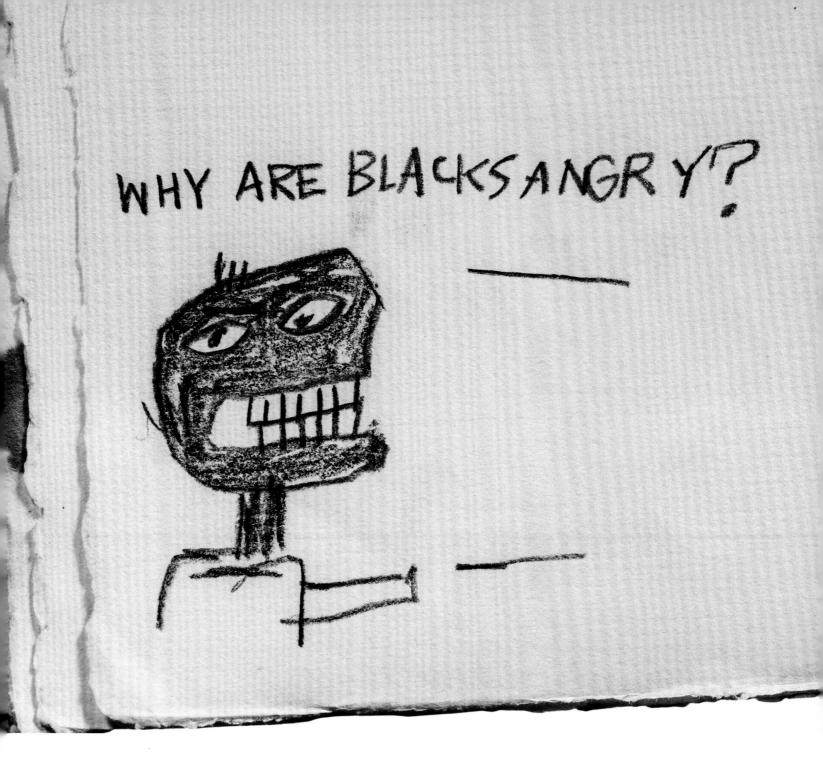

Jean-Michel Basquiat

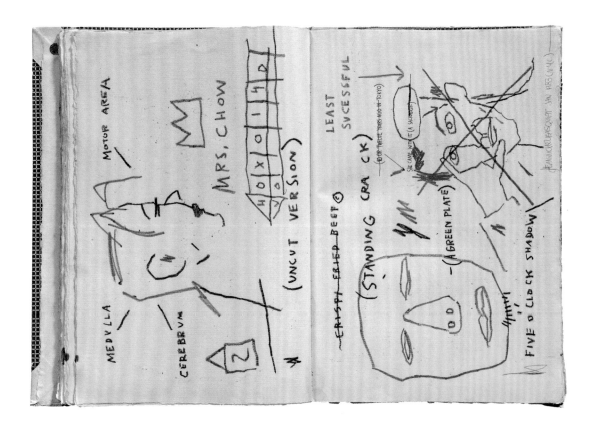

Jean-Michel Basquiat

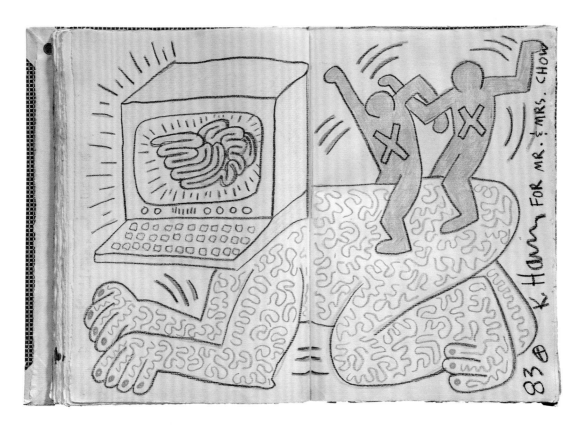

Keith Haring

Cy Twombly

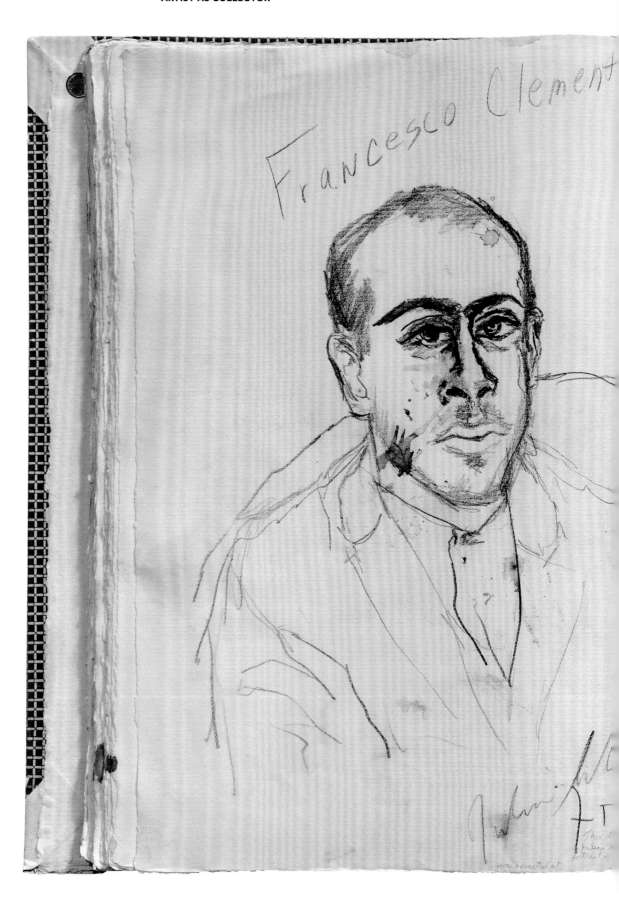

Francesco Clemente
by Julian Schnabel

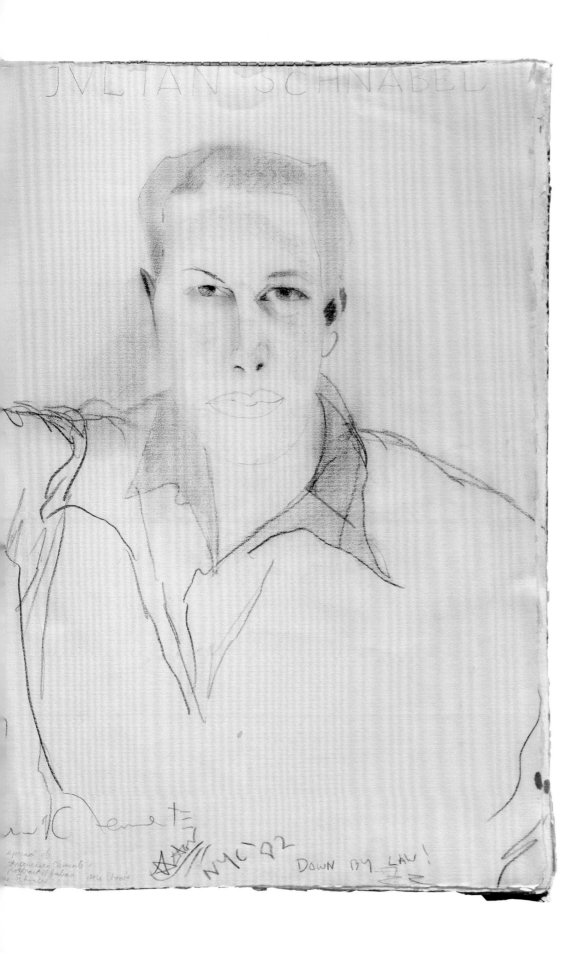

Julian Schnabel
by Francesco Clemente

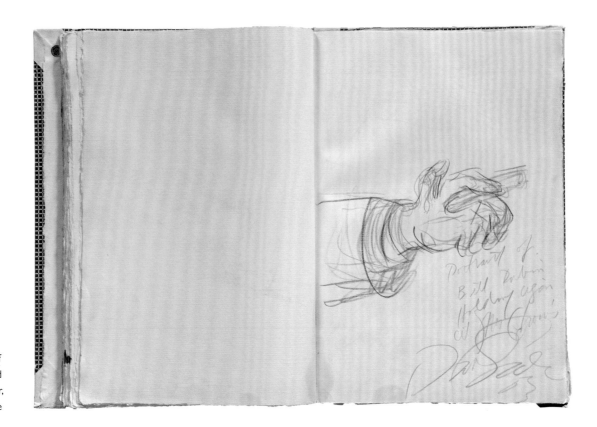

Portrait of
William Rubin's hand
holding a cigar,
by David Salle

Joe Glasco

Georg Baselitz

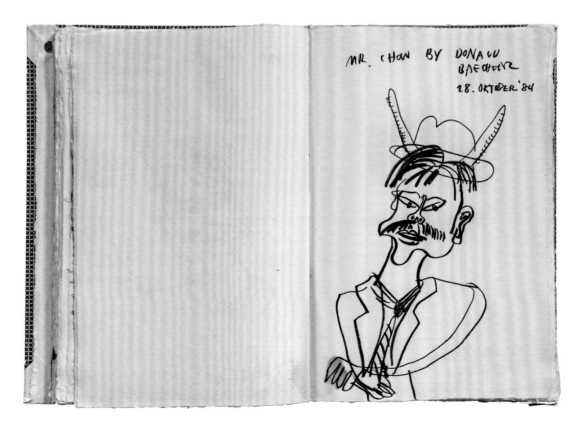

Donald Baechler

209

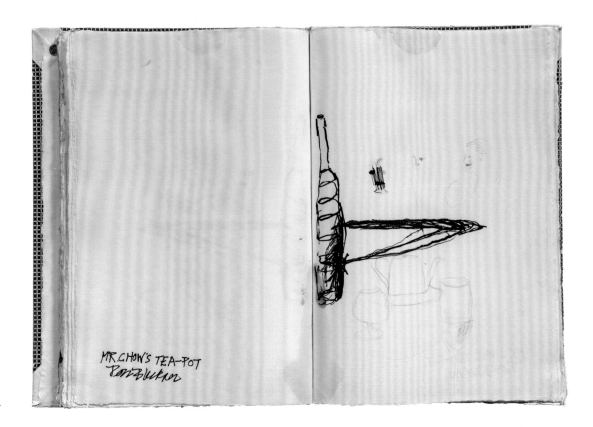

Ross Bleckner

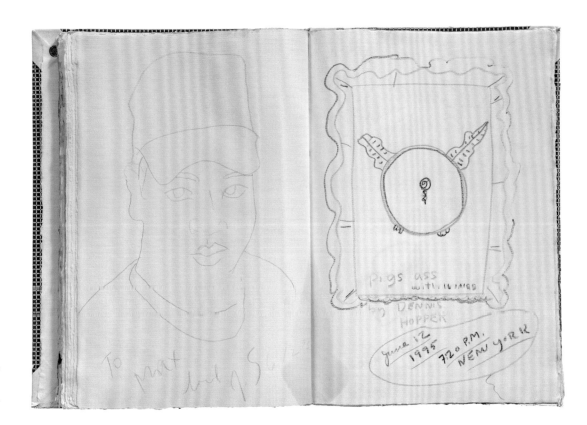

LEFT Maximillian Chow
by Julian Schnabel
RIGHT Dennis Hopper

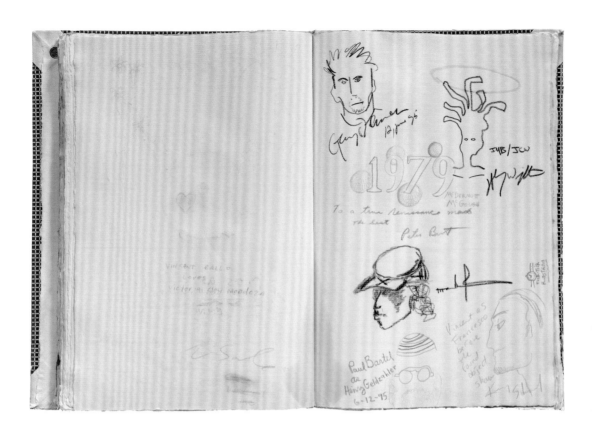

Gary Oldman,
Peter Brandt,
Ronnie Cutrone,
Paul Bartel
as Henry Geldzahler,
and Kenny Scharf

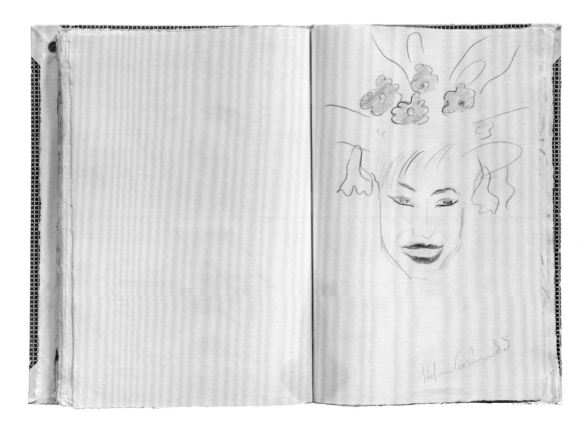

Mystery guest 1

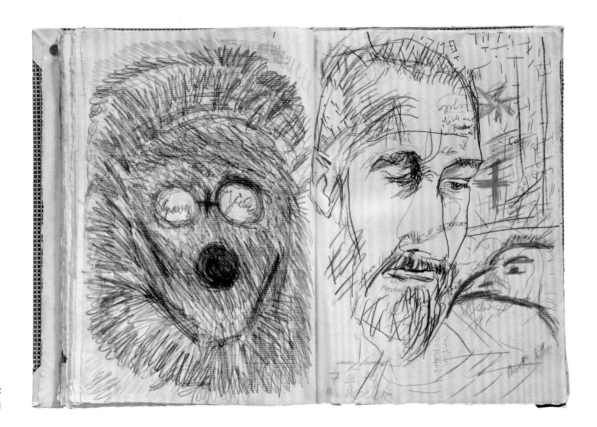

LEFT Georg Baselitz
RIGHT Julian Schnabel

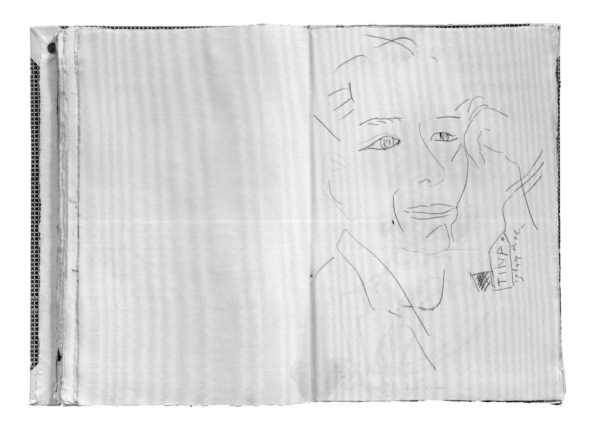

Mystery guest 2

Zao Wou-ki

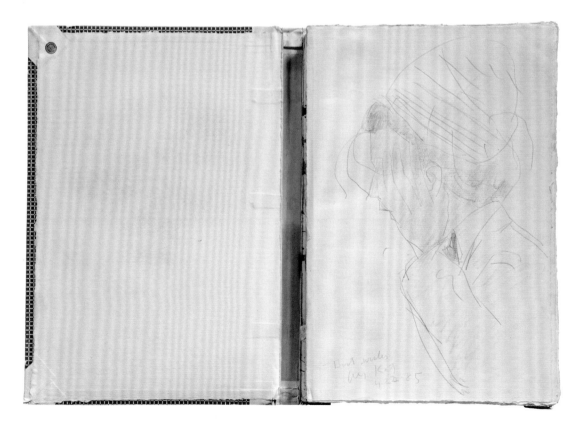

Alex Katz

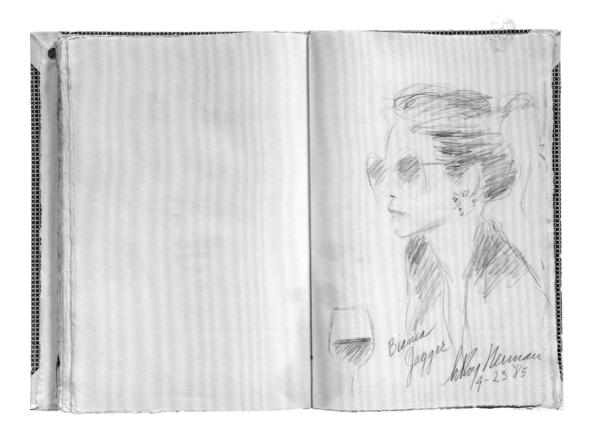

Drawing of Bianca Jagger
by LeRoy Neiman

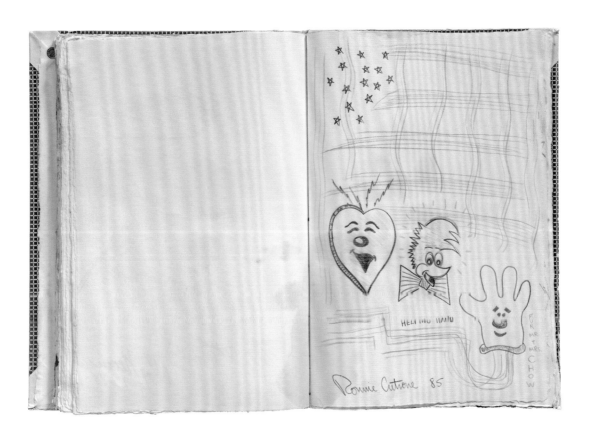

Ronnie Cutrone

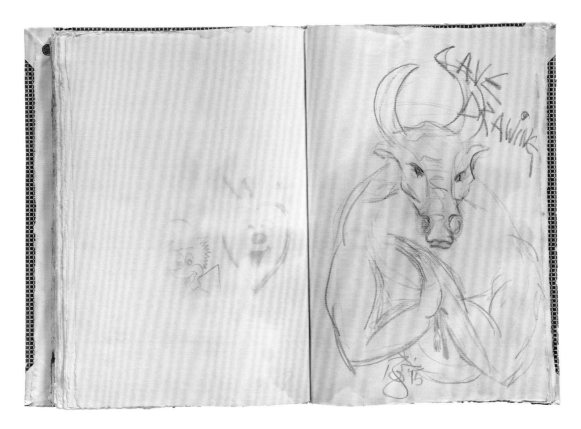

Gary Oldman

Larry Rivers

Andy Warhol

George Condo

John Chamberlain

George Condo

LEFT Mystery guest 3
RIGHT Brian Clarke

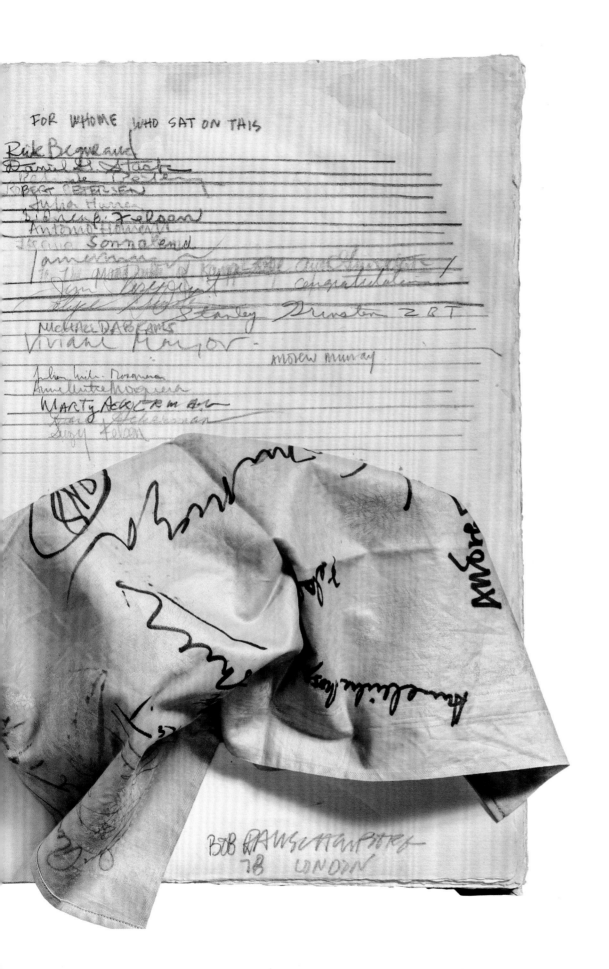

Robert Rauschenberg

VOICE FOR MY FATHER

A TRUE STORY

Story By

Chris Chun Maximillian Chow

Michael Chow

Screenplay By

Michael Chow

Zhou Xinfang © 1982 Ed Ruscha

SUPER: (V.O.) In 2005, Senator Joseph Lieberman and Lamar Alexander introduced a bipartisan bill (S.1117) to the U.S. Senate. The 1.3 billion dollar bill is to educate American youth to have a better understanding of Chinese culture. The bill consists of eight acts, each named after one of the most influential men in the history of China. Among the eight is Zhou Xinfang, and this is his story.

EXT. ROME - 1967 - NOON

Under a clear sky lies the eternal city of Rome. A taxi passes the Coliseum.

> MICHAEL CHOW (V.O)
> I don't know where to start the story of my father. Perhaps the story begins on that particular morning. That morning, I left my home in London to visit a friend in Rome.

Coming out of a side street, a taxi pulls over in front of a small restaurant. MICHAEL CHOW (late 20s), with long hair, steps out and checks the address. At the door, a sign in Italian reads "Dinner 7:00 - 12:00".

INT. RESTAURANT - ROME

Michael cautiously enters the dimly lit restaurant. An Italian PORTER is cleaning the floor.

> MICHAEL
> I'm looking for Myra Mariotti.

The porter shrugs with both shoulder and hand.

> PORTER
> (in Italian)
> I don't know.

> CHINESE GIRL (O.S.)
> She is not here.

A CHINESE GIRL rises from behind the bar. She is in her early 20s, with a cowlick over her forehead. She studies Michael.

> CHINESE GIRL (CONT'D)
> Are you Michael Chow?

> MICHAEL
> Yes.

> CHINESE GIRL
> I saw you in the Ovaltine commercial!
> (beat; excited)
> Do you know who I am?

He studies her, then shakes his head "no."

(CONTINUED)

2.

CONTINUED:

 CHINESE GIRL (CONT'D)
 I'm your sister!

Michael stares at her, bewildered.

 CHINESE GIRL (CONT'D)
 Vivian!

Stunned. He grins.

 MICHAEL
 Vivian?!

EXT. MR CHOW RESTAURANT LONDON – WINTER – 1977 – NIGHT

SUPER: Ten years later. London.

New Year's Eve. Festive lights twinkle in the snow. Silence, except for MUFFLED MUSIC coming from the MR CHOW restaurant. It is a two-story building with glass windows showing a glimpse of an elegant spiral staircase.

INT. MR CHOW RESTAURANT – LONDON

New Year's Eve. The restaurant is jam-packed. Red balloons float five-deep from the ceiling. A sign says "Happy New Year 1978."

John Lennon's "Beautiful Boy" is playing. Champagne flows freely. The place is full of celebrities and celebrity wannabes. MICHAEL, now in his late 30s with shorter hair, is the perfect host. He climbs the spiral staircase.

A Beijing duck is being carved in front of a table. A MAN stops Michael.

 SIR DAVID
 Mr. Chow.

 MICHAEL
 Sir David.

 SIR DAVID
 (while eating)
 This is Bill Thompson, he writes
 for Time Magazine. I was telling
 Bill your father is a Beijing Opera
 star. He's supposed to be famous or
 something, right? Is he still
 performing?

 MICHAEL
 I think so.

(CONTINUED)

CONTINUED:

> BILL
> What's his name?

> MICHAEL
> Zhou Xinfang.

> BILL
> Does he have a stage name?

> MICHAEL
> Qi Lin Tong.

> BILL
> Oh, my God. Qi Lin Tong: Unicorn
> Child. I remember, I wrote an
> article -- after he died...

A SINGLE HEART pounding for a few beats. SOUNDS OF THE ROOM become mute. The background seeds away from Michael.

> PEOPLE (O.S.)
> (faded sound)
> 10,9,8,7,6,5...

A large man with a top hat lifts Michael up and gives him a big kiss on the cheek.

> TOP HAT MAN
> (in silence)
> Happy New Year!

The Music of "Auld Lang Syne" breaks the silence.

EXT. MR. CHOW RESTAURANT - LONDON

People are celebrating inside, and the music of "Auld Lang Syne" fills the night.

INT. MICHAEL'S RESIDENCE - LATER

Michael enters, red confetti still on his jacket. He loosens his bow tie.

INT. MICHAEL'S RESIDENCE - CINEMA

Michael walks into his cinema. From the drawer behind the large projector TV screen, he takes a small red lacquer box. He holds the box for a moment and as he opens it, a photo floats down like a leaf.

EXT. HOSPITAL - SHANGHAI - 1975 - DAY

SUPER: 1975. Shanghai.

(CONTINUED)

CONTINUED:

Black rain pounds into the gutter. Moving up, a sign says "Hua Shan Hospital." Followed by a blurry image through the window. A long hallway with various doors on both sides leads to the patient's room.

INT. HOSPITAL - HALLWAY

The wall is messy with Cultural Revolution slogans. An old man with an I.V. pole walks away at a snail's pace.

A YOUNG NURSE comes out of a patient's room. She wipes away tears before entering the Nurse's station, interrupted by an AGED NURSE, nervously pushing her aside.

 AGED NURSE
 (in Chinese; challenging)
 You can't cry. Why were you crying?

 YOUNG NURSE
 (in Chinese)
 I just came from Zhou Xinfang's
 room. He is...

 AGED NURSE
 (in Chinese)
 I thought so... What's the matter
 with you? No one can show him
 sympathy.
 (whispers)
 Now go back and take care of him.

The Young Nurse wipes the tears away and composes herself. She walks back to Xinfang's room. A pair of doors are close. One of the glass windows is cracked. As the door swings open a blurry image of a patient in bed is revealed.

INT. HOSPITAL - XINFANG'S ROOM

Moving forward, a photo drops from a hand, like a leaf. From the hand to the arm, towards a man, 80 years old, with disheveled white hair. It is Xinfang. He is lying on the shabby bed, one of his eyes is hidden behind shattered and frosted glass. The other lens magnifies a glaring, oversized eyeball.

INT. OPEN AIR THEATER - BACKSTAGE - NINGBO - 1900 - DAY

A PAIR OF YOUNG BOY'S WIDE, WATCHFUL EYES.

SUPER: 1900. During the realm of Empress Dowager.

A brush mixes makeup on a newspaper that features an illustration of the Boxer Rebellion.

 (CONTINUED)

CONTINUED:

Next to it, two WILD MOUNTAIN WALNUTS on the table.

 MALE ACTOR (O.S.)
 (in Chinese)
 Xinfang, my beard!

Before the command is finished, the eyes have disappeared.
Seconds later, the nimble boy hands over a costume beard,
which is snatched by an adult male hand.

 ANOTHER MALE ACTOR (O.S.)
 (in Chinese)
 My hat. And horse whip.

A small hand presents a hat and horse whip. It is quickly
taken by a larger hand. A minor commotion occurs as the
ACTORS exit to begin their performance.

A moment later, a boy's face appears in the mirror. This is
ZHOU XINFANG (6).

Alone now, Xinfang picks up a long, white beard and tries it
on. The big beard on his small face looks very funny. He
laughs.

His joy is short-lived. The pops and bangs of EXPLODING
FIRECRACKERS interrupt his revelry, and worse, the
performance. Xinfang yanks off the beard and bolts out the
door.

EXT. OPEN AIR THEATER - FRONT STAGE

The FIRECRACKERS get louder and more disruptive as Xinfang
hurries up the aisle of the simple open-air theater. It is
empty except for a few old men who lean back with their eyes
closed, appearing to be asleep.

Three actors perform Beijing opera on stage. A man kneels
with a chain in his hands, two actresses stand to the side,
and a central figure of a judge looms in the background. As
Xinfang passes by, an OLD MAN grabs his arm and gestures to
the firecracker noise coming from outside.

 XINFANG
 (whispers in Chinese)
 I know!

Xinfang rushes on.

EXT. OPEN AIR THEATER - CORRIDOR

Xinfang stops abruptly before the long, dark corridor that
leads outside.

 (CONTINUED)

CONTINUED:

A few rats scurry through the gloomy passageway. When another round of firecrackers goes off, Xinfang steels himself and steps into the darkness...

EXT. OPEN AIR THEATER - OUTSIDE

Doors open, bright light illuminates the scene. Xinfang emerges from the dark tunnel, squinting in the bright light. As his vision clears, he sees three boys (9,11,12) kneeling and playing with firecrackers.

 XINFANG
 (shouting in Chinese)
 Quiet! My father is on stage!

The 9-year-old boy stands up.

 9-YEAR-OLD BOY
 (in Chinese)
 Your father is an actor?

Xinfang nods. The boy spits.

 9-YEAR-OLD BOY (CONT'D)
 (in Chinese)
 Piece of shit. Do you know who I
 am?

Xinfang shakes his head.

 9-YEAR-OLD BOY (CONT'D)
 (in Chinese)
 My father is the mayor!

The two boys mock Xinfang by mimicking Beijing Opera. They are surprised when the OLDEST BOY stops them. Grinning, he approaches Xinfang with one hand behind his back. Xinfang tentatively smiles back. When the boy presents something to him, he accepts the gesture of friendship.

But the boy has handed Xinfang a live firecracker.

Before Xinfang realizes what has happened, the firecracker explodes in his face, badly injuring his forehead. Blood is everywhere.

Xinfang SCREAMS. He manages to grab the oldest boy, and beats him. The boy tries to run, but Xinfang grips him tightly.

Some of the old men exit the theater to see what the commotion is. Xinfang continues to beat the oldest boy but soon loses consciousness. His world fades to darkness.

EXT. OPEN AIR THEATER - ON STAGE

Xinfang's eyes flutter open. He sees he is lying on the stage. The theater is empty.

> THEATER OWNER (O.S.)
> (in Chinese)
> You pathetic actors, dime a dozen!
> You all owe me money! Take your
> precious son and get out of here!

In the distance, Xinfang sees a blurry FEMALE FIGURE rushing to him, towel in hand. He reaches for her.

> XINFANG
> (soft murmur; in Chinese)
> Di'e (father) --

Pulling off her headdress as she kneels beside the boy, she reveals she is, in fact, a Dan (female role) actor: Xinfang's FATHER.

> XINFANG'S FATHER
> (in Chinese)
> It's all right, Xinfang. You'll be
> all right, you'll be all right--

He holds up Xinfang's head and wipes off the blood.

INT. BANK - NEAR BY THE BUND - SHANGHAI - DAY

Xinfang, his head still bandaged, stands with his father in front of the cashier's window. It is an elegant, imposing European bank with a towering interior of carved marble.

> CHINESE CLERK
> (in Chinese)
> How many times must I tell you?
> Your cousin doesn't work here
> anymore.

The Chinese clerk glances at his British boss, who shakes his head with disapproval.

> CHINESE CLERK (CONT'D)
> (whispers; in Chinese)
> You cannot borrow money here!
> This is not your kind of bank.

EXT. STREET - NEAR PIER 16 - PART OF THE BUND - DAY

Horse-drawn carts are parked next to a sedan as rickshaws pass by.

(CONTINUED)

CONTINUED:

Government ministers in pigtails and traditional robes stand
next to British gentlemen in long coats. Shanghai at the turn
of the century is a cacophonous mix of cultures.

While they walk, Xinfang's father flexes his hand.
Recognizing the sign of rheumatism, Xinfang reaches into his
father's pockets and withdraws the wild mountain walnuts seen
earlier. His father takes them gratefully and squeezes them,
soothing the pain.

They pass two street musicians. The man sits on a chair,
playing Hu Qin (Chinese violin). The young boy sings Beijing
Opera while performing an acrobatic headstand, balancing on
the old man's head. A begging bowl lies at their feet. As
Xinfang walks on, his gaze stays fixed on the singing boy.

They continue their aimless walk, now near the busy Pier 16
intersection. A few steps later, Xinfang's father spots a
man, KELAN (40s), in plain clothes walking off a boat,
followed by a troupe.

Xinfang follows as his father approaches the man.

 XINFANG'S FATHER
 (shouts in Chinese)
 Kelan!

Kelan shows no recognition of Xinfang's father. He moves
closer and closer, inspecting first the face, then the mouth.

 XINFANG'S FATHER (CONT'D)
 Do you know who I am?

Kelan shakes his head "No".

 XINFANG'S FATHER (CONT'D)
 I played with you last season --
 from February to April.

 KELAN
 Oh... yeah. I didn't recognize you
 without the makeup.

Kelan studies Xinfang as the boy looks around, overwhelmed by
the crowd, who are gathering around a poster.

 XINFANG'S FATHER
 Do you need someone for Dan (Female
 roles)?
 (off Kelan's gesture "no")
 Of course. I understand.

Kelan glances at Xinfang.

 (CONTINUED)

CONTINUED: (2)

> KELAN
> I remember you. You really know
> your way around backstage.
>> (to Xinfang's father)
> Does he act? My boy just broke his
> leg and we have an important
> performance in Hangzhou this
> weekend.
>> (off Xinfang's father's
>> grin)
> What happened to his forehead?

Kelan shows his disinterest.

> XINFANG'S FATHER
> Nothing! Stupid accident. A little
> makeup will cover it up. He's very
> bright. He can read -- and write.

The troupe is surprised to hear that, as well as Kelan.

> KELAN
> He can?!

Off Xinfang's father's nods, Kelan points to the poster.

> KELAN (CONT'D)
> What does it say?

He leads everybody to the poster. They push through the crowd
and get to the front.

Xinfang looks at his father, and then looks at the poster.

> XINFANG
> It says many European were killed
> by Boxer Rebellions.

Xinfang's father smiles proudly. Kelan nods.

> TROUPE MEMBER A
>> (whispers)
> Is that what it says?

> TROUPE MEMBER B
> How do I know? You know I can't
> read.

Kelan hands a piece of paper to Xinfang's father, who grins
in gratitude.

INT. THEATER - BACKSTAGE- SHANGHAI - NIGHT

YAGUO (7) is a skinny boy who plays a child role in Kelan's troupe. His broken leg is in a splint and he pouts from a corner as Xinfang's father unwraps the bandage around Xinfang's forehead. The deep wound is still open in places, wet and raw.

The father unties his son's pigtail and puts the hair up under a hat. Tending to the cut on Xinfang's half-shaven forehead, he gently wipes away the dried blood. Xinfang winces but remains still, even when his father applies makeup directly on the open wound.

Xinfang shuts his eyes tight and bites his lip to keep from crying out. Xinfang's father, moved by his son's bravery, puts down the brush and squats before him.

 XINFANG'S FATHER
 (sadly)
 To succeed in opera, you have to
 sacrifice all.

Xinfang nods.

INT. THEATER - STAGE

The small drum BEATS, the big drum BEATS, and the Chinese violin begins to play. The audience stirs as the musician's hands move faster and faster.

 OLD MAN (O.S.)
 (in Chinese)
 Great Chinese violin!

The GONG SOUNDS. Kelan comes out in a Clown role. Xinfang follows behind. All their movements are accompanied and punctuated by the small orchestra.

Xinfang freezes with stage fright. He looks at the audience and sees blurred faces. Only the oil lamp burning in front of him is in focus. Irritated, Kelan cues him several times. Each time Xinfang hears a distant murmur. Finally Kelan's cues become loud and clear and Xinfang blurts out his line.

The audience roars with laughter. His timing, however accidental, was perfect.

The audience's response has an immediate and profound effect on Xinfang. He grins, and performs more confidently.

 (CONTINUED)

CONTINUED:

The audience applauds. Kelan smiles. The kid is a natural. A
star is born.

INT. THEATER - LATER

Xinfang reads a book on a thin pallet on the stage, where all
the actors sleep.

> XINFANG'S FATHER
> Xinfang, you had a big day. Go to
> sleep.

Xinfang sets his book aside and lies back as his father tucks
a worn blanket around him.

> XINFANG
> Dad, I had fun today. Can I do it
> again tomorrow?

Xinfang's father nods and smiles at him, but as soon as
Xinfang's eyes close, his smile fades and he looks weary and
sad. He puts the pair of wild mountain walnuts on top of
Xinfang's book and sighs.

He sits with his son for a moment, watching him sleeping,
studying him as if trying to memorize his every pore.

> XINFANG'S FATHER
> The only thing I can give you is
> opera.

He rises, and goes to speak with Kelan.

EXT. ON THE ROAD - DAY

Morning light. Xinfang's head bounces lightly against a hard
surface. Honking sounds. Xinfang's eyes drift open. He sees
first Yaguo reading his book upside down, and beside him, his
father's wild mountain walnuts.

Xinfang sits up and discovers he is on a horse carriage with
Kelan and his troupe.

> XINFANG
> Where's my father?

> KELAN
> You were sleeping like a log. Your
> father couldn't come with us. You
> did really good last night. I'll
> find you the best opera tutor, and
> I will take care of you.

 (CONTINUED)

CONTINUED:

Yaguo looks on while Kelan talks to Xinfang.

EXT. NOODLE SHOP - DAY

The cart stops by a small noodle shop. Kelan and most of the troupe get off the cart. Only Xinfang and Yaguo remain.

Xinfang knows now what happened. He scoops up the walnuts, squeezing it so tightly that his knuckles turn white. He stares at the empty road behind him, tears in his eyes.

Kelan returns with two bowls of soup noodles; one plain with scallion on top, one with a single slice of belly pork.

Xinfang gazes at the road. Kelan nudges him gently. From the expression in Kelan's eyes, you can tell he likes the boy. He offers him the noodles with pork and gives the plain ones to Yaguo.

> KELAN
> No work, no meat.

Seeing Yaguo frown at this news, Xinfang uses chopsticks to pick up the pork from his bowl and offers it to him. Yaguo slaps Xinfang's chopsticks, and the meat drops onto the road.

> KELAN (CONT'D)
> What is wrong with you?!

Kelan grabs Yaguo's eyelids and twists them violently. Yaguo's SCREAMS are drowned out by the Beijing Opera GONG.

EXT. COUNTRYSIDE THEATER - YARD - DAY

Miserable, Xinfang sits in the corner clutching the walnuts.

> YAGUO (O.S.)
> Forget him. Would you teach me how
> to read?

Yaguo holds a book, his eyes bruised like a panda. Xinfang looks up and nods.

> YAGUO (CONT'D)
> I never had one. You were very
> lucky to have a father.

> KELAN (O.S.)
> Back to training!

Xinfang jumps up and runs over. Yaguo follows, limping.

On the floor lie Xinfang's forgotten walnuts.

INT. COUNTRYSIDE THEATER

The troupe practices together. Xinfang and Yaguo, with his splinted leg, do handstands against the back wall.

Kelan paces up and down with a stick in his hand.

> KELAN (O.S.)
> God made us poor. As an actor, we
> must use everything: mouth,
> hands...

Kelan looks at Yaguo's panda eyes.

> KELAN (CONT'D)
> ...And eyes.

As Kelan's feet get closer and closer to the two upside down kids, the panda-eyed Yaguo turns to Xinfang.

> YAGUO
> (whispers)
> How come he never beats you?

WHACK! The stick smashes Yaguo's broken leg, knocking him down onto Xinfang. They look at each other and burst out laughing.

MONTAGE - XINFANG LEARNING BEIJING OPERA

Xinfang kneels in front of a Beijing Opera teacher, performing the traditional kowtow ceremony.

After Xinfang finishes his third kowtow, he looks up. He is now 9 years old. A third Beijing Opera master stands there, very still. He is the master's master. This is a big kowtow ceremony with a Verger. Kelan stands to one side, proud.

The master teaches Xinfang every aspect of Beijing Opera - Kung Fu, mime, singing and recital. The audience is different at each of Xinfang's performances, but their enthusiastic applause is the same.

INT. THEATER - SHANGHAI - 1906 - AFTERNOON

A STAGEHAND and a POSTER MAN (33) stand in the wings watching a confident Xinfang (11), with his costume beard, perform Lao Sheng (leading man) during a dress rehearsal. Yaguo (12) helps Kelan move the props on the opposite side of the stage.

> STAGEHAND
> That kid playing Lao Sheng (leading
> man) is good. How old is he?

(CONTINUED)

CONTINUED:

> POSTER MAN
> Eleven. A child prodigy. He became
> famous when he was seven. That's
> why his stage name is Seven Year
> Wonder. Tomorrow night is his
> Shanghai Debut.

Xinfang finishes singing and walks toward the Poster Man.
Yaguo waves a book.

> YAGUO
> Xinfang, I finished reading it.

Xinfang raises his arm to acknowledge Yaguo. As he passes the
Poster Man, he can't help but notice his unusual eyebrows.

> POSTER MAN (O.S.)
> Qi Ling Tong! (Seven Year Wonder)
> I'll be writing your poster for
> tomorrow night!

Xinfang bows humbly and walks away.

EXT. STREET - SHANGHAI - EARLY MORNING

Sunrise. Only the SOUND OF BIRDS singing can be heard on the
quiet Shanghai street. The Poster Man walks along carrying
brushes and paints. He sings to himself, changing the words
back and forth between Qi Ling Tong (Seven Year Wonder) and
Qi Lin Tong (Unicorn Child). He sets down his supplies when
he reaches the theater.

He picks up his brush but realizes just as he is about to
start writing that there are several hairs protruding from
it. He pulls them out and begins his work.

He puts the poster up. It reads "Qi Lin Tong" (Unicorn Child)
instead of "Qi Ling Tong" (Seven Year Wonder). The name has
been changed forever.

INT. THEATER - BACKSTAGE - SHANGHAI - 1908 - NIGHT

Yaguo (14) and Xinfang (13) remove their makeup as Kelan
enters, holding an open letter and the poster. He approaches
Xinfang.

> KELAN
> The most prestigious opera school
> in Beijing would very much like you
> to enroll as a guest student.

Yaguo is all ears.

(CONTINUED)

CONTINUED:

 KELAN (CONT'D)
 I have taught you everything I
 know. With your talent, you will
 really excel in that new school.

 XINFANG
 (glances at Yaguo)
 I will only enroll if Yaguo can
 join me.

 KELAN
 I don't think it's possible, but I
 can ask.

 XINFANG
 Yaguo can read and write. It might
 help.

Kelan nods and opens the poster.

 KELAN
 I saved this poster. The one that
 changed your stage name to Qi Lin
 Tong (Unicorn Child). I hope
 someday you will have your own
 unicorn backdrop.
 (hands the poster to him)
 Keep this. Make me proud.

Fatherless Yaguo looks on. Xinfang sees sadness and hope in
Kelan's eyes. Kelan turns to leave, reaches for his pocket.

 KELAN (CONT'D)
 I think you want this back.

On the table, he puts the walnuts.

INT. ELITE BEIJING OPERA SCHOOL - CAFETERIA - BEIJING - NOON

A long line of students waits to get porridge. A CHEF cuts
watermelon in the back. Xinfang waits near the front with MEI
LANFANG, a talented student who plays Dan role (female role).
Yaguo stands by Xinfang, followed by MASTER CHENG (late 50s),
a charismatic teacher of Beijing opera.

 YAGUO
 Mei Lanfang, I heard a rumor that
 Xinfang and you will be performing
 for the Empress Dowager soon. Is
 that true?

As Mei Lanfang is about to answer, Master Cheng overhears it
and laughs.

 (CONTINUED)

CONTINUED:

> MASTER CHENG
> Don't be absurd. To perform for the
> Empress Dowager is an honor
> reserved for the few.
> (looks at both boys)
> Mei Lanfang, Zhou Xinfang -- Maybe
> one day.

> MEI LANFANG
> Like who? Master Cheng.

> MASTER CHENG
> Like Tan Xinpei.

The three boys respond with awe at the mere mention of the
name.

> MASTER CHENG (CONT'D)
> He is known as "The Voice That
> Reaches the Heavens." Next time
> when he performs, you can all
> assist him.

A server plops a big ladle of porridge into Xinfang's bowl,
bringing him back to earth.

> MASTER CHENG (CONT'D)
> We are lucky to be in the theater.
> That means we are all historians.
> History is not for the past, but
> for the future. All of you have a
> lot of important reading to do.

> XINFANG
> What kind of reading?

Master Cheng looks around and points to the table. The boys
quietly follow.

INT. ELITE BEIJING OPERA SCHOOL - KITCHEN - BEIJING - AFTERNOON

Xinfang walks into the kitchen and sees Yaguo desperately
eating watermelon, the white part of the skin. He eats
continuously, one after another.

> XINFANG
> What are you doing?

Yaguo looks at Xinfang, gets up and closes the door. He picks
up more watermelon skins and continues eating.

> YAGUO
> My voice is cracked. This can help.

 (CONTINUED)

CONTINUED:

Xinfang is alarmed. Yaguo keeps eating.

EXT. ELITE BEIJING OPERA SCHOOL - YARD - BEIJING - DAY

Students in plain clothes stand in formation, all doing the same exercise - kicking leg. Master Cheng with a stick in hand paces among them, barking commands and critiques.

> MASTER CHENG
> ... You all have talent. But talent alone is not enough. There is a saying that ten years of practice is required for a single minute on stage. Singing is the most important talent. After all it's called Beijing Opera. Now, one by one you can recite for me. Clarity in each and every word.

A boy starts.

> MASTER CHENG (CONT'D)
> Wrong words! And No clarity!

He points to the next boy. Yaguo, now desperate, cannot afford another mistake. He quietly moves to the end of the group, but gets caught by the teacher's eye. Yaguo takes out a note and scans it.

Master Cheng points to Yaguo and motions him forward. Yaguo looks nervous, but he recites perfectly. Master Cheng nods with satisfaction.

> MASTER CHENG (CONT'D)
> Yaguo, now you check out everyone else for me.

Master Cheng leaves. Yaguo is surprised.

INT. OPEN AIR THEATER - BACKSTAGE - THE SUMMER PALACE, OF EMPRESS DOWAGER - BEIJING - NIGHT

TAN XINPEI sits before a mirror, putting on makeup. Xinfang, Yaguo and Mei Lanfang scurry about behind him, sneaking glances at the great man while they do their chores. They freeze when Tan Xinpei turns toward them. He gestures for Xinfang to fetch his headdress.

Xinfang deferentially presents the headdress to Tan Xinpei. He seizes it, never taking his eyes off Xinfang.

(CONTINUED)

CONTINUED:

> TAN XINPEI
> I saw you perform in Shanghai once.
> You have talent.

Xinfang gasps. Yaguo's eyes widen. Tan Xinpei enjoys the
effect he's having on the boys and milks the moment for all
it's worth.

> TAN XINPEI (CONT'D)
> But... your steps are too big.

Fear creeps into Xinfang's eyes, but Mei Lanfang is all ears.
Xinfang frowns briefly, unsure of what Tan Xinpei means. He
recovers and nods his gratitude.

EXT. OPEN AIR THEATER - THE SUMMER PALACE, BEIJING

Xinfang watches Tan Xinpei perform for the EMPRESS DOWAGER,
who nods approvingly. While Tan Xinpei sings, we rise with
his voice to the heavens.

INT. ELITE BEIJING OPERA SCHOOL - DORM - MORNING

Still dark. Yaguo wakes up. On the ceiling is a sign saying
"Quickly get out of the bed, wash your face and hands". He
washes his face. Another sign says "Get dressed fast". He
dresses in front of the mirror and yet another sign, "Hurry
and practice singing".

Xinfang is still sleeping. Through the mirror, Yaguo sees a
pamphlet slip out of Xinfang's books. He quietly walks over
and picks it up. I

Yaguo carefully slips back the pamphlets.

EXT. YARD, ELITE BEIJING OPERA SCHOOL

The sound is agonizing. Yaguo, devastated but determined,
practices singing with such resolve that his face is flushed.
But his cracked voice gets worse and worse. It's hopeless.

As Yaguo turns, he is startled to see Master Cheng is
standing behind him.

INT. XINFANG'S ROOM - DORM - LATER

Xinfang, in a deep sleep, is gently awakened by Yaguo.

> XINFANG
> You are not practicing your voice?

 (CONTINUED)

CONTINUED:

> YAGUO
> What am I going to do?

> XINFANG
> What's wrong?

> YAGUO
> My voice is getting worse... Even
> Master Cheng says that.

> XINFANG
> (sits up)
> There are a lot of things you can
> do in the theater. Remember, you
> can read and write.

> YAGUO
> I am not talented like you.

Yaguo snaps out of it and picks up Xinfang's pamphlet.

> YAGUO (CONT'D)
> Where did you get this?

> XINFANG
> Master Cheng.

INT. THEATER - STAGE - BEIJING - 1911 - SUMMER - NIGHT

Yaguo works as a stagehand. Xinfang is ready for his
entrance. He passes a book to Yaguo, the loose pamphlets from
the book drop onto the floor. Yaguo quickly picks them up and
looks at Xinfang.

> YAGUO
> (whispers)
> These are revolution pamphlets.

No time to acknowledge, Xinfang hurries onto the stage. He
performs confidently, and his voice is exceptionally
beautiful tonight. Yaguo's face betrays heartbreak as he
listens to Xinfang. The audience applauds heartily while a
pleased theater boss watches off stage.

> AUDIENCE
> (various people shouting)
> Bravo!

Suddenly, Xinfang's voice cracks so badly it stops him in his
tracks.

There are gasps of shock from the audience, as well as Yaguo,
followed by complete, horrified silence.

(CONTINUED)

CONTINUED:

Xinfang tries to continue, but it is soon obvious that his voice is gone. He struggles on nevertheless, a true professional.

From Xinfang's POV, the whole theater and the audience start spinning around him, faster and faster.

INT. CAFETERIA - BEIJING - AFTER PERFORMANCE - NIGHT

Actors are everywhere, eating noodles and gossiping. There's not one empty seat in the place. When Xinfang walks in, everyone falls silent and stares at him.

No one moves except Yaguo, who rises, waves his hands and calls out to Xinfang. This show of friendship from the lowly Yaguo is as bad, perhaps worse, than utter isolation.

Humiliated, Xinfang turns and runs out.

EXT. STREET - BEIJING - DAY / NIGHT

Xinfang runs as fast as he can, tears in his eyes. Initially he is too caught up in his own grief to notice anyone or anything, but as he tires and slows down, he begins to notice passersby.

Before long, Xinfang forgets his own troubles and focuses on the world around him, its squalor and misery and stench. A naked toddler picks up a scrap from the street and laughs. Its beleaguered mother looks on, her eyes far older than her years. A toothless old man with a beard and pigtail sucks on a pipe and coughs, choking.

For the first time in his life, Xinfang really studies the people and their suffering. Their expressions, their gaits, their voices are so real.

THE SOUND OF THUNDERS is followed by rain.

EXT. XINFANG'S DWELLING - BEIJING - NEXT MORNING - SUNRISE

Xinfang is depleted and soaked from the rain. The storm has subsided.

INT. XINFANG'S DWELLING

Xinfang bursts into the building, walking through a long corridor, and goes to his bedroom.

INT. XINFANG'S BEDROOM

He slings off his white cloths and looses his pigtail.

(CONTINUED)

CONTINUED:

A hand approaches and opens the mirrored cabinet, reveals the pair walnuts.

> XINFANG'S FATHER (V.O.)
> To succeed in opera, you have to sacrifice all.

The hand picks up the blade from behind the walnuts. As the mirrored cabinet door closes, reveals Xinfang's face damp with perspiration.

The room is in disarray. Clothes and undergarments strewn on the floor.

From behind, we see Xinfang, totally naked, standing still in front of the mirror, with the blade in his hand. FREEZE in time like a statue.

EXT. STREET - BEIJING - MORNING

SUPER: Three weeks later.

A group of people with various lengths of pigtails huddle near a poster.

Xinfang looks much stronger, like a hairless lion with his bald, shaven head. He approaches them. They are trying to figure out what the poster says but not one of them is literate.

> YOUNG MAN
> What does it say?

A MIDDLE-AGED MAN stands before the poster, frowns in concentration, trying to decipher the message.

> MIDDLE-AGED MAN
> The Qing--ended?

> CROWD
> What?

People start laughing at him. As Xinfang pushes through the crowd, everybody turns and stares at him. He nudges the MIDDLE-AGED Man aside.

> XINFANG
> I can read it.
> (reading in Chinese)
> "The Qing Dynasty has been overthrown..."

His voice is harsh but quiet. People can't hear.

(CONTINUED)

CONTINUED:

> CROWD
> (in Chinese)
> Speak louder! Louder!

Someone brings a crate. Xinfang steps up on it and continues
reading as loudly as he can.

> XINFANG
> (in Chinese)
> "The Qing Dynasty has been
> overthrown. Sun Yat-sen is our
> President, supported by the warlord
> and the prime minister. The pigtail
> is the symbol of foreign rule,
> therefore, it must be cut off.
> China is now a Republic."

As he reads on, the crowd cheers at the news. They begin to
murmur excitedly, though most eyes remain on Xinfang, who is
finding a new but equally powerful public voice.

The applause crescendos. Xinfang is thrilled to know that he -
- and his voice -- can still command attention and
admiration.

Xinfang's speech becomes inaudible as his thoughts rise up to
the clear sky.

BEIJING OPERA MUSIC fades in.

INT. THEATER - BEIJING - NIGHT

Beijing Opera music. A clown's face. Audience responds with
laughter.

Xinfang bounds through the backstage door. He walks up to a
stagehand.

> XINFANG
> Where is boss?

> STAGEHAND
> He'll come when he comes.

Hearing the audience laughing and clapping, Xinfang peeks
through the curtain and watches the clown perform on stage.

Xinfang's focus is so intense it silences all sound. The
clown actor is not even singing, but the audience loves him.
Xinfang smiles, seeing the connection between the clown and
the audience.

> (CONTINUED)

CONTINUED:

Xinfang is fascinated by the clown. As he slowly turns
towards us, the stage behind him goes dark.

 THEATER BOSS
 What do you want?

Xinfang turns abruptly.

 XINFANG
 Boss! I have an idea for a new
 opera...

 THEATER BOSS
 You walked out on me... Remember?
 What do you want me to do? You lost
 your voice.

Theater boss shakes his head and walks away. Xinfang feels a
hard slap on his back. It's Yaguo.

 YAGUO
 Where is your hair, you asshole?
 Where have you been?!

 XINFANG
 Did you see how the audience is
 mesmerized by the clown? And he's
 not even singing.

EXT. THEATER - BEIJING - CONTINUOUS

They step outside.

 YAGUO
 Let's go back to Shanghai. I know
 we can find plenty of actors and a
 run-down theater. We will use the
 theater to support our revolution.

Yaguo is excited and starts running as if he is going to look
for the theater in Shanghai right now.

 XINFANG
 (shouts)
 Where are you going?

 YAGUO
 (shouts back)
 It's a whole new world, Xinfang! We
 can write new rules!

INT. NEW THEATER - SHANGHAI - 1913 - DAY

SUPER: 1913. Shanghai. The principle of Qi style is formed.

On stage, Xinfang rehearses with several actors.

> ACTOR
> I am already playing two roles. Why
> can't Yaguo play the emperor?

> XINFANG
> (gestures to the throat)
> No, he can't.

From the back, the entrance curtain is being drawn. Yaguo
stands in the light with a blank look and slowly takes a step
back into the shadow. A young man runs past Yaguo onto the
stage.

> YOUNG MAN
> (shouting)
> The prime minister is assassinated
> by the warlord!

Everybody gathers on the stage. Xinfang's face is grim, his
brow furrowed in concentration. For a long moment he shows no
reaction, says nothing. Then, finally and deliberately--

> XINFANG
> (looks at Yaguo)
> Change next week's program.
> Everything modern, even the
> costumes. We will write a new opera
> about the assassination.

The actors murmur and though the words are indistinct, the
mood is clear: they're more nervous than excited about this
idea.

> TALL YOUNG ACTOR
> Are you serious? The warlord will
> kill us all.

> SKINNY ACTRESS
> Who would want to come? It's too
> dangerous.

The actors exchange looks, waiting for a response that never
comes.

INT. NEW THEATER - SHANGHAI - DAY/NIGHT

Xinfang and a few of his colleagues discuss the script while other members of the company hustle in the background working on costumes and props. From the look of things, everyone has decided to stay.

Everyone looks rough around the edges; rumpled clothes, untidy hair, tired expressions. They have been working like mad but their eyes are on fire, their voices loud and strong.

Day gets dark. After everybody goes home, Xinfang writes the script alone in the theater at night. He almost falls asleep, but he pinches himself and forces himself to continue.

INT. NEW THEATER - BACKSTAGE - NIGHT

A rheumatic hand passes an envelope to a backstage guard. It bears the name Zhou Xinfang. The guard looks up and accepts it. ANOTHER MAN (early 30s) pushes forward and passes the man.

> ANOTHER MAN
> My name is Lee. Tell Qi Lin Tong
> (Unicorn Child) I want to see him.

The guard sheepishly gets out of his counter.

EXT. STREET - OUTSIDE THEATER - WINTER - NIGHT

In every direction the streets are silent, not a soul in sight. The only sound is the HOWLING WIND. Few lights are on in this shabby neighborhood.

Closer to the theater is the INDISTINCT SOUND OF THE AUDIENCE.

INT. NEW THEATER

Through the theater door, a dense crowd. The spectators here are not old men who lean back and listen with closed eyes. They are young and old alike, all leaning forward with their eyes glued to the stage.

Yaguo watches from the wings, in awe of Xinfang's power over the audience.

The prime minister, played by Xinfang in modern clothes, is struck by an assassin's bullet. The audience gasps. With his dying breath, he sings. No longer angelic, the song is filled with rich, deep emotion. The rough voice gives expression to each word.

 (CONTINUED)

CONTINUED:

> XINFANG
> (playing the prime
> minister; singing in
> Chinese)
> Every day the Sun goes down,
> someone goes with it. Today it's
> me. My death is not important.
> Tomorrow, the sun will rise again
> from the east. It will be brighter
> than ever. This time, it will rise
> for China...

Singing stops. The final note lingers, followed by stillness.
A moment later, a roar of applause. Xinfang holds the
audience in thrall. His singing brought the audience to their
feet. Most of them are moved to tears. In the back stands a
man, proud. It is Xinfang's father.

INT. NEW THEATER - XINFANG'S DRESSING ROOM - LATER

LEE, with his legs crossed, sitting in the shadow and
smoking.

Actors are all exited about the performance, as well as
Yaguo. Xinfang is removing the makeup in front of the mirror.

The guard enters with the large envelope which bears the name
Zhou Xinfang.

> GUARD
> Mr. Zhou, a man left this for you
> earlier.

Xinfang, with makeup on his hands, gestures Yaguo to open it.
Yaguo takes out a book of newspaper cuttings from the
envelope, which reveals Xinfang's twelve years career.

> YAGUO
> Looks like you have a very devoted
> fan.

As Xinfang turns back to continue, he notices a pair of feet
at the doorway. As he looks up, he finds a rheumatic hand and
a clearly emotional countenance spread across Weitang (Way-
Tang).

From Xinfang's reaction, Yaguo senses the bitter sweet moment
and gestures everyone to leave the room. The door closes.

EXT. SHANGHAI SQUARE - 1927 - DAY

In the heart of Shanghai a small square is crowded with cars
and rickshaws, surrounded by all walks of life.

 (CONTINUED)

CONTINUED:

Pulling back, the theatre sign is revealed. Moving past a window an office is exposed.

INT. SKYLINE THEATER - SMALL GANGSTER'S OFFICE - LATER

The SMALL GANGSTER (Boss Lee), in his mid 40s, sophisticated, works at his desk. He is the same man we saw backstage fourteen years ago. He looks up at a SKINNY ACTOR who shakes and fidgets nervously. His hollow eyes and even hollower cheeks indicate a man in the throes of a terrible opium addiction.

The Small Gangster thinks for a moment, reaches into his pocket, takes out a money clip with bills, peels one off from the top, and flips it across the desk.

 SMALL GANGSTER
 Now get out.

He pushes a button under his desk. Instantly, the door opens. Two well-dressed associates enter. Their clothes disguise their real job, which is seedy and violent.

The Skinny Actor grabs the bill, bows and hurries out. Small Gangster gets up and leaves the room. His associates follow.

INT. SKYLINE THEATER - CORRIDOR

Small Gangster with his associates walks towards us and passes by. Moving out the window.

EXT. SKYLINE THEATER - OUTSIDE

A chauffeur-driven sedan pulls in front of the theater, where a crowd jockeys for tickets from scalpers. Some arrive on rickshaws but most are on foot.

The driver gets out and opens the door. LILLIAN (early 20s), is a beautiful Eurasian socialite, with curly hair. She wears a Western dress and walks with her Russian friend HELEN (early 20s), wearing traditional Chinese dress.

People stare at them as they approach the entrance. Lillian's brohter ROBERT (early 30s), Eurasian, an amateur warrior-type performer, follows.

INT. SKYLINE THEATER - UPSTAIRS BOX

The theater is packed with people and filled with smoke. The classic Monkey King play is in full swing.

 (CONTINUED)

CONTINUED:

Behaving like a monkey, the Monkey King easily jumps on the table without moving his upper torso, as light as a feather. The audience applauds enthusiastically.

Small Gangster walks upstairs with his associates. He enters the box, designed as though for royalty. Lillian sits with Helen. Robert sits behind them.

> SMALL GANGSTER
> Robert -- the king of Monkey Kings!
> Welcome. It is indeed an honor.

> ROBERT
> Hey, Boss Lee!

He rises, and they shake hands.

> ROBERT (CONT'D)
> This is my sister Lillian Qiu, and
> our friend Helen Matthau.

> SMALL GANGSTER
> Ms. Qiu... Ms. Matthau.

Lillian nods. Helen extends her hand.

> HELEN
> Boss Lee.

> SMALL GANGSTER
> Miss Qiu, I'll inform Xinfang we
> have such distinguished guests.

He smiles and exits. As he walks out, two waitresses bring two trays of food and drinks to the box. They set everything up: Chinese sweet soup with sticky rice balls, cookies, watermelon seeds, oranges, bananas, tea and beer, a feast of small dishes.

A waitress bows slightly to them.

> WAITRESS
> (in Chinese)
> Compliments from boss Lee.

Robert nods with a smile. The waitresses leave.

INT. SKYLINE THEATER - BACKSTAGE - DRESSING ROOM

Xinfang, now in his early 30s, touches up the scar on his forehead with makeup. An assistant stands at his side. A hand passes a Beijing Opera base garment to Xinfang.

(CONTINUED)

CONTINUED:

 XINFANG
 I can manage. Why don't you sit and
 have some tea.

The man looks at Xinfang. It's Xinfang's father. He quietly
walks out the room and closes the door.

 YAGUO
 He is just trying to help you.

Xinfang pauses for a second.

 XINFANG
 I know.

 YAGUO
 Then why don't you take it?

Door opens. Yaguo looks up and nods when he sees the Small
Gangster enter.

 SMALL GANGSTER
 Maestro Zhou, the Qiu family is
 here tonight, Robert and his
 sister.

Xinfang continues doing his makeup.

 SMALL GANGSTER (CONT'D)
 By the way, you made the right
 decision.

He leaves with an awkward smile.

 YAGUO
 What decision?

 XINFANG
 (murmurs)
 No -- I just signed another five-
 year contract.

 YAGUO
 Why? -- Another five years?! I
 thought you wanted to continue your
 reform.

INT. SKYLINE THEATER - STAGE

Bright lights come on in time with the music of the
orchestra. The gossip dies down as applause rises. The eager
audience watches.

 (CONTINUED)

CONTINUED:

The small drum sounds the beat. The musician who plays it doubles as the conductor who controls the rhythm. As the beat speeds up, Chinese violin begins to play. On the resonant note of a small gong, Xinfang enters, handsome without the beard.

The crowd stirs and applauds his entrance. Women in the front rows throw handkerchiefs and flowers on the stage, screaming like crazed fans.

When Xinfang begins singing, the audience calms down to listen, completely under his spell. He is utterly in character.

The light in front of Xinfang is blurred, but as he eyes the audience from left to right, each and every person is in perfect focus.

Xinfang glances habitually at the box upstairs. He sees Robert and Helen.

He finally sees Lillian. The world stands still.

INT. SKYLINE THEATER - UPSTAIRS BOX

> HELEN
> (whispers)
> He is great with that rough voice.

> ROBERT
> That's Qi Lin Tong's (Unicorn
> Child) trademark.

Helen eats watermelon seeds at such a pace that requires special control of the mouth muscles, all the while transfixed by Xinfang.

> HELEN
> His wife is one lucky woman.

Lillian's brother overhears.

> ROBERT
> She is not that lucky. He's been
> trying to get divorced forever.

He laughs. Lillian looks at her brother but doesn't say anything.

> ROBERT (CONT'D)
> He got married when he was very
> young. They say he hasn't seen his
> wife in years.

(CONTINUED)

CONTINUED:

> HELEN
> Yes... in Shanghai, nowadays women
> have rights. A friend of mine took
> eight years to get a divorce.
> Finally she got one, but the next
> morning, she married the same jerk.

Helen laughs. Lillian is mesmerized by Xinfang on stage.

> HELEN (CONT'D)
> (whispers to Lillian)
> Lillian, I'm short again, I need to
> borrow 1000 Yuan.

Lillian is still captivated by Xinfang on stage, just nods.

> HELEN (CONT'D)
> Can I pick it up tomorrow?

Lillian turns, looks at Helen and nods.

INT. QIU HOUSEHOLD - DAY

From the hallway to the living room. Sepia photos are
displayed on the mantelpiece above the fire. One features a
Scottish man named Ross in formal 19th century attire with
his Chinese wife. A ten-year-old Eurasian girl with four-inch
bound feet sits on his lap. They are Lillian's grandparents
and her mother.

The opulence on display makes it clear Lillian's family is
extremely wealthy. But at the moment none of the finery is of
interest to Lillian, who paces in frustration.

Lillian's Mother (late 50s) enters, a Western woman in
appearance, but thoroughly Chinese in demeanor. The four-inch
bound feet force her to take small steps. She sits, frowning
in disapproval.

> LILLIAN'S MOTHER
> Stop your pouting, Mr. Tang will be
> here any minute.

Lillian stops pacing, faces her mother and smiles darkly.

> LILLIAN
> What about my request?

> LILLIAN'S MOTHER
> Charity party in our house? And
> inviting actors? Don't be
> ridiculous.
> (MORE)

 (CONTINUED)

CONTINUED:

> LILLIAN'S MOTHER (CONT'D)
> I know what you're up to. Mr. Tang
> comes from a long line of
> bankers...

> LILLIAN
> Mother, I will, but not right now.
> I really have no desire to meet
> anyone.

Lillian approaches the door. Lillian's brother enters with
Mr. Tang, a well-dressed, well-groomed man. He looks exactly
like what he is: a banker, though educated in the U.S.
Lillian passes them and exits, leaving them confused.

EXT. ZHANG GARDEN ENTRANCE - DAY

Yaguo's rickshaw approaches Xinfang, who waits at the
entrance in traditional Chinese dress. From Yaguo's POV,
Xinfang is having an intimate chat with TIAN HAN (early 30s),
in a suit, charismatic with ruffled hair, obviously an
artist. From the distance, Yaguo observes with interest.

Flashy cars dropping off glamorous guests excite the crowds
who have come to watch the spectacle. Yaguo gets off the
rickshaw.

> XINFANG
> Yaguo, Tian Han -- Tian Han, Yaguo.

> YAGUO
> Xinfang was very impressed with
> your last play, although I missed
> it. But it seems it didn't run very
> long?

> TIAN HAN
> It's touring. It's now in Beijing.

Yaguo turns and walks on.

Several SIKH DOORMEN in traditional attire with high turbans
stand by the entrance.

> LEAD SIKH DOORMAN
> Stop! This party is only for
> invited guests.

Xinfang squares his shoulders proudly, withdraws a beautiful
invitation from a pocket and offers it to the guard. The
doorman waves off the invitation; he can't read it anyway.

Young women in the crowd recognize Xinfang and rush toward
him with autograph requests.

 (CONTINUED)

CONTINUED:

<div align="center">YOUNG WOMEN IN CROWD</div>
<div align="center">Qi Lin Tong! (Unicorn Child!)</div>

EXT. GARDEN - DAY

In the center of the garden, a pair of tango dancers performs in front of the band. Europeans are prominent in this party. It is an elite but eclectic crowd: bankers, politicians, diplomats, as well as a Nationalist General who chooses a distinguished seat with his entourage.

<div align="center">MAN (O.S.)</div>

...The foreign power will never abandon shanghai. They are too committed...

Yaguo overhears a few men passionately discussing politics and enthusiastically joins the debate. Tian Han follows.

Lillian is busy directing servants and accepting congratulations on the beautiful party, as well as promises to donate money to the charity.

She notices Xinfang the moment he enters the garden. Her eyes light up when she sees him, but she can't take two steps in his direction without being interrupted. She steals glances at him, attracted despite his humble, out-of-date attire. Helen, across the buffet table, gives her a silent 'go on'.

Xinfang, abandoned by Tian Han and Yaguo and oblivious to Lillian's attention, is starting to realize how out of place he is. He looks at the finely tailored suits the more fashionable men wear. When they look at him, their eyes are filled with judgment, even disdain.

Xinfang follows people to a sumptuous buffet table with several waiters standing behind, serving. There are things Xinfang has never seen before. He doesn't know what to pick. A waiter offers him some cheese. He shakes his head and smiles awkwardly.

Yaguo and Tian Han are now in the middle of a discussion.

<div align="center">YAGUO</div>

...Anyone with half a brain who cares about China knows that communism is the answer.

High-Class Man A looks at Yaguo's shabby suit.

<div align="center">HIGH-CLASS MAN A</div>

If you want stability for China, we need foreign protection.

<div align="right">(CONTINUED)</div>

CONTINUED:

 TIAN HAN
 I didn't know that China is for
 sale? Shanghai has been colonized
 for 80 years.

Tian Han has created an awkward moment. They don't know what
to say. The Nationalist General looks on.

Lillian sees Xinfang standing by the buffet table and doesn't
know what to do. As he is about to leave, Lillian extricates
herself from her conversation and "accidentally" crosses his
path.

 LILLIAN
 Mr. Zhou! Aren't you hungry? Are
 you leaving already?

Xinfang, awed by her beauty and embarrassed to admit he's not
enjoying her party, can't come up with anything to say.

 LILLIAN (CONT'D)
 (smiles)
 Ah. You only came to be polite. I
 am Qiu Lilin.

 XINFANG
 No, no, no. It's not that... I'm
 Zhou Xinfang.

 LILLIAN
 I know. Perhaps you're rushing off
 to meet someone.

 XINFANG
 No! No...

 LILLIAN
 You're blushing.

 XINFANG
 No. My -- my friend Tian Han wants
 me to join him for his rehearsal.

 LILLIAN
 I see. I know you don't have a
 matinee...

 XINFANG
 You do?

Lillian smiles and nods. VOICES rise on the other side of the
garden. A scuffle breaks out between Yaguo and High-Class Man
A.

 (CONTINUED)

CONTINUED: (2)

Tian Han pulls Yaguo away. Joined by Xinfang, they exit. The
seated Nationalist General beckons his assistant, and
whispers in his ear.

Yaguo dusts himself off and looks around.

> YAGUO
> Middle of next month, I'm going to
> join the strike. You should come.
> Thousands of workers will be
> marching.

> XINFANG
> I leave all the politics to you.
> I'm just an actor.

> TIAN HAN
> Judging by your smile, it looks
> like you will be doing more than
> just acting.

They all laugh.

EXT. STREET - SHANGHAI - AFTERNOON

Xinfang exits his apartment. He flags down a rickshaw.

The Shanghai street is busy. Cars, bicycles and rickshaws
speed by, hawkers shout to attract customers, small kids sell
newspapers, and street performers provide all kinds of
strange and wonderful entertainment.

The rickshaw makes a sharp turn into a lane and disappears.
A moment later, a horse and carriage with its hood up comes
out of the lane. Xinfang has switched.

EXT. OUTSKIRTS OF SHANGHAI

A horse carriage arrives and parks behind a carriage by the
street.

A foot descends, it is Lillian. She walks into a noodle shop
and disappears. Back to the pair of carriages. Another foot
descends from the other carriage. It is Xinfang. He walks
into the noodle shop and disappears.

The shadow of sun moves across the facade of the building.
Lillian and Xinfang exit with smiles. They pause.

(CONTINUED)

CONTINUED:

> LILLIAN
> I have a confession to make. I have
> been to your performance three
> times. Same opera, but you're never
> the same.

> XINFANG
> How come I never saw you there?

> LILLIAN
> I was hiding in the third tier
> gallery. In fact, I'm going
> tonight.

Smiling, she shows the ticket to Xinfang.

> XINFANG
> That's where my audience is. I will
> find you.

They walk to their respective carriages and climb in. The
carriages take off.

EXT. OUTSIDE OF THE NOODLE SHOP - NEXT DAY

Empty roadside. Two carriages approach simultaneously from
opposite directions. Lillian and Xinfang exit from their
respective carriages, and enter the noodle shop together.

EXT. THE NOODLE SHOP

The Door opens, and Lillian and Xinfang exit, holding hands
and wearing different clothing. This time, a single carriage
awaits.

Xinfang and Lillian sit close together. This small space is
ideal for their romantic ride.

> LILLIAN
> How old were you when you got
> married?

> XINFANG
> It was a mess. I was only nineteen,
> and it was an arranged marriage by
> my father... To please him...

> LILLIAN
> Your father is also an actor?
> (off Xinfang's nods)
> Were you trained by him?

(CONTINUED)

CONTINUED:

 XINFANG
 No.
 (pause)
 Next week, I have a night off.

Xinfang looks at Lillian with a smile.

 LILLIAN
 That's great! I know a Russian
 restaurant, only Europeans eat
 there. No one will see us.

Lillian gives Xinfang a sweet smile and he takes her into his
arms. She rests her face on his chest, listening to his heart
beat, feeling so safe and content. Finally, she falls asleep.

INT. QIU HOUSEHOLD - A WEEK LATER - NIGHT

Lillian is dressed up and is about to leave. Her mother stops
her.

 LILLIAN'S MOTHER
 I've set up another meeting next
 week with Mr. Tang. And this time,
 you'd better be there.

 LILLIAN
 All right, mother. I'm late. Bye
 bye!

Lillian runs out. Her mother shakes her head.

INT. RUSSIAN RESTAURANT - SHANGHAI - NIGHT - LATER

Xinfang, in a new suit, is late. He spots Lillian, in a
beautiful western dress, waiting in a corner booth. He grins
and hurries to join her.

 XINFANG
 Sorry I'm late.

A Russian waiter brings the menu. This is an elegant
restaurant, busy and full of Europeans. RUSSIAN MUSIC plays
in the background; a pianist is playing at the piano bar.
There is a pleasant murmur of people chatting and laughing.
Soon, their voice die down. Some tables are now empty. The
Russian waiter comes with the bill and cleans their desert
plates.

Xinfang reaches in his pocket, but instead of a wallet or a
neat bundle of cash, he extracts many rumpled bills and
scraps of paper with notes.

 (CONTINUED)

CONTINUED:

He takes out his notes and gives all the money to the waiter, trusting him to take the correct amount.

> LILLIAN
> Let me do it.

Before Xinfang can react, Lillian has taken the bill with an irresistible smile. She scans it, frowns and waves the waiter over, pointing at various items and totals.

> LILLIAN (CONT'D)
> We didn't order this. And the
> addition is wrong.

Lillian picks a 50 Yuan bill from Xinfang's hand and hands it to the waiter.

The Russian waiter is confused, and only bows. He takes the money and leaves. Xinfang is impressed.

> LILLIAN (CONT'D)
> Do you like this place?
> (off Xinfang's nod)
> I love this place. It makes me feel
> like I'm in London or New York.

> XINFANG
> Your world is very different from
> mine.

> LILLIAN
> In some way, it is true. But we are
> both outcasts.

Lillian looks into Xinfang's eyes.

> XINFANG
> I know... The other night, middle
> of my performance, suddenly I dried
> -- I forgot my line -- completely.
> (beat; tender)
> I was thinking of you, it took me
> by surprise.

> LILLIAN
> I'm going to arrange a meeting for
> you to meet my mother.

> XINFANG
> No -- I don't think that is...

The waiter comes and clears their strawberry dessert plates.

(CONTINUED)

CONTINUED: (2)

> LILLIAN
> She always wanted lots of
> grandchildren. And they will be
> half of me and half of you. The
> best part of us!

Xinfang agrees with her.

Xinfang and Lillian stand up to leave. As they exit, a
Chinese man peeks out from the back of a booth for a final
look at the couple.

EXT. OUTSIDE, QIU HOUSEHOLD - DAY

Lillian walks home. Mr. Tang angrily rushes out of her house,
followed by her brother.

INT. QIU HOUSEHOLD - LIVING ROOM

Lillian enters. Her mother turns, her face twisted in rage.
She throws a newspaper in front of Lillian.

Two photos of Lillian and Xinfang are beneath a headline
reading "Eurasian socialite seen with matinee idol Qi Lin
Tong (Unicorn Child)."

> LILLIAN
> Eurasian... When will they get
> tired of that word?

> LILLIAN'S MOTHER
> How awful. You were seen with that
> actor!

> LILLIAN
> Mother, I'm not going to marry Mr.
> Tang.

Lillian lies down on the sofa.

> LILLIAN'S MOTHER
> Sit up! Most unattractive...
> I can assure you, you'll never
> marry that actor!

> LILLIAN
> Try and stop me.

INT. QIU HOUSEHOLD - LILLIAN'S BEDROOM - LATER

Closet doors are slammed shut and locked.

Drawers are locked one by one.

 (CONTINUED)

CONTINUED:

Two female servants exit Lillian's room after they lock
everything. One servant looks over her shoulder and shoots
Lillian a sympathetic glance, but then the door closes and
the lock CLICKS shut.

Lillian sits on her bed in the only clothes she has access
to: her Chinese pyjamas and a beautiful jade bracelet. She
stares out of the window and sighs in frustration -- but not
defeat.

EXT. STREET - SHANGHAI - DAY/NIGHT

A boy rides a bicycle back and forth from Xinfang's apartment
to Lillian's mother's house.

EXT. OUTSIDE OF QIU HOUSEHOLD - AFTERNOON

The boy stops in front of the house, hands a letter to a
female servant.

INT. QIU HOUSEHOLD - LILLIAN'S BEDROOM - MORNING

Lillian, wearing pyjamas in bed, reads Xinfang's letter. Her
expression is full of love.

INT. QIU HOUSEHOLD - LILLIAN'S BEDROOM - TWO WEEKS LATER - DAY

The door opens, and Lillian's mother walks in.

> LILLIAN'S MOTHER
> Lillian, Mr. Tang has graciously
> decided to forgive you, and he has
> asked my permission for your hand,
> which I have granted.

Instead of getting annoyed, Lillian becomes very gentle. She
holds her mother's hand, but mother slowly pulls it away.

> LILLIAN
> Mother, I know you mean well, but I
> want you to understand: he needs me
> and I need him. Xinfang and I, we
> love each other.

> LILLIAN'S MOTHER
> Mr. Tang can give you a privileged
> life. The real world is dangerous
> and cruel. You will soon get over
> him. Besides, I was told that he's
> already married.

(CONTINUED)

CONTINUED:

> LILLIAN
> Someday, Xinfang and I will be
> married, but for now, I want to be
> with him.

> LILLIAN'S MOTHER
> You're young and a hopeless
> romantic. I can't let you do this.

> LILLIAN
> I'm not accepted anywhere. They
> call me half-breed. You of all
> people should know that.

> LILLIAN'S MOTHER
> I've accepted who I am. I'm
> Chinese, and I'm proud of it.

Lillian gets very emotional.

> LILLIAN
> I beg you, let me be free. If only
> you could meet Xinfang, maybe...

> LILLIAN'S MOTHER
> (pounds on the table)
> I will not! I forbid you!

Lillian seizes her chance to escape. She gets up and runs
out.

> LILLIAN'S MOTHER (CONT'D)
> (shouts)
> Lillian!

She tries to catch her, but with her tiny bound feet it's
impossible.

EXT. OUTSIDE, QIU HOUSEHOLD - DAY

Lillian bursts from the house just as a storm breaks,
unleashing torrential rain that quickly soaks her flimsy
pyjamas.

The servants can be heard shouting after her. She continues
running, pushes through the gate and into the street.

It's empty, no one in sight. A rickshaw, cover closed, tears
past her. Lillian waves her hand. The rickshaw passes her
without acknowledgement.

> LILLIAN
> Please!

(CONTINUED)

CONTINUED:

The rickshaw continues running.

> LILLIAN (CONT'D)
> (screaming)
> Please!!

The RICKSHAW MAN stops, turns to her and starts shouting. His words mix with the sound of heavy rain.

> RICKSHAW MAN
> Communists are marching.

> LILLIAN
> (more frantic)
> Please!

> RICKSHAW MAN
> Nationalist soldiers, they are all
> waiting for them.

Lillian pulls off her jade bracelet and offers it to him. The Rickshaw Man looks at it, then opens the cover and motions for her to get in.

Lillian jumps in and the rickshaw races on. Several servants emerge from the house with umbrellas, screaming for her.

EXT. STREET - SHANGHAI - DAY

The rain stops. The empty street with the sound of the rickshaw man's PITTER PATTER FEET slapping the wet street. The Rickshaw passes across the street and the scene closes in from the right side of the rickshaw to reveal the backs of Nationalist soldiers' wet raincoats waiting before many rows of empty blocks.

The thunderous marching and chanting foreshadows a tumultuous uproar. Marchers begin to emerge from behind every corner of the buildings

POV of marchers. In the distance, there are Nationalist soldiers with sandbags and firearms. Moving rapidly closer and closer towards the barrels of the machine guns, the bullets begin to fly, leading to intense GUNFIRE. It is a massacre.

SUPER: 1927. April 12th Incident.

The bodies of the marchers are catapulted into the air eerily as the force of the Nationalist attack takes its toll. As the marchers fall, their bodies contort grotesquely at a tense speed.

(CONTINUED)

CONTINUED:

Yaguo's face reveals a horrified reaction. The sound of
PIERCING SCREAMS and AGONIZING HOWLS of pain fill the air as
the marchers clash with the destructive forces of the
Nationalist warriors.

EXT. STREET - OUTSIDE OF XINFANG'S APARTMENT - LATER

The rickshaw man's feet race on the wet road.

The rickshaw pulls up in front of a building. The door to the
flat opens, a man's foot steps out. Xinfang, dressed in a
raincoat, stuffs a messy bundle of cash in the rickshaw man's
hand. The rickshaw man runs off.

Xinfang turns toward the building. Lillian sits on the front
stairs, half-soaked, shivering, thoroughly exhausted but
radiant.

> XINFANG
> Lillian!

She rushes to him and collapses in his embrace. He covers her
with his raincoat completely.

EXT. STREET - SHANGHAI - 1932 - DAY

SUPER: Five years later.

Two Nationalist G-men, wearing their signature raincoats and
hats and carrying umbrellas, stand by the street. They stick
out like sore thumbs. They see Yaguo and a MAN get off a
tram, walk towards a house and knock on the door. The door
opens.

EXT. HOUSE - ROOF TERRACE - DAY

The place is filled with bustling activity. Tian Han
rehearses with a group of people while someone shoots 16mm
film in the corner. Yaguo and the man come up from the
staircase. He is JIAN QUAN (early 40s), he looks slightly out
of place but his ambitions can be seen in his hard and hungry
eyes.

> YAGUO
> Tian Han, this is Jian Quan. He is
> a journalist. He is doing research
> and writing a book on Beijing
> opera.

> TIAN HAN
> More research? We don't have time
> for research. What we need is
> action.
> (MORE)

(CONTINUED)

CONTINUED:

 TIAN HAN (CONT'D)
 (smiles with gesture)
 Don't mind me. Welcome to our
 factory.

 YAGUO
 There are two Nationalist
 detectives down there.

Tian Han takes a deep draw on his cigarette.

 TIAN HAN
 I think they're the same people who
 followed me the other day. We are
 playing hide and seek. I hide, they
 seek...

INT. SKYLINE THEATER - XINFANG'S DRESSING ROOM - DAY

Xinfang applies makeup in front of the mirror while his
dresser prepares his costumes. Small Gangster enters.

 SMALL GANGSTER
 Maestro Zhou, our contract...?

Xinfang continues to put on his makeup.

 XINFANG
 Yes. The contract? Five years...
 well... The kind of opera I want to
 perform, it won't be that
 profitable.

 SMALL GANGSTER
 That's right. I pay you more than
 any other actor in Shanghai. Why do
 you want to change that?

He sits, takes a ledger from his pocket, and places it next
to Xinfang, who quickly glances at it.

 SMALL GANGSTER (CONT'D)
 Besides, as you know, your current
 contract allows you to borrow up to
 ten grand a year. Within the last
 five years, you've borrowed the
 maximum.

He points to the ledger. Xinfang looks at it carefully.

 XINFANG
 What?

(CONTINUED)

CONTINUED:

> SMALL GANGSTER
> (smiles coldly)
> I see. You didn't know. Anyway you
> look at it, you owe me. Perhaps you
> should ask your wife.

> XINFANG
> My wife?

EXT. STREET, NEARBY SKYLINE THEATER - SHANGHAI - NIGHT

Heavy rain. Tian Han, soaking wet in raincoat and hat, stands
before a shop window. In the reflection, two pathetic
Nationalist G-men stand across the street with open
umbrellas. Tian Han shifts his gaze. To the left is the
theater with Qi lin Tong's (Unicorn Child) banner above its
front door.

Tian Han calmly crosses the street and turns into a side
lane. When the Nationalist G-men follow, they only see
several rickshaws parked on the side with their hoods up and
flaps closed against the rain. After they leave, Tian Han
pops out of one of the rickshaws and runs to the theater.

EXT. OUTSIDE, SKYLINE THEATRE - SHANGHAI

A doorman stands by the back door polishing a small silver
plate. He puts it down to receive a flower delivery. He takes
the bouquets and goes inside. Tian Han darts over and slips
into the theater.

INT. SKYLINE THEATER - BACKSTAGE

SINGING AND MUSIC come from the stage. Actors prepare to go
on, some putting on costume, some making up. All are busy.
Two costumed actors pass Tian Han and eye him suspiciously.

Tian Han searches for Xinfang's dressing room. He finally
hears his voice. A well-dressed young actor exits the room.
Tian Han slips in.

Xinfang is before the mirror, about to put on his beard. In
the reflection, he sees Tian Han dash in.

> XINFANG
> Tian Han?

> TIAN HAN
> Can you hide me?

Xinfang takes Tian Han's soaking raincoat and hat, hangs them
on the wall.

> (CONTINUED)

CONTINUED:

He takes off his friend's jacket and grabs a Beijing Opera undergarment for him to put on. Hurried and nervous, Tian Han puts his arm in the wrong sleeve.

While he tries to figure out how to wear the undergarment, Xinfang ties a white band on Tian Han's forehead. He grabs a brush and paints white makeup all over Tian Han's face, then points to another dressing table.

> XINFANG
> Put some more on.

Door opens. The Small Gangster enters with two Nationalist detectives, both holding closed, dripping umbrellas.

> TALL DETECTIVE
> (very excited)
> A Ya! Qi Lin Tong (Unicorn Child)! –
> – Mr. Zhou! My wife and I are big
> fans.
> My wife won't believe this.

Tian Han does a bad job of applying makeup in the corner.

> XINFANG
> Thank you. Enjoy the performance.

> TALL DETECTIVE
> We can't tonight. But we will be
> back.

Small Gangster notices the stranger in the mirror. Xinfang realizes that the Small Gangster has observed Tian Han. In the mirror Tian Han observes a pool of water that has dripped off his raincoat. He signals Xinfang with his eyes. Xinfang catches on. Simultaneously, Small Gangster catches Xinfang's eyes and slowly turns his head to the pool of water on the floor. Xinfang feels at this moment the game is up.

> SHORT DETECTIVE (V.O.)
> Oh, no!

Everybody in the room turns and looks at him.

> SHORT DETECTIVE
> I'm sorry.

They all look down and see two small pools of water under their umbrellas. Another awkward moment.

> SMALL GANGSTER
> Don't worry, I'll take care of it.

(CONTINUED)

CONTINUED: (2)

Small Gangster ushers them out. Xinfang grabs a costume and hangs it over the raincoat.

Leading the detectives away, Small Gangster looks from Xinfang to Tian Han, then back to Xinfang with a smirk and a nod.

After they leave, Xinfang passes a towel to Tian Han.

> XINFANG
> Wash it off over there.

While Tian Han washes his face, Xinfang goes to his jacket and searches the pockets. He finds his crumpled money and puts all the bills into Tian Han's jacket.

INT. XINFANG'S HOUSE - NIGHT

Lillian reads on the sofa. Xinfang enters, looking nervous.

> XINFANG
> Is it true...

> LILLIAN
> Shh!

Lillian rises, walks to the bedroom and opens the door. Children are sleeping, #1 daughter (4), #2 daughter (2), and #3 daughter (6-month old), all in baby pink pyjamas, their blankets almost off the bed. Lillian covers them, then returns to Xinfang.

> LILLIAN (CONT'D)
> Now tell me.

> XINFANG
> (whispers)
> Over the last five years, Lee told
> me you borrowed over 50,000 Yuan.
> We're spending too much. Why didn't
> you tell me?

Lillian smiles, goes to the cabinet, opens the drawer, and takes out a bank account book. She shows it to Xinfang.

Xinfang studies the book. It shows 90,000 Yuan in their account. He is confused.

> LILLIAN
> The fifty we borrowed, we pay no
> interest. But we do get interest
> from the bank, plus our savings.

(CONTINUED)

CONTINUED:

 XINFANG
 But why? If we don't need the
 money.

 LILLIAN
 Lee will never be satisfied unless
 they have some hold on you, and use
 that for leverage. Haven't you
 noticed how he uses opium to
 control some actors and treat them
 like dirt? If he can't control you
 over money, then he will look for
 something else.

 XINFANG
 (angry)
 How other people behave is not my
 concern. In the future, consult me.

 LILLIAN
 Why are you so upset... Don't be so
 naive. Someone has to protect you.

 XINFANG
 (loudly)
 I'm not a child!

 LILLIAN
 Shh!

 XINFANG
 Fourteen years ago, when I did the
 assassination play...

 LILLIAN
 Yes, I know. What about it?

 XINFANG
 Lee was the one who protected our
 troupe from the warlords.

 LILLIAN
 (pause)
 You must do your reform work. We
 must get out of his grip.

SOUND OF CRYING. #1 daughter stands by the bedroom door.
Lillian runs over to her.

INT. TIAN CHAN THEATER - SMALL GANGSTER'S OFFICE - DAY

The Small Gangster sits at his desk looking at some
documents. A quick KNOCK. The door opens.

 (CONTINUED)

CONTINUED:

> ASSISTANT (O.S.)
> Mrs. Zhou is here.

The Small Gangster looks up to see Lillian, impeccably dressed.

> SMALL GANGSTER
> Miss Qiu, this is an unexpected surprise. Please, sit down.

> LILLIAN
> I prefer to stand, thank you. And I am Mrs. Zhou.

Lillian's expression makes it clear she's acting as Mrs. Zhou whatever her legal status.

> SMALL GANGSTER
> (with sarcasm)
> Of course, Mrs. Zhou. How may I help you?

Lillian reaches in her handbag and withdraws a fat envelope and a receipt, which she puts on the Small Gangster's desk.

> LILLIAN
> I'm repaying the money we borrowed. Please count it and sign that release note.

> SMALL GANGSTER
> Mrs. Zhou, this isn't necessary.

> LILLIAN
> It is necessary. We are not renewing the contract.

> SMALL GANGSTER
> Mrs. Zhou, I implore you to sit down.

Lillian holds his gaze for a long second before finally sitting down. Her expression remains as determined as ever.

> SMALL GANGSTER (CONT'D)
> Nobody can break my contract. You know that.

> LILLIAN
> We just don't want to renew, we're not breaking the contract.

(CONTINUED)

CONTINUED: (2)

> SMALL GANGSTER
> What's the difference?
> (beat)
> We are both business people.
> Xinfang is more popular than ever.
> If it's a question of money, I'm
> quite happy to...

> LILLIAN
> Everything else comes second,
> Xinfang's work comes first. Please
> sign it.

Lillian passes the note to the Small Gangster. He is angry
but tries to act calm.

> SMALL GANGSTER
> Shanghai is a dangerous place. You
> may not know Xinfang owes me.

> LILLIAN
> I don't know. Just sign it.

He leans close to Lillian.

> SMALL GANGSTER
> Do you know who I am?

He presses a button under his desk. Instantly, the door
opens.

> LILLIAN
> I'm sure you're about to tell me.

Without turning, Lillian feels the presence of the two goons
guarding the door.

> SMALL GANGSTER
> I'm the last person in Shanghai
> that you want to mess with.
> Besides, once I sign this, I can no
> longer protect Xinfang and your
> family.

> LILLIAN
> Sign it.

The Small Gangster looks at Lillian, thinks briefly, then
picks up a pen and signs. He tosses the receipt back to her.

Lillian takes the receipt and rises. Small Gangster stands up
and puffs his chest.

(CONTINUED)

CONTINUED: (3)

> SMALL GANGSTER
> Mark my words: from this day on
> your husband will never work in
> Shanghai again!

The two associates exchange a look with the Small Gangster.
He holds the moment, then nods. Lillian leaves.

INT. TIAN CHAN THEATER - DRESSING ROOM

Xinfang, assisted by a dresser, is making up. Lillian walks
in. Through the mirror, Xinfang gestures the dresser to
leave.

> LILLIAN
> He said you will never work in
> Shanghai again.

Xinfang pauses, puts down the brush, and leans back.

EXT. XINFANG'S HOUSE - SHANGHAI - A FEW WEEKS LATER - MORNING

Holding #3 daughter and carrying a small bag, Lillian exits
the house with #1 daughter and #2 daughter. A taxi waits
outside.

#1 daughter and #2 daughter climb into the back, followed by
Lillian with the baby in her arms. She places the small
travel bag of baby clothes on the seat beside her.

> LILLIAN
> (to taxi driver)
> We're going to the North Station,
> but we have two stops before. Here
> are the addresses.

The driver looks from the paper to Lillian and back again.

> TAXI DRIVER
> You sure?

Lillian nods. The taxi speeds up. #1 daughter looks out the
back window. Their home gets smaller and smaller until it
disappears.

EXT. OUTSIDE, SMALL SHOP - LATER

The taxi arrives at a small shop in the rundown part of
Shanghai. Cautious but not fearful, Lillian takes the purse
and the baby and steps out of the taxi, leaving the two girls
in the car.

INT. SMALL SHOP

The dirty shop is very small. It sells snacks, drinks and cigarettes. A sole CUSTOMER, male, talks to the SHOPKEEPER. Lillian interrupts.

> LILLIAN
> Mr. Gibson sent me.

The Shopkeeper motions her to the back of the store. Lillian opens a door behind the counter, briefly exposing a sweaty fat Caucasian sitting behind his desk.

A moment later, Lillian comes out with the baby. She puts a pink paper bag into her purse and hurries out.

EXT. OUTSIDE, SMALL SHOP

Lillian gets into the taxi. It takes off.

Lillian looks sadly at #2 daughter. Seeing she is sweating, Lillian takes off her hat and wipes her wet hair.

EXT. HELEN'S HOUSE – SHANGHAI – LATER

The taxi pulls up in the French Concession. Lillian gets out with the baby and #2 daughter. As she takes the bag, #1 daughter tries to leave with her. Lillian stops her.

> LILLIAN
> You stay in the car.

> #1 DAUGHTER
> I want to come too.

> LILLIAN
> Just do as I say. You wait in the
> car. I'll be back.

#1 daughter looks unhappy, but sits back. Lillian closes the door. #1 daughter moves closer to the window. She sees Lillian carrying the baby and taking #2 daughter to the front door with a small bag.

Helen emerges from the house. The two talk for a moment before Lillian kisses and holds #2 daughter very tight. She hands her and the small bag to Helen, who goes back in the house and closes the door.

Lillian gets back in the cab with the baby, grief-stricken.

> #1 DAUGHTER
> Mommy, where is my sister?

(CONTINUED)

CONTINUED:

> LILLIAN
> She is with Auntie Helen...

> #1 DAUGHTER
> Why?

> LILLIAN
> We're going on an adventure -- it's
> too difficult to take your
> sister...

> #1 DAUGHTER
> Mommy, why are you crying?

> LILLIAN
> I'm not. I got something in my eye.

Lillian opens her handbag to get a handkerchief, exposing the
contents of the pink paper bag: A small PISTOL.

As the taxi pulls away, Lillian looks through the window. The
Shanghai streets move, faster and faster, blurred through her
tears...

INT. TRAIN CORRIDOR - MOVING - SHANGHAI - DAY

Yaguo stands in the corridor with some of the troupe. Some
look for their compartments while others settle in.

> WELL-DRESSED YOUNG ACTOR
> What is the accommodation like?

> YAGUO
> (glaring at him)
> Accommodation like?
> (pause)
> What did Xinfang name our troupe?

> WELL-DRESSED YOUNG ACTOR
> Change the wind?

> YAGUO
> What does it mean?

> WELL-DRESSED YOUNG ACTOR
> Reform?

> YAGUO
> Exactly. It's impossible to change
> the wind. But, we're going to do
> it!
> (beat)
> Go and check the equipment.

> (CONTINUED)

CONTINUED:

Xinfang walks down the corridor, smiling.

 XINFANG
 Where are they?

Yaguo points to a compartment.

Xinfang slides the door open. His smile fades.

Lillian, holding #3 daughter, sits there in a daze. #1
daughter looks concerned about her mother's distress. Tears
in her eyes, Lillian clutches their absent #2 daughter's
little hat.

EXT. SHABBY THEATER - TIAN JIN - LATER

Xinfang, Lillian, the two girls, Yaguo, and the troupe arrive
at the theater. It is located at the edge of the city, next
to a beautiful river. The theater owner greets Xinfang and
Yaguo and uses the key to unlock the front door.

INT. SHABBY THEATER

They open the creaky door. The theater, unused for many
years, requires a major spring cleaning.

The troupe members mumble with discontent. The well-dressed
young actor looks around with his mouth gaping in disbelief.

Despite his troupe's reaction, Xinfang walks around and
checks the details of the stage, clapping his hands for the
acoustic response. Yaguo whistles using his thumb and index
finger.

 YAGUO
 Listen! We'll have a meeting with
 Maestro in one hour. Be back on
 time!

 LILLIAN
 For goodness' sake, can't you wait
 till tomorrow?!

The troupe falls silent. Lillian takes the children and
leaves. Xinfang quietly follows her. Actors exchange glances.
The Well-Dressed Young Actor picks up a piece of debris and
throws it on the floor.

 WELL-DRESSED YOUNG ACTOR
 (whispers)
 Are we going to perform here? It's
 a joke.

 (CONTINUED)

CONTINUED:

Yaguo overhears it.

> YAGUO
> What did you say? A joke?
> To get here, do you have any idea
> what Xinfang and his family have
> had to sacrifice?

> WELL-DRESSED YOUNG ACTOR
> I'm so...

> YAGUO
> Beijing Opera was dying. The
> audience was literally half
> asleep... It was Xinfang who
> innovated the internal character-
> driven theater.

> ANOTHER ACTOR
> We know...

> YAGUO
> No, you don't. No -- It is almost
> impossible to recover from a
> cracked voice. But he uses his
> weakness. This man not only
> overcomes it, but makes his singing
> even more powerful.
> (to himself)
> I should know.

> VETERAN ACTRESS
> We know. That's why we are all
> here.

INT. SHABBY THEATER - DAY

A group of troupe members fixes the stage while another group
cleans the theater. All work hard. The well-dressed young
actor, wearing work clothes, sweats harder than any of the
others. In a short time, the whole theater is transformed.

EXT. SHABBY THEATER - SUNRISE

Male and female performers stand before the river, exercising
their vocal cords as the sun rises from the east. Male lead
role, junior male role, female role, painted face male role
are all mixed together. The full singing range fills the
morning air.

INT. SHABBY THEATER - NOON

Xinfang obsessively checks the acoustics of the theater by sitting in different seats while directing a stagehand to clap from various spots on stage. Lillian observes from the balcony. Xinfang gives Lillian a nod of acknowledgement. Acrobatic and Kung Fu actors practice their routine, from tumbling to splitting legs to kicking and all manner of martial arts.

> XINFANG
> (to stagehand)
> Stage left, the acoustic is not
> clear. It will help to dig some
> holes under the stage.
> (shouts)
> Dig holes!

The stagehand can't hear him.

> XINFANG (CONT'D)
> I'm coming down.

As Xinfang walks toward the stage, Yaguo enters the room with the theater owner in heated argument. As Xinfang joins them, the three elevate their voices louder and louder, taking turns outdoing one another. Lillian observes from the above in a state of amusement. She hesitates before descending. She quietly takes the theater owner by the arm to seat him. Xinfang and Yaguo look at each other and exit.

EXT. SHABBY THEATER - DAY

Midday sun. Yaguo stands beside the orchestra, the troupe gathered around him. Musicians are seated on the side and ready to begin.

> YAGUO
> Where were we? Sorry... I was
> saying actors must master four
> things: entrance, rhythm, focus and
> exit. This is the quintessence of
> Xinfang's Qi style.

> WELL-DRESSED YOUNG ACTOR
> Tell us the secret to making an
> entrance?

> YAGUO
> There is no secret, only magic. Our
> every movement on stage is
> punctuated and accompanied by
> music, right?
> (MORE)

(CONTINUED)

CONTINUED:

 YAGUO (CONT'D)
 (everyone nods)
 Therefore, it has the most powerful
 entrance in any theater. In that
 split second, like lightening --
 the movement and music become one.
 That's the magic.

Xinfang exits from the theater.

 YAGUO (CONT'D)
 Maestro. Please give us a
 demonstration of entrance.

Xinfang takes a fan from an actor, and gives a quick look at
the orchestra leader. Immediately, music starts. Xinfang
begins to move. He uses every muscle in his body, like a
dancer. He flips open the fan, and allows silence to linger
before reciting a few lines. He stops and he addresses the
troupe.

 XINFANG
 In entrance, it is most important
 to bring the backstory, and above
 all, the essence of the character
 to that moment.

 AN ACTRESS
 Can you explain to us the use of
 rhythm?

 XINFANG
 When I open my fan,
 (gestures)
 I break the rhythm. At that moment,
 I captured the attention of the
 whole theatre. As an actor, we must
 control the rhythm at all time. And
 the rhythm controls the focus.

Well-dressed young actor interrupts Xinfang.

 WELL-DRESSED YOUNG ACTOR
 Maestro, how do we find the focus
 of a scene and why is exit
 important?

 XINFANG
 Let's say you take a scene out of a
 play... Now... if the missing scene
 affects the continuation of the
 story, that is the focus of the
 scene.
 (beat)
 (MORE)

 (CONTINUED)

CONTINUED: (2)

 XINFANG (CONT'D)
 As for the exit,
 (again flips open the fan)
 How about we all exit and focus on
 our lunch?

The actors smile, happy to have learned and ready to eat.
Yaguo joins Xinfang. As Lillian exits the theater, both Yaguo
and Xinfang look on with curiosity. Lillian nods as if to say
everything is fine.

Yaguo gives an awkward smile and walks away. Xinfang and
Lillian look at each other.

MONTAGE - BEIJING OPERA REFORMING

Xinfang sits by the stream, puts his hand into the water. As
he feels the water flowing through his fingers, he notices a
twig moving down the stream. As the twig passes him, it is
trapped by a rock under the water. After many attempts, it
finally frees itself and gently flows away.

Troupe members rehearse. Lillian instructs a few of them at
the back of the set.

The troupe lines up on stage and bows after their first
performance in the new theater. Xinfang is in the center. The
audience applauds loudly.

Different nights, different plays, different audiences -- but
with same feverish applause. Months pass. Many seasons
pass...

Hundreds of black & white photos fade in, showing the
different characters and plays that Xinfang has been
performing for these years, mixed with posters from different
cities that Xinfang has travelled to. The series of black &
white photos saturates with color, and ends with an image of
an older Xinfang.

Lillian, with a pregnant belly, walks to Xinfang and adjusts
his costume.

Another photo is taken.

INT. THEATER - STAGE - DAY

Older Xinfang is in the middle of rehearsal with his troupe
when an actor runs on stage, panicking.

 ACTOR
 Mrs. Zhou is in labor!

Xinfang and all the actors rush backstage.

INT. THEATER - BACKSTAGE

Xinfang leads Lillian to the dressing room. Several actors follow, trying to help. #3 daughter (2) sees mommy is gone and starts crying.

INT. THEATER - DRESSING ROOM

Xinfang stands there, holds Lillian, doesn't know what to do. A veteran actress grabs a long coat and puts it on the floor.

> VETERAN ACTRESS
> Lay her down.

Xinfang lays Lillian down, then looks to the actress for the next step. Lillian is sweating, so is Xinfang.

> VETERAN ACTRESS (CONT'D)
> I can do this. Everybody out,
> (pointing to Xinfang)
> including you. Someone get me lots
> of towels and hot water, quickly!
> Move, move, move...

The actress pushes everybody out.

INT. CORRIDOR, OUTSIDE OF DRESSING ROOM

Xinfang stands just outside the door with #3 daughter, still crying. She starts peeing. While Lillian's SCREAMING continues, the girl's CRYING gets louder. Xinfang is in panicked.

INT. THEATER - RESTROOM

#3 daughter squats down on a Chinese pit toilet with wet pants. Xinfang tries to take them off, but he is overwhelmed so much that he can't find the button. She starts to pee again. Xinfang's wet hands shake.

> #3 DAUGHTER
> You don't know anything!

> ACTOR (O.S.)
> (as baby cries)
> Maestro, where are you? It's a son!

INT. RENTAL HOME - 1935 - NIGHT

Someone knocks on the door.

Lillian, holding her 6-month-old son, opens it. She is shocked to see her brother.

(CONTINUED)

CONTINUED:

> LILLIAN'S BROTHER
> Lillian, I'm sorry to surprise you
> like this.
>> (looks at the baby)
> I didn't know you had a boy.

Lillian steps aside so her brother can come in. #1 daughter (6) plays with #3 daughter (3) on the floor. Lillian's brother pats #1 daughter's head.

> LILLIAN'S BROTHER (CONT'D)
> You must be the first daughter.

> #3 DAUGHTER
> Who are you?

> LILLIAN'S BROTHER
> I'm your uncle, your mother's
> brother. You must be the 2nd one.

#1 daughter interrupts just as #3 daughter is about to answer.

> #1 DAUGHTER
> Mommy, why are you crying?

Lillian's Brother turns and sees Lillian is crying.

> LILLIAN'S BROTHER
> What's wrong?

Lillian composes herself.

> LILLIAN'S BROTHER (CONT'D)
> Mother was very happy to hear that
> she has grandchildren. She would
> very much like to ask you to come
> home.

> LILLIAN
> I am no longer the girl you knew --
> It doesn't matter how harsh life
> is... wherever my husband is that's
> my home.

> LILLIAN'S BROTHER
> Mother was concerned about that.
> Have you finally gotten married?

Lillian's serious face unnerves her brother. She smiles suddenly.

(CONTINUED)

CONTINUED: (2)

> LILLIAN
> Not yet, but soon. Xinfang's
> divorce paper just came through.

> LILLIAN'S BROTHER
> I have good news, too.
>> (beat)
> You know boss Liu (Big Gangster),
>> (off Lillian's nod)
> He opened a new theater, and wants
> Xinfang to come back to Shanghai.
> He'll guarantee his safety.

Lillian is pleased. Edith Piaf's "Mon apéro" plays.

INT. HOTEL - GRAND LOBBY - DAY

Like in any important city, this grand hotel lobby is where
the world meets. There is a dancing area in the middle and,
on the right-hand side, a Caucasian pianist in a suit
accompanies a French female singer's performance.

Heads turn and people murmur excitedly as Lillian passes
through.

The BRITISH HOST (mid 40s) is surprised and delighted to see
Lillian.

> BRITISH HOST
> Mrs. Zhou! How nice to see you
> back. I sat boss Liu at your table.

> LILLIAN
> Thank you, Chris. I'm happy to be
> back.

He takes Lillian to the table. BIG GANGSTER (late 40s) rises
and offers Lillian a seat.

A WAITER brings a refill for Big Gangster and Lillian's usual
drink. Lillian smiles, looks around, and breathes the
glamorous air of Shanghai.

> BIG GANGSTER
> Mrs. Zhou! Welcome back to
> Shanghai. How is Xinfang?

> LILLIAN
> Thank you for asking. He is well. I
> think he is ready to come back.

(CONTINUED)

CONTINUED:

> BIG GANGSTER
> I talked to Lee. This silly
> business of not letting Xinfang
> perform in Shanghai, it's
> ridiculous. I've taken care of it.

> LILLIAN
> Thank you.

> BIG GANGSTER
> Shanghai wants your husband back;
> Xinfang's performances are very
> much missed.
> (pause)
> We will have the grandest opening.
> Now. While I'm in a very generous
> mood, let's do some business.

Lillian looks relieved.

EXT. OUTSIDE, GOLDEN THEATER - DAY

In front of the theater, a giant red banner hanging from the
top of the building reads "Welcome home, Qi Lin Tong (Unicorn
Child)."

There is a long line in front of the theater. All the advance
tickets are sold out, but people still try to get in. As
everybody rushes forward, the theater staff tries to close
the iron gate. The crowd breaks it down.

> MAN (O.S.)
> (in Chinese)
> Call the police! Call the police!

> OLD MAN (O.S.)
> (in Chinese)
> I already called!

Moments later.

Policemen arrive and try to control the crowd with sticks.

INT. FRONT, GOLDEN THEATER - NIGHT

Big Gangster sits with his wife and friends in the box. The
theater is packed with hundreds of excited spectators,
standing room only. Big Gangster smiles with pride.

Lights off. Tonight stagehands stop whatever they are doing
and watch Xinfang's entrance.

(CONTINUED)

CONTINUED:

A small drum and Chinese violin start the music. The curtain rises. The stage is empty except for a pair of chairs and a decorated table. A huge unicorn backdrop dominates the background. Kelan's prediction has come true. A flood of light illuminates the stage.

INT. GOLDEN THEATER - BACKSTAGE

Off stage. Xinfang stands across from the orchestra. His body starts to move in his inner rhythm. The conductor's eye focuses on Xinfang. Beat after beat, the music starts, Xinfang is immersed in the character. He explodes onto stage.

INT. FRONT, GOLDEN THEATER

Everybody stands up and rushes to the front, leaving the seats in the back empty. The VIPs in the front rows are shocked by the people standing around the stage.

 AUDIENCE A
 Bravo!

 AUDIENCE B
 Bravo!

Xinfang tries to begin, but the crowd applause drowns him out. He is overwhelmed by this display of adoration, stronger than any he has ever experienced.

Xinfang steps back and signals the orchestra leader to start the music again. After trying several times, they realize it's impossible to continue.

The orchestra stops playing. Crew members look at the audience. The applause becomes louder and louder.

Finally, with hand to fist, Xinfang takes a traditional Chinese bow. That night, although there was no performance, Beijing Opera reached its height.

EXT. NEW AISA RESTAURANT - DAY

Formally dressed guests greet each other as they head inside.

INT. 1ST FLOOR PRIVATE ROOM OF NEW ASIA RESTAURANT

JANE (Chinese, early 30s), attractive with an underlying sexuality, puffs her cigarette while studying a pair of old cut 10-carat D.I.F. diamond earrings. Helen helps Lillian get ready for the wedding. Nearby, two girlfriends chat.

 (CONTINUED)

CONTINUED:

> JANE
> Where did you get them? What a
> gorgeous pair of earrings!

> HELEN
> Wedding gift from Lillian's mother.
> They belong to the family.

> JANE
> I'm getting married too. Where is
> mine? Look at the size of these
> diamonds.

> LILLIAN
> Your fiancé is a good man.

Jane keeps on looking at the earrings without looking up.

> JANE
> Oh, I am not marrying that one.

> LILLIAN
> It's almost time! Go and check
> where Xinfang is.

One girl stands.

> GIRLFRIEND A
> I'll go.

INT. 2ND FLOOR PRIVATE ROOM OF NEW AISA RESTAURANT

#3 daughter plays with #1 daughter. Both hold dolls in their
hands and giggle. A nanny holds the sleeping baby boy.

Xinfang, absently watching the children, sits upright in the
corner in morning suit and bow tie. #2 daughter sits next to
him. In synchronized motion, they eat watermelon seeds. The
#2 daughter is finally reunited with her parents.

> #3 DAUGHTER
> Daddy looks so serious.

> #1 DAUGHTER
> He always looks like that. Look at
> his funny suit.

> XINFANG
> I heard that, No.1!
> (beat)
> That's why they call it a monkey
> suit.

(CONTINUED)

CONTINUED:

The kids laugh as Lillian's girlfriend enters.

> GIRLFRIEND A
> Oh, my God! You're here. It's time
> to go!

Xinfang stands and straightens his tuxedo. #2 daughter
watches. She looks from him to her sisters.

> #2 DAUGHTER
> Where are you going, daddy?
> I want to come with you!

#2 daughter runs over and grabs Xinfang's leg. She holds it
tight and refuses to let it go.

> XINFANG
> (jittery)
> I'm getting married. You stay here,
> get to know your sisters.

#2 daughter looks at her sisters. They glare at her.

INT. NEW ASIA RESTAURANT MAIN DINING HALL

The dining hall is filled with people of all ages, including
some foreigners. They chat and laugh, enjoying a good time.

Lillian's mother sits with Xinfang's father, who doesn't look
very healthy. While they talk, Robert rises and walks to
greet Yaguo, who sits at a table with Tian Han and Xinfang's
friends. Two distinctive groups are obvious; artists and
socialites, like oil and water.

The wedding march begins to play.

Everyone gasps when Lillian enters on her brother's arm. She
is absolutely gorgeous in a traditional Western white wedding
dress. Her train is carried by two seven-year-old
bridesmaids.

From Lillian's POV, Xinfang is nowhere in the vicinity of the
altar as she approaches it and arrives.

Lillian cranes to the right and spots Xinfang, hiding among
the guests, still eating watermelon seeds and chatting away.
Too nervous to participate in the ceremony, the veteran actor
has stage fright.

All the fear dissipates when he looks at Lillian. He rises to
join her. The room resounds with friendly chuckles and
giggles. Xinfang falls in love with her all over again.

MONTAGE – GLAMOROUS SHANGHAI

Beijing Opera music starts. Xinfang, dressed as the prime
minister performs "Pursuing the general under the moon."

 XINFANG
 (playing the prime
 minister; singing in
 Chinese)
 What a smart general...

The audience joins Xinfang in singing the chorus. And soon –

The whole of Shanghai is singing together with Xinfang, from
East to West. Balancing a bowl of noodles on his head, A BOY
rides his bicycle through the crowd.

 BOY
 (singing in Chinese)
 ... What a ...

As the boy passes, an OLD RICKSHAW MAN going the opposite
direction picks up the lines of the song...

 OLD RICKSHAW MAN
 (singing in Chinese)
 ... What a ...

As he passes a barber shop, the barber takes over...

 BARBER
 (singing in Chinese)
 ... smart general ...

Mixed music takes over; No true glamor without decadence.
Nanking road is lit up with neon signs like a gaudy Christmas
tree. Women of the night cruise the streets, opium dens
pulsate with somnambulant bodies, housewives are glued to
mahjong tables, Europeans in tuxedos play Bridge and
Roulette, all spin the night away.

Russian magicians are busy sawing bodies in half, Catholic
priests with traditional turn-around collars and long black
robes move among the crowd. American sailors with white
uniforms like a glass of milk making shore visits. Foreigners
and Chinese alike dance to tunes of Flamenco, Samba, Foxtrot
and Tango.

Sexy nightclub singers in traditional Chinese dress breathe
their husky voices into the mike while gangsters roam the
floor. Old scholars, who believe in harmony, play Chinese Go.
Chinese nouveau-riche flaunt chauffeur-driven Rolls Royces,
covering engines with mink furs to keep them warm.

(CONTINUED)

CONTINUED:

A sweating coolie pulls a giant cart, one hundred times his weight. Wealth and poverty coexist side by side.

A man sporting a white suit, brown correspondent shoes, and a stylish hat to match, sits in a moving rickshaw. Street children observe their prey. From nowhere, a boy runs out, snatches the hat and disappears.

Japanese and German businessmen do little 'real' business while keeping occupied with spying activities. Jewish refugees fleeing from Nazi Germany pour into Shanghai, the only city that welcomes them. Poverty-stricken Shanghainese share the little they have with the new arrivals.

Newspaper front page, from afar, moves forward. Headline:

"Japanese aggressors bomb Shanghai train station."

"Japanese army launches massacre in Nanking."

"Thousands of Jewish refugees flood into Shanghai ghetto." A photo shows Chinese people sharing their food and clothes with refugees.

"Zhou Xinfang's live broadcast of "The eternal regret of the Ming Dynasty" A patriotic opera blasts from radio speakers. A photo shows Xinfang with headphones and a mike.

SOUND OF BABY CRYING.

"Zhou Xinfang performs for frontline troops while his wife gives birth to son." "Despite heavy rain, hundreds of soldiers sit on wet ground." A photo shows Xinfang performing on stage in the downpour.

INT. TIAN HAN'S HOUSE - NIGHT

Xinfang and Lillian climb a narrow staircase.

EXT. TIAN HAN'S HOUSE - ROOF TERRACE

They reach the roof terrace, where 40 people are gathered. Tian Han sees Xinfang and Lillian. He walks towards them.

> TIAN HAN
> Xinfang, Lillian, it seems I'm
> always saying goodbye to you.

Yaguo and Jian Quan join them.

> LILLIAN
> (to Yaguo)
> I heard you're going away...

(CONTINUED)

CONTINUED:

 YAGUO
 Everyone here is going somewhere. A
 group of us is going to our Party's
 headquarters in Yan'an. Jian Quan
 is taking us...

 JIAN QUAN
 (to Xinfang)
 I've seen your Fisherman's Revenge
 so many times. I was very moved by
 it. Once I performed on stage, of
 course, as a amateur. I really
 enjoyed it.

Tian Han stands on a small stage, gesturing everyone closer.

 TIAN HAN
 Friends -- friends.
 (beat)
 This is a very dark time for China.
 The Japanese have surrounded
 Shanghai. Some of us are leaving
 tonight. We'll be parting but,
 whether we stay or leave, we must
 fight on.

In the distance, the whole city is covered in smoke. The
night sky flares up like fireworks with distant cannon and
machine gun fire. A YOUNG MALE ACTOR jumps up on the stage.

 YOUNG MALE ACTOR
 You all know Tian Han wrote the
 song "March of the Volunteers".
 (beat)
 I think this is the appropriate
 moment.

The young actor surveys the troupe and starts singing. Those
who were sitting jump to their feet. All join in the song.

 EVERYBODY
 (singing, in Chinese)
 Arise! All who refuse to be slaves!
 Use our blood to build our new
 Great Wall. As the Chinese nation
 faces its greatest peril, all
 forcefully expend their last cries.
 Arise! Arise! Arise!

Among them, Yaguo is moved to tears.

Across the roof terrace skyline, many buildings are ablaze.

INT. XINFANG'S HOUSE - DINING ROOM - 1940 - NIGHT

The dining table is set formally for the traditional family
New Year's feast. Xinfang's father sits next to Xinfang. He
smiles as he watches his grandchildren laugh and chatter.

Lillian takes several cards from an envelope and arranges
them in order of seniority. Xinfang, preoccupied, eats
hastily and has almost finished.

 LILLIAN
 Children, before we start eating, I
 want to give you English names. One
 day, all of you will be going to
 study abroad.

She gives a card to each girl.

 LILLIAN (CONT'D)
 (to #1 daughter)
 You're Susan.
 (to #2 daughter)
 You're Cecilia, and--
 (to #3 daughter)
 You're Irene.

They take the cards and look at them. Lillian hands the two
remaining cards to #1 son and #2 son (1).

 LILLIAN (CONT'D)
 (to #1 son)
 Here is your English name, William.
 (to #2 son)
 And you're Michael.

Baby Michael takes the card. He puts it in his mouth,
thinking it's food. Sitting between Xinfang's Father and
Lillian, Irene takes a piece of chicken.

 IRENE
 (to herself)
 Yuck. This chicken's got blood in
 the bone!

She gives the chicken to Xinfang's Father. Both her parents
notice it.

 XINFANG
 Take that back!

Irene is preoccupied with her name card.

 (CONTINUED)

CONTINUED:

> IRENE
> I don't like "Irene". I want
> "Cecilia".

Lillian uses her chopsticks to find a good piece of chicken, passes it to Xinfang's Father, and removes the bloody piece.

Xinfang stands up and leaves.

> IRENE (CONT'D)
> Why is daddy working again tonight?

> LILLIAN
> The New Year Eve's performance is
> the most important one. Oh -- he
> missed the photo.

Lillian signals the servant, who is familiar with the Zhou family New Year's Eve photo ritual and ready with camera and tripod.

Everyone smiles but Xinfang is missing.

The flash pops.

EXT. TEMPLE - DAY

It's a cold, snowy day.

Paper money and worldly goods burn for the afterlife in a bronze bowl-shaped fireplace. From behind, a large group of people in white kneel and bow to the body at the end of the room. A portrait of Xinfang's father hangs on the wall. A Taoist priest loudly describes the whole process.

Xinfang, William (7) and Michael (3), in traditional all-white funeral clothes, kneel in the front. Michael sneaks a peek at William, who is wailing. He looks at Xinfang. There are no tears. Michael tries to cry, but can't. He looks at William again and forces himself to cry, but still no tears.

INT. XINFANG'S HOUSE - DINING ROOM - 1941 - NIGHT

Xinfang and his family repeat the New Year's Eve family tradition. Susan (14), Cecilia (12), Irene (9), William (7) and Michael (3) are gathered around the table, all looking at Xinfang's father's full, untouched setting and empty chair.

A flash pops.

INT. THEATER - BACKSTAGE - NIGHT

From backstage, a hand carries an envelope on a small silver
tray. A KNOCK at the door of Xinfang's dressing room. The
door opens, Xinfang takes the envelope.

INT. XINFANG'S HOUSE - LIVING ROOM - MORNING

The children are scattered in the living room.

> LILLIAN
> He asked you to perform privately?
> Isn't he the Green Gang Gangster?
> (with a half-smile)
> We should just call him "Three G."

> XINFANG
> He's self-promoted. He is working
> for the Japanese.

> LILLIAN
> So... the Japanese will be there?
> Tell him you never perform
> privately.

Xinfang has no response.

> LILLIAN (CONT'D)
> What are you going to do?

A servant walks in with some tea.

> SERVANT
> Mr. Zhou, turn on the radio. Big
> news.

Xinfang turns on the radio, flips channels until a Chinese
announcer speaks urgently. The whole family gathers around
the radio and listens with all ears.

> RADIO SPEAKER
> (in Chinese)
> Without any warning the Japanese
> have made a sneak attack on Pearl
> Harbor. The United States and Japan
> are at war.

EXT. STREET - SHANGHAI - A FEW WEEKS LATER - DAY

> XINFANG (O.S.)
> Now the Japanese will sweep
> Shanghai, even the British and
> French concessions.

(CONTINUED)

CONTINUED:

All the barbed-wire fences are removed from the French
Settlement. The Japanese have taken over the last piece of
Shanghai. As Xinfang's car passes, Japanese tanks and
soldiers fill the street along with the sound of distant
machine gun fire and bomb explosions.

EXT. OUTSIDE, BACK OF CARLTON THEATER – AFTERNOON

Heavy Rain. The day is getting dark.

INT. CARLTON THEATER – BACKSTAGE

A small silver tray with a thicker envelope goes backstage.

Xinfang takes the envelope and opens it up. A bullet drops on
the floor. The note is very short and simple. Two actors rush
in with the same letter and bullet.

> ACTOR A
> Maestro, we got a threatening note--
> (reading the note)
> "Stop performing these operas. They
> are offensive to our new hosts. The
> next bullet will be for you."

The other actor clutches the bullet, trembling slightly.

> ACTOR B
> We're going to be killed?

The sound of bombing in the distance shakes the whole
theater. Actor C rushes in, also with a bullet in hand.

> ACTOR C
> Maestro! The theater is flooded!

Xinfang looks at them calmly and thinks for a moment.

> XINFANG
> Put some planks on the floor.

> ACTOR B
> You still want to open tonight?
> Nobody will show up. It's too
> dangerous.

> XINFANG
> No. We must open. Especially
> tonight. In fact, I will change
> some lines in my singing.

> ACTOR A
> Change lines to what? Which lines?

(CONTINUED)

CONTINUED:

Xinfang looks at him and smiles.

 XINFANG
 See you on stage.

INT. STAGE OF CARLTON THEATER - NIGHT

Packed theater. First three rows are flooded and wood boards
are in place. Some spectators sit and some stand on the
planks. They are so excited the water doesn't bother them.

From Xinfang's POV, PLAINCLOTHES DETECTIVES who work for the
traitor are strategically placed at every exit. They have
surrounded the theater.

With their signature raincoats and hats, it's easy to spot
them. Their faces are grim, their eyes dart back and forth.

Xinfang is not intimidated.

Tension builds. Xinfang looks at the conductor. The Chinese
violin player starts to play. Xinfang is steadfast as he
sings his revised lines:

 XINFANG
 (singing in Chinese)
 As long as we have hope in our
 hearts, there will be a day when we
 will reclaim China.

The crowd knows these two lines have been changed, and the
meaning is clear. First surprised, the crowd goes wild.
Xinfang's eyes flit to the detectives. They exchange looks,
and while the audience cheers, they begin to move.

Within seconds, all of them walk to the front of the stage.

 FAT DETECTIVE
 Stop! Stop! Zhou Xinfang, you're
 under arres...

Boom! He slips through a plank. His bottom hits the ground
and his pants get soaked. The audience bursts out laughing.
The music stops. The audience goes silent.

Xinfang glances at the conductor. The drum starts, followed
by Chinese violin. The audience fills with anticipation.
Xinfang sings straight to the detective and repeats the
changed lines:

 (CONTINUED)

CONTINUED:

> XINFANG
> (singing in Chinese)
> As long as we have hope in our
> hearts, there will be a day when we
> will reclaim China.

The audience roars with ferocious enthusiasm.

INT. CAR - MOVING - LATER

Xinfang sits squeezed between two burly plainclothes officers including the fat detective who fell in the theater, still uncomfortable in his wet pants. Xinfang looks more insulted than scared.

EXT. ENTRANCE AREA OF WU SHIBAO'S COMPOUND - NIGHT

The car pulls into the fortified compound, crawling with German shepherds and men with machine guns. Looking out his window, Xinfang notices a car pass with a Japanese driver and two plainclothes men in the back. They lock eyes. Xinfang's car stops, several black-clad guards emerge to open the gate. Policemen escort Xinfang inside the compound.

INT. WU'S COMPOUND

The detectives escort Xinfang down a long, dark hallway to a huge door leading to a vast dining chamber. Inside WU (mid 40s), with violent eyes and a permanent smile, sits before a huge table set with a sumptuous feast. Smiling, he beckons Xinfang to step closer.

> WU
> I'm glad you could come. I have
> specially prepared your favorite,
> braised pork.

Xinfang glances back at the detectives and others, who have stationed themselves beside the open door. He sits. When a servant tries to serve him, he declines.

> WU (CONT'D)
> I've sent you two invitations. I'm
> very happy this one got your
> attention.

His face is unreadable. Xinfang clears his throat.

> XINFANG
> You should know I never perform
> privately.

(CONTINUED)

300

CONTINUED:

 WU
 You can make an exception. The
 Japanese are my honored guests.
 They are our new hosts in Shanghai.

 XINFANG
 But -- I don't think that's
 possible...

 WU
 The Japanese royal family will soon
 be visiting Nanking. They inform me
 that it's their wish for you to
 perform for them.

 XINFANG
 No. They are misinformed. Thank you
 for the great honor, but I doubt
 the royal family will enjoy the
 type of opera I perform.

 WU
 (smiles wider)
 Oh, no. Don't be so modest. I was
 told if we put all the leading men
 in one pot and distill them, we
 still can't produce one Qi Lin Tong
 (Unicorn Child). With that said,
 (pause)
 With your long, illustrious career,
 surely you must have, at some
 point, performed privately?

Xinfang levels him with his gaze.

 XINFANG
 Only recently. For our troops at
 the battle front.

Wu keeps smiling, but his eyes have gone cold. He laughs
sardonically.

 WU
 Zhou Xinfang, you have a reputation
 of being brave. Let me now show you
 my theater, which is somewhat
 different from yours.

He motions Xinfang to follow him.

INT. BASEMENT, TORTURE CHAMBER

Followed by four guards, Xinfang walks down the dim stairs
toward a hallway lit by weak, bare bulbs. The light hardly
reaches the damp stone walls. Water drips from the ceiling.

There is just enough light for Xinfang to see the barred
cells that line the hallway. In some, he can make out torture
implements: hanging cuffs, water tanks, electric chairs. As
they pass an electric chair, Wu stops.

> WU
> Qi Lin Tong (Unicorn Boy), this is
> the way I practice my art. You've
> been acting for many years, but I
> bet you've never sat on a chair
> like this.

He smiles. Xinfang walks towards the chair.

> XINFANG
> On stage, I've sat on all kinds of
> chairs, including many thrones.
> Certainly I can sit on this one.

Xinfang sits on the electric chair and looks at Wu defiantly,
challenging him to make the next move. Wu smiles wider, never
taking his eyes off Xinfang.

> WU
> I've prepared two gifts for you.
> You may choose one.

Wu puts on his spectacles. The guard brings a tray with two
boxes. He opens one, filled with shining gold bars. He
pauses, allowing Xinfang to admire them. He slowly opens the
other box.

> WU (CONT'D)
> Specially scented perfume.

There is a glass bottle with liquid inside.

> WU (CONT'D)
> It's made with acid.

A tense moment. Xinfang slowly rises and walks toward Wu
without taking his eyes off him. He picks up the bottle.

> XINFANG
> I prefer the perfume. Now get a
> driver to take me back!

(CONTINUED)

CONTINUED:

Wu freezes for a moment, then motions the guard to take Xinfang back.

INT. WU'S COMPOUND - BEDROOM

Wu complains as he undresses.

> WU
> That stupid actor turned me down!

His wife lies in bed reading a magazine.

> WIFE (O.S.)
> What actor?

> WU
> Qi Lin Tong! (Unicorn Child!)

His wife puts down the magazine as he gets into bed. It is Jane, the young woman at Lillian's wedding!

> JANE
> Zhou Xinfang?!

He starts kissing her neck, but Jane gently pushes him away with a sugary smile.

> JANE (CONT'D)
> Not tonight. Maybe tomorrow.

She picks up a cigarette pack. She takes one, lights up, takes a deep drag and slowly exhales...

INT. XINFANG'S HOUSE - DINING ROOM - MORNING

All the children have finished their breakfast and gone to school except Michael (3), who quietly sits at the table with Lillian. The radio is on in the living room.

Xinfang sits at the other end of the table, worried. He takes a sip of tea and puts the cup down. A moment later, he takes another sip and puts it down again. He looks around the table at the empty chairs and finally at Michael. He rises, touches Lillian's shoulder and leaves. The door closes.

Lillian is pale. She now looks more worried than Xinfang. She gazes tenderly at Michael, then quickly grows determined. She leaps from the chair and rushes to the bedroom.

INT. XINFANG'S HOUSE - BEDROOM

Lillian opens the bottom drawer of her bedside table, pushing away some clothes to reveal the pistol seen before. She picks it up and releases the cartridge.

The shrill ring of the phone startles Lillian. She drops the cartridge and the gun on the floor. She hesitates, then picks up the receiver.

 LILLIAN
 Hello?

INT. CARLTON THEATER - STAGE - LATER

Xinfang's troupe looks exhausted and worried.

 XINFANG
 I'm very sad to say that I have to
 disband this troupe. I will
 probably be arrested soon.
 (pause)
 I don't want to risk your lives
 because of my actions.

He makes eye contact with each member of the troupe.

 XINFANG (CONT'D)
 Leave Shanghai if you can.

The actors are more saddened than surprised.

 VETERAN ACTOR
 When will we get back together?

 XINFANG
 I don't know. But I hope soon...
 We'll meet again, in a free China.

The actors exchange looks. A middle-aged actor steps forward.

 MIDDLE-AGED ACTOR
 I think I speak for everyone when I
 say it has been an honor to perform
 with you.

Xinfang can barely contain his emotions as he shakes the middle-aged actor's hand and says his good-byes to his troupe.

INT. HOTEL GRAND LOBBY - AFTERNOON

This is the same hotel where Lillian met with the Big Gangster. This time, there is no piano player and French singer. The grand lobby is quite empty. Its few customers and a skeleton staff all look serious and worried.

Jane, wearing a raincoat and still have her scarf on, has already ordered tea, rises to greet Lillian.

> JANE
> I'm glad you came.

> LILLIAN
> (flatly)
> Thank you for the call.

Lillian sits. The waiter, depressed but happy to see Mrs. Zhou, brings her usual drink.

> JANE
> You're as beautiful as ever.

> LILLIAN
> Thank you.

> JANE
> Is Xinfang all right?

> LILLIAN
> He's well.

> JANE
> So. Did you bring the...

Lillian takes out a small wrapped box and puts it on the table in front of her. Jane stops, eyes wide open, and smiles sweetly.

> JANE (CONT'D)
> I'll make sure everything is all
> right for Xinfang.

> LILLIAN
> Thank you for your help. I must get
> back.

Jane smiles awkwardly as she watches Lillian exit. She grabs the box, opens it and gasps slightly. She takes out the diamond earrings Lillian's Mother gave her as a wedding gift. She snaps the box shut and looks around.

(CONTINUED)

CONTINUED:

The place is empty, all the customers and waiters are gone.
In the distance, Jane sits alone.

Telephone rings, gets louder and louder.

INT. XINFANG'S HOUSE - BEDROOM

The shrill ring of the phone startles Lillian. She drops the
cartridge and the gun on the floor. She hesitates, then picks
up the receiver.

> LILLIAN
> Hello?

INT. WU'S COMPOUND - BEDROOM - AFTERNOON

Jane sits by the bed, holding the phone for a moment. She
slowly hangs it up, deep in thought. She quickly rises, puts
on her raincoat and scarf, and exits.

INT. WU'S COMPOUND - CORRIDOR

Looking across the corridor through the slightly opened study
door, Jane sees her husband, Wu sitting at his desk. She
steals way down the long staircase and scurries out the front
entrance of the building. Seconds later, a car glides into
view and stops in front of the entrance. It is drive by the
same Japanese soldier Xinfang saw in the compound.

LOW ANGLE
The car door opens. Two pairs of boots step out onto the
street. As they approach the CAMERA LEADS them back up the
stairs and down the corridor.

OTS - MOVING
We follow the two men down the corridor. They reach a door,
which is ajar, and push through it. Wu, is sitting at his
desk, working intensely.

Wu removes his spectacles, looks up surprised. BANG, BANG - a
bullet explodes in his forehead, another enters his left eye.

1945 VICTORY MUSIC fades in.

INT. CAR - 1945 - DAY

A chauffeur-driven car travels through the streets of
victorious Shanghai. Lillian, three movie tickets in hand,
sits between Xinfang and Michael (7), who looks out the
window.

(CONTINUED)

CONTINUED:

> LILLIAN
> What do you think of the name
> Vivien Leigh? I mean, Vivian.
>
> XINFANG
> For who?

Lillian takes his hand and places it on her abdomen. He sits
up.

> MICHAEL
> Mommy, you mean I will have a
> younger sister?

Lillian grins.

> MICHAEL (CONT'D)
> (whispers)
> How come daddy is not working
> today?
>
> LILLIAN
> (whispers)
> Do you know how hard I worked to
> get these tickets? Still, it was
> not as hard as getting your sister
> Susan's visa to America. That is
> like getting half of the moon.
>
> MICHAEL
> I want to go to America too!

Xinfang is in his own world again.

EXT. OUTSIDE, MOVIE THEATER

The car stops in front of the movie theater. A big "Gone With
the Wind" poster hangs on the building. A group of people
wait to get in, including some Guo Min Dang (Nationalist)
soldiers.

Xinfang steps out of the car. Lillian and Michael follow.

> FEMALE (O.S.)
> Qi Lin Tong! (Unicorn Child!)

A group of people rushes Xinfang, clamoring for his
autograph. Michael holds Lillian's hand and stands to the
side. Two young men stop in their tracks.

> TALL YOUNG MAN
> Look! Young Unicorn Child!

> (CONTINUED)

CONTINUED:

Michael is very pleased to hear that.

 MICHAEL
 Did you hear that, mommy?! They
 call me Young Unicorn Child!

Lillian looks at him and smiles. While they're talking, more
and more people come to Xinfang. It's now impossible for them
to go in and watch the movie. Xinfang looks at Lillian and
then gets back in the car. Lillian takes Michael's hand and
follows. Michael looks disappointed.

INT. XINFANG'S HOUSE - BOYS' BEDROOM - LATER

Michael puts on a beard and mimics his father, striking a
dramatic Beijing Opera pose in front of the mirror. The big
beard on his small face looks very funny. In the background,
William enters.

Somewhat out of breath, Michael continues vigorously
performing Beijing Opera. As he takes the final pose, he sees
William.

 MICHAEL
 Do you know who I am?

 WILLIAM
 You're a walk-on!

 MICHAEL
 No! I'm Young Unicorn Child!

Michael COUGHS. Asthma. William carries him to his bed, where
a big album full of Russian stamps lies open. William pushes
it aside.

William goes to the table and picks up a medicine bottle, one
of many. He feeds Michael medicine.

INT. XINFANG'S HOUSE - DINING ROOM - 1946 - NIGHT

There are full table settings for Xinfang's father and Susan,
but their chairs are empty. Xinfang, Lillian, Cecilia (17),
Irene (15), William (12), and Michael (8) sit around the
table. A tiny one-year-old Vivian sits in the dolly's chair.

Everyone smiles. A flash pops.

INT. NATIONALIST POLICE STATION - DAY

Xinfang sits, surrounded by Nationalist policemen. One is in
uniform, but the rest are in plain clothes.

 (CONTINUED)

CONTINUED:

> NATIONALIST POLICE (O.S.)
> Tian Han is back in Shanghai. We
> know you have been to the communist
> compound. Oh yes, we know
> everything.

A detective pokes his head in the door, sweeps the room with
his eyes, then shuts it again. It is the same detective who
so long ago searched for Tian Han. He is older and fatter.

> NATIONALIST POLICE (CONT'D)
> I'm warning you, it's unhealthy to
> hang out with people like Tian Han.

Xinfang just looks at him.

> NATIONALIST POLICE (CONT'D)
> I'm a fan, a big fan, but that
> doesn't mean I won't put you away.

Xinfang still doesn't respond.

INT. THEATER - BACKSTAGE - A FEW WEEKS LATER - NIGHT

A hand carries an envelope on a small silver tray. It goes
backstage, where Xinfang talks to an actor after performance.

> DOORMAN
> Tian Han's driver is waiting. He
> says it's urgent.

Xinfang opens the envelope to find a note.

INT. CAR - SHANGHAI

Xinfang looks at the note while being driven through the
streets of Shanghai by Tian Han's chauffeur.

> TIAN HAN (V.O.)
> My good friend, I've arranged the
> meeting. Also enclosed is a poem
> I've written for you. Be safe!
> (Tian Han's poem)
> The past nine years, Mei Lanfang
> grew his moustache and retired from
> active life, and Cheng Yanqiu
> washed off his makeup to become a
> farmer.

> (MORE)

CONTINUED:

> TIAN HAN (V.O.) (CONT'D)
> But through it all, there was a
> heroic actor, Zhou Xinfang, who
> built an invisible bridge to touch
> our hearts from the depths of the
> stage.

As the car passes, Xinfang spots a 40-foot lit up portrait of
Chiang Kai-shek. It dominates the city.

EXT. COMMUNIST COMPOUND - SHANGHAI

The car approaches the communist compound. The driver senses
danger and turns to Xinfang.

> DRIVER
> Squat down, sir. Better not to be
> seen.

Xinfang crouches down as the car approaches the gates. After
the car goes through, the gates close.

INT. XINFANG'S HOUSE - MASTER BEDROOM - LATER

Xinfang walks in, sees Lillian sleeping facing the other way.
She opens her eyes as he lies down beside her.

INT. XINFANG'S HOUSE - DINING ROOM - MORNING

Lillian and Michael have breakfast. The daily newspapers lie
on the table. Xinfang walks in.

> LILLIAN
> Why don't you ask your father.

> MICHAEL
> (whispers)
> I don't think he wants any of us to
> be in the theater.

> XINFANG
> Ask me what?

> LILLIAN
> Are you going to tell me where you
> were last night?

While she talks, she stirs Xinfang's orange juice with a
spoon.

> XINFANG
> I went to say goodbye to Zhou
> Enlai!

(CONTINUED)

CONTINUED:

> LILLIAN
> It's in all today's papers.

> XINFANG
> What? Why?

Xinfang grabs the paper. We see the title "Nationalist negotiation with the Communists has broken-down. The Communists are on the run again."

> XINFANG (CONT'D)
> (to Michael)
> Don't tell any of this to your
> school friends.

Michael nods, looking puzzled. Lillian hands Michael an asthma pill. He looks down to take it. When he looks up, three years have passed.

INT. XINFANG'S HOUSE - DINING ROOM - 1949 - MORNING

A book of sample flags for the new People's Republic of China lies on the table in front of Michael, now 11. Lillian helps a tailor to fit Xinfang's jacket.

> LILLIAN (O.S.)
> (grave)
> Michael, choose the flag very
> carefully. China is relying on you
> to make the right choice.

> MICHAEL
> Really?

Lillian gives Michael a look as if to say "don't be dumb", then continues to help Xinfang with the fitting. Xinfang is uncomfortable. One sleeve is still missing.

> LILLIAN
> Your father has been invited to
> join the National Committee of
> China. Only 600 members! He is
> going to the founding ceremony in
> Beijing.

> MICHAEL
> Can I go?

> LILLIAN
> Even I'm not invited.

(CONTINUED)

CONTINUED:

> MICHAEL
> (disappointed)
> Can I tell this to all my friends?

Lillian nods.

> XINFANG
> Tomorrow I have a rehearsal of
> "Pavilion", followed by the
> performance. Do you want to come?

Michael is thrilled.

> XINFANG (CONT'D)
> It's a story between father and
> son.

> LILLIAN
> That's your father's classic. You'd
> better bring enough handkerchiefs.
> There won't be a dry eye in the
> house.

> MICHAEL
> Why?

> LILLIAN
> You'll see.

> MICHAEL
> Why?

> LILLIAN
> It's about an old couple. They find
> an abandoned baby at the pavilion
> and raise him as their own son.
> (beat)
> Years later. One day, the boy and
> the father revisit the pavilion,
> they meet a woman--
> (beat)
> of course, she turns out to be his
> real mother. Now, the father and
> son must part. That's where the
> handkerchief comes in handy.
> (very serious)
> Michael, that's how you were found.

> MICHAEL
> Really?

As Lillian is about to answer, Michael gives her a look that
says "I got you this time."

INT. THEATER - SHANGHAI - NEXT DAY - AFTERNOON

Michael (11) watches Xinfang and a group of actors in plain clothes rehearsing the opera "Pavilion of the Pure Wind".

Xinfang puts his hand on a kneeling boy's head. Accompanied by the music, Xinfang swings his head in one quick movement.

> XINFANG
> (playing the father,
> reciting in Chinese)
> Son -- Son--

INT. THEATER - SHANGHAI - NIGHT

Xinfang enters on long crutches, wearing all white with large patches. He plays the poor woodcutter, the father of the boy. Michael's clapping joins the applause of a packed house.

Michael, who rarely sees Xinfang perform, is amazed by the audience's electricity and has never been so proud to be his son.

INT. NEW ASIA RESTAURANT - SHANGHAI - LATER

Xinfang is a fixture at the restaurant. Michael sits across the table. There's braised belly pork and vegetable plates, among other dishes. Xinfang eats quickly, as usual.

> MICHAEL
> You always eat so fast.

Michael starts coughing.

> XINFANG
> Bad habit. Always in a hurry to go
> on stage. Why are you still
> coughing?

> MICHAEL
> But you just came from the stage.
> Doctor says asthma is forever.

Xinfang pushes the vegetable dish to Michael.

> MICHAEL (CONT'D)
> I never see you eat vegetables.

> XINFANG
> When I was a boy, that was all I
> ate.
> (MORE)

(CONTINUED)

CONTINUED:
 XINFANG (CONT'D)
 Traveling with an opera troupe, you
 only got one piece of meat a day --
 and then only if you had performed.
 (beat)
 Those days, people were so poor
 they didn't even give their
 children names.

Michael looks at his father with great compassion. He didn't
know his father, the great star, had suffered so much.
Michael points to the scar on Xinfang's forehead.

 MICHAEL
 How did you get that scar?

Xinfang raises his hand to his forehead. The memory of the
scar is painful for Xinfang, and he tries to make it lighter.

 XINFANG
 Some kids were playing with
 firecrackers. I was poor. I had
 never seen a firecracker before.
 They gave me one that was already
 lit --
 (makes a gestures of an
 explosion to his face)
 What a surprise.

Michael looks sad.

 XINFANG (CONT'D)
 You're the only one who knows this.
 It's our secret.

A manager and a waiter come and fuss over the table.

EXT. TIAN AN MEN SQUARE - 1949 - DAY

Tian An Men square is filled with people and flags.

EXT. ENTRANCE AREA OF TIAN AN MEN PODIUM

Bird's-eye view from the top of the podium. A large group of
officials, some in suits, some in long garments, some in
uniforms, wait in the entrance area. Lots of guests are
arriving.

Security officers check documents at various entrances.
Guests move towards the entryway. Xinfang, in suit, is with
Tian Han.

 TIAN HAN
 Look! Yaguo is back!

 (CONTINUED)

CONTINUED:

They walk toward Yaguo, who is pleasing an official standing
next to him. Xinfang taps Yaguo's shoulder.

 XINFANG
 (excited)
 Yaguo!

Yaguo looks older and more serious.

 YAGUO
 Let me introduce Comrade Jian
 Quan... and...

 TIAN HAN
 (as the official turns)
 Yeah, we have met before!

 JIAN QUAN
 That was quite a memorable evening,
 remember? We all sang your
 "Marching of the Volunteers."
 Congratulations! Now that song will
 become our national anthem.

A female assistant whispers to Yaguo.

 YAGUO
 Please -- we have to take care of
 the invitation... You go first.

Xinfang and Tian Han walk on.

 TIAN HAN
 In Yan'an -- he must have gone
 through a lot.

Security stops them and inspects their documents.

EXT. TOWARD THE TOP OF THE PODIUM

Tian Han and Xinfang walk among other guests. Something
exciting occurs to Xinfang.

 XINFANG
 The other day when Chairman said
 "Today, Chinese people stood up,"
 it was very moving.

 TIAN HAN
 He ignited the pride of all Chinese
 everywhere. This will be our
 nation's beginning.

MONTAGE - XINFANG - 1949

Xinfang, Tian Han and around 40 people walk up a 30-foot wide staircase toward the podium. Paul Robeson's deep, moving voice slowly sings the Chinese National Anthem first in Chinese, then in English. Multiple images appear, mixed with archival news footage: armored tanks rolling by, squadrons of planes flying, seas of red flags, peace doves being released...

In the distance, Chairman Mao's voice thunders:

 CHAIRMAN MAO (O.S.)
 (in Chinese)
 Today, the People's Republic of
 China is constituted...

While all these images come and go and converge, a dominating red flag comes to the front. Paul Robeson's voice blends into the National Anthem played by the orchestra.

As they climb the stairs, 30 people become 20,15,10, 5, 2 and finally Xinfang alone reaches the top of the podium to stand before the new flag of the People's Republic of China, gracefully waving in the wind.

The National Anthem becomes the French L'International.

The flag dissolves to another, a red one with a yellow hammer and sickle.

SUPER: Ten years later.

Xinfang slowly raises his right fist over his shoulder.

 XINFANG (V.O.)
 I support, follow, fulfill, obey,
 pledge my loyalty. I'll never
 betray the Party...

 MAN (V.O.)
 Your name?

 XINFANG (V.O.)
 Zhou Xinfang.

The climax of the L'International is reached. Xinfang looks older. He rises to his full height, a proud member of the Communist Party.

EXT. XINFANG'S HOUSE - 1959 - DAY

By the staircase, Lillian sees a very tall William carrying a tray with a pot of tea. A late starter in Beijing Opera, he wears costume boots with a 4-inch high platform every waking hour.

> LILLIAN
> Where is daddy?

> WILLIAM
> He is writing in the study. I'm
> bringing him some tea.

> LILLIAN
> I'll take it.

Lillian takes the tray and exits the house. From the courtyard, she goes up a flight of stairs to Xinfang's study.

INT. XINFANG'S HOUSE - STUDY ROOM, UPSTAIRS

Among the bookshelves are four big closed book cabinets containing historical books of different dynasties. Surrounded by all his scripts, Xinfang writes at his desk. He doesn't hear Lillian enter.

> LILLIAN
> Xinfang, you need to sleep.

> XINFANG
> No, I have to finish this.

> LILLIAN
> You always have to finish
> something.

Xinfang sighs and looks up but doesn't set his pen down.

> XINFANG
> I really have to finish this
> speech. I'm sorry. I know I haven't
> been around much lately.

> LILLIAN
> You haven't been around at all. I
> know we live a privileged life. You
> have all your titles piling up. You
> are an artist, not a politician.
> Our family has sacrificed enough
> for your art, but I'm not prepared
> to make sacrifices for this.

(CONTINUED)

CONTINUED:

 XINFANG
 (stressed out, annoyed)
 I'm doing the best I can.

Lillian's tone remains calm, but her eyes blaze.

 LILLIAN
 You and I, when we started, we were
 one. Everyday, you fought, I
 fought. And now...

Xinfang throws his pen aside.

 XINFANG
 I don't need this.

 LILLIAN
 Neither do I!

Xinfang violently pushes everything off his desk. A large
glass bowl smashes. Silence follows the outburst.

Lillian is shocked, then appalled. She stares at him for a
long while, then quietly exits and slowly closes the door.

In the reflection of the broken glass bowl, Xinfang stares
deep into his own image.

INT. COMMUNIST COMPOUND - WAITING ROOM - DAY

A TELEPHONE RINGS. Yaguo's Assistant (30s), picks it up, then
puts it down. He waves Lillian in. She has been waiting for
some time.

INT. COMMUNIST COMPOUND - OFFICE

Door opens. Lillian stands in the doorway. A male official is
busy signing documents at a big desk. Everything is neat and
organized. The official finishes and looks up. It is Yaguo.

 YAGUO
 Sorry to make you wait. Every day
 is so busy. Please, have a seat.

Lillian, smiling, walks over and sits in front of the desk.

 LILLIAN
 You are such a busy man, now I have
 to make an appointment to see you.

 YAGUO
 It must be important for you to
 have come all the way here.

 (CONTINUED)

CONTINUED:

> LILLIAN
> Xinfang and I -- we had a fight.
> (pause)
> His focus is not on his art. He
> hasn't performed for a long...

Yaguo listens intently, then smiles.

> LILLIAN (CONT'D)
> What's so funny?

> YAGUO
> As a matter of fact, I might have a
> project for him...

> LILLIAN
> He would listen to you. That's what
> he needs.

Sound of SPLASHING WATER.

INT. XINFANG'S HOUSE - STUDY ROOM - DAY

Xinfang looks out the window to see his chauffeur washing the
car in the yard.

> XINFANG
> Yes, Hai Rui.
> (beat)
> I know the character well. The
> official in the Ming Dynasty. Went
> to the Emperor, risked his own life
> by speaking the truth...

Xinfang turns around. Yaguo and Lillian are seated
comfortably on the sofa. A tea set is on the table next to
the book of Hai Rui.

> YAGUO
> That's right.

With both hands, Yaguo slides a book toward Xinfang.

The project excites Xinfang. Yaguo stands and shakes hands
with Lillian before Xinfang escorts him out. Lillian sits,
deep in thought. Xinfang returns moments later, looks at her.

> XINFANG
> What's wrong?

(CONTINUED)

CONTINUED:

Lillian doesn't answer. Xinfang touches his firecracker scar with his right hand.

MATCH CUT TO:

INT. XINFANG'S HOUSE - STUDY ROOM - 1951 - DAY

Xinfang, right hand touching his firecracker scar, looks at the closed door. He looks down at the open drawer and sees a box lined in silk, indented where its contents used to be. He shuts the drawer, walks to the window and looks out.

INT. XINFANG'S HOUSE - STUDY ROOM

Lillian has already left the room. Xinfang sits alone.

EXT. CENTRAL PEOPLE'S GOVERNMENT HEADQUARTER - BEIJING - NIGHT

It is a traditional building, one of the palaces which belonged to the Empress Dowager. It was a dream theater for every actor at the turn of century.

INT. CENTRAL PEOPLE'S GOVERNMENT HEADQUARTER - 1959

Yaguo watches the audience through the curtain. The many V.I.P. guests make it look like every single government official is in the audience.

Yaguo returns to the dressing room. Xinfang is already made up, quiet before his mirror and summoning his strength.

> YAGUO
> When we were kids, our ultimate
> dream was to perform here in the
> palace. Tonight, you will achieve
> your dream.

Two assistants help Xinfang put on his beard. He rises and puts on his sumptuous classical Beijing Opera costume, wildly out of place in stark, gray, communist China.

> XINFANG
> No, my dream is different... As
> long as I have audience in the
> upper gallery, I am content.
> (gestures)
> But tonight there are no galleries.

> YAGUO
> After all these years, you have
> never asked even once how I felt
> about giving up opera.

(CONTINUED)

CONTINUED:

Xinfang is taken aback by Yaguo's abrupt remark. His
assistant hurries him to go on the stage. Xinfang takes a
deep breath and exits.

INT. HALLWAY TOWARD THE STAGE

Xinfang walks through a dim lit hallway, as he opens the door
the world explodes with light.

INT. STAGE - LATER

The Emperor sits on a throne with a high desk in the center
of the stage, surrounded by important officials and various
guards. Xinfang, as Hai Rui, sings

> XINFANG
> (playing Hai Rui, singing
> in Chinese)
> While the emperor eats delicious
> food, his subjects starve to death.
> You treat people like animals. You
> kill them according to your whim.
> If you could see people's hardship
> for even one moment, it would be a
> million times better than
> obsessively prolonging your own
> life.
>
> EMPEROR
> What?!
> (singing in Chinese)
> Even before your execution, you
> dare to criticize me! Take him
> outside and cut him into a thousand
> pieces!

INT. XINFANG'S HOUSE - DINING ROOM - 1963 - NIGHT

The joy of New Year's Eve is by so many empty chairs. There
are full place settings for Xinfang's father, Susan, Cecilia,
Irene, Michael and Vivian. Only Xinfang, Lillian, and William
(29) remain.

Their facial expressions are serious.

A flash pops.

**EXT. SHANGHAI BEIJING OPERA HEADQUARTER - ROOF TERRACE -
SUMMER - SUNSET**

Sunset. A rehearsal is taking place on the terrace of the
theater. Some TRAFFIC NOISE can be heard in the background.
Xinfang teaches two young actors how to make an entrance.

(CONTINUED)

CONTINUED:

William, in makeup, plain clothes and his 4-inch high
platform Beijing Opera boots, rehearses with a FAMOUS ACTRESS
and an eager, energetic YOUNG ACTOR.

William turns quickly. His spear accidentally catches the
Young Actor's face and scratches it. The actor falls to the
floor. Xinfang quickly runs over. He takes a small bottle of
white medicine from his pocket, and tends to the Young
Actor's wound.

Jian Quan appears from the staircase with his people,
including Yaguo. The group freezes at once. Even the street
noises are silenced. The Young Actor recovers from his wound
and jumps up. Everyone disperses except Xinfang and William.

An actress carries a tray with a pot of tea. The Young Actor
intercepts her and grabs the tray.

He walks over to the table where everyone is seated and puts
the tray on the table. His hand shakes as he pours tea for
Jian Quan.

 JIAN QUAN
 There is a project for which I
 really need your cooperation. The
 time has come. We need to
 drastically reform the Bejing
 Opera.

 XINFANG
 What do you have in mind?

 JIAN QUAN
 Well, I think we should perform
 Beijing Opera for our people. It is
 all about Emperors and Empresses.
 Even the costumes are antiquated.
 We should start from a blank page.

 XINFANG
 Yes. But we should always take the
 new from the old. Beijing Opera is
 unique, it's a total theater,
 China's national treasure...

William nods. The Young Actor stands on the side listening.

 JIAN QUAN
 I know in the past you contributed
 a great deal, but now we must
 modernize and reform Beijing Opera
 to meet current needs. Anyway,
 think about it, and we'll talk.

 (CONTINUED)

CONTINUED: (2)

Everyone rises when Jian Quan makes a gesture to leave. Yaguo and his entourage follow.

> WILLIAM
> (whispers)
> What do you think?

Xinfang doesn't answer.

EXT. BACKSTAGE ALLEY OF BEIJING OPERA HEADQUARTER

Two cars are parked behind the busy street alley with drivers. The entourage gets in the second car. Jian Quan and Yaguo walk away from the car.

> JIAN QUAN
> I don't think talking will do much good.
> (beat)
> You know his career better than anyone. Do some research and write a piece to prove to the world his fame is not all that... Diminish his achievements.
> (pause)
> Is this too tough for you?

> YAGUO
> For me, the Party will always come first.

Jian Quan is moved by Yaguo's remarks.

> JIAN QUAN
> Well said. We have to remove all the relics.

> YAGUO
> You mean, people like Tian Han?

Jian Quan doesn't answer.

INT. XINFANG'S HOUSE - STUDY ROOM - DAY

Outside the window, the wind blows. The last leaf of autumn falls.

Various newspapers are scattered on the floor. Different articles about the same subject:

"Eradicate the poisonous root of 'Hai Rui Appeals to Emperor'."

(CONTINUED)

CONTINUED:

"Unveil the black background of Zhou Xinfang's creation. The poisonous root of 'Hai Rui Appeals to Emperor,' criticizes our Chairman."

"Fake Hai Rui - a tool of his anti-revolutionary conspiracy".

"Smash Zhou Xinfang's fierce attack over proletariat dictatorship".

Xinfang stands up and calmly walks towards the window. All he sees outside is grey sky. Lillian looks on.

The door opens. The servant brings in a box of cakes, then shows Yaguo in. Lillian begins clearing the newspapers.

 XINFANG
 No! Leave them there.

Lillian pauses for a second.

 LILLIAN
 Let me get some tea.

She walks out.

 YAGUO
 I'm very upset about these
 articles. Terrible, terrible --

 XINFANG
 You know they're not true.

 YAGUO
 I do. But your options are very
 limited.

 XINFANG
 What do you mean?

 YAGUO
 Well, you have two choices. One is
 ignore the matter, but it will only
 get bigger and bigger. Eventually
 it will become very serious. The
 other is to write an open letter of
 apology. That's the best way. With
 luck, you may defuse the situation.

INT. XINFANG'S HOME - HALLWAY

Lillian appears with tea and cake as Yaguo storms out.

 (CONTINUED)

CONTINUED:

He rushes out. Lillian reaches the door. She sees Xinfang sitting there, his left hand touching his scar.

EXT. XINFANG'S HOME

A bonfire.

INT. COMMUNIST COMPOUND - YAGUO'S OFFICE - NIGHT

Heavy rain with thunder. Through the office window, Yaguo is at his desk, reclining from his chair taking a smoke. The phone rings. After Yaguo picks it up, immediately his body stiffens, lifting the phone higher and higher.

EXT. UNKNOWN MILITARY AIRPORT - SHANGHAI SUBURB - NIGHT

The violent storm continues. A car arrives at the boarding bridge. THE ENGINE IS RUNNING. Yaguo, in raincoat, is received by an official who leads him towards the airplane in the distance.

INT. HALLWAY OF A SECURED COMPOUND IN BEIJING - NIGHT

Following an unknown figure walking through a COLD hallway. People passing by look stiff.

A door at the end of the hall opens. Yaguo is escorted in.

INT. OFFICE IN THE SECURED COMPOUND

Two people await Yaguo: an official and his assistant. They sit around a conference table, drinking tea.

The official puts the tea cup down and gestures Yaguo to sit. Yaguo retrieves a small file from his briefcase, withdraws a sheet of paper. It appears to be a list of names. As he circles one name, the door swings open. Jian Quan and two men enter unannounced. Yaguo and the others rise immediately.

Yaguo hands the paper to Jian Quan, who looks at it and smiles. As he puts the paper down, the official leaps forward to look, knocking the tea cup over. The wet paper reveals the circled name: Zhou Xinfang.

EXT. XINFANG'S HOUSE - SHANGHAI - 1966 - DAY

SUPER: August 23, 1966.

A BOTTLE CRASHING melds with BRAKES SCREECHING to a halt. A truck stops at Xinfang's house. Two other trucks are already waiting.

(CONTINUED)

CONTINUED:

Young men and women in green uniforms with red bands around
their arms. Most are teenagers. They are the famous RED
GUARDS.

The RED GUARD LEADER jumps off the truck and walks to the
yard. A young Red Guard intercepts. A German Shepherd barks
behind him.

INT. XINFANG'S HOUSE

The Red Guards storm into the house. Lillian (61), William
(32) and a servant (50s) are shocked by the chaos.

> MALE RED GUARD
> Where is Zhou Xinfang?!

Lillian struggles to appear calm and controlled.

> LILLIAN
> How dare you burst into my house
> like this?! My husband is not
> here...

> MALE RED GUARD
> This house has been confiscated.
> All of you must move into one room.

> WILLIAM
> On what authority?

> MALE RED GUARD
> We're the authority.

Several Red Guards search the house. A young Red Guard shouts
from the top of the staircase.

> YOUNG RED GUARD
> Look what I found!

He shows the others a stamp album.

> WILLIAM
> Don't touch that...

Before William can finish, the young Red Guard has tossed the
stamp album into the air. Hundreds of stamps flutter down in
a mushroom shape, gentle as snow.

EXT. XINFANG'S HOUSE

A bonfire.

INT. BEIJING OPERA THEATER - BACKSTAGE - DAY

Xinfang walks up the stairs. As he goes backstage, a bucket of water rigged to the door pours onto his head. He calmly takes a handkerchief from his pocket and wipes his face.

He is startled by a chorus of cold laughter and looks up to see a group of actors and strangers waiting for him.

Most of them are Xinfang's colleagues and students. Many familiar faces, including the Young Actor who was accidentally hit by William.

> YOUNG ACTOR
> Zhou Xinfang! You're anti-
> proletariat, anti-revolutionary.
> It's a very serious crime.

A stranger grabs the back of Xinfang's neck and pushes him across the stage to the front. Another stranger follows.

INT. FRONT, BEIJING OPERA REHEARSING THEATER

On stage, a group of young actors rehearse the new modern opera.

The soldiers, with their light makeup, theatrical army uniforms and modern prop rifles, bear no resemblance to the traditional Beijing Opera. Only their singing remains true.

INT. BEIJING OPERA REHEARSING THEATER - CONFESSION ROOM - DAY

Two men sit Xinfang down and interrogate him. A pen and paper are already placed before him.

> INTERROGATOR B
> Zhou Xinfang. You wrote the play
> "Hai Rui". Is it true that Hai Rui
> the character and you speak with
> one voice? Are you criticizing our
> Chairman?

> XINFANG
> No. It's not true.

> INTERROGATOR B
> Tell the truth! Come clean...

> INTERROGATOR A (O.S.)
> (quietly)
> Go and get some tea.

(CONTINUED)

CONTINUED:

After Interrogator B exits, Interrogator A sits down across from Xinfang, who stares at him. We have not seen Interrogator A's face.

 INTERROGATOR A (CONT'D)
 How did you get your stage name?

The question takes Xinfang by surprise.

 XINFANG
 It was a mistake by a poster man,
 because Qi Lin Tong (Unicorn Child)
 and Qi Ling Tong (Seven-Year-Old
 Wonder) sounded alike.

 INTERROGATOR A
 Do you know who I am?

Xinfang shakes his head.

 INTERROGATOR A (CONT'D)
 My grandfather was that poster man.
 He is the one who gave you that
 stage name Qi Lin Tong (Unicorn
 Child).

Xinfang realizes why he looks so familiar. He is the spitting image of the Poster Man with bushy eyebrows.

 POSTERMAN'S GRANDSON
 There are many important people
 like you already in prison,
 including your friend Tian Han.

When Xinfang hears Tian Han's name, he is devastated.

 POSTERMAN'S GRANDSON (CONT'D)
 I'll try to help you. Just write
 and confess, it will make your life
 much easier.

Xinfang scans the documents, then shoves them away.

INT. XINFANG'S HOUSE - STUDY ROOM - DAY

Lillian and Xinfang have moved to the study, small but clean. There is a bed on one side by the window. Opposite are three tall bookshelves with hundreds of books and scripts, all precisely organized. Xinfang's desk is in the corner, and there is an armchair between the bed and desk.

(CONTINUED)

CONTINUED:

Surrounded by his books and scripts, Xinfang reads at the
desk while Lillian folds clothes on the bed. They talk
quietly, as if the walls have ears.

> LILLIAN
> I've been wondering how our girls
> are doing abroad.

Xinfang sighs.

> LILLIAN (CONT'D)
> Michael -- he worships the ground
> you walk on. You didn't know that,
> did you?

Xinfang shakes his head.

A servant enters with a tray of food and a pot of tea. She
sets it on Xinfang's desk. There is his favorite dish,
braised pork, along with scrambled eggs, vegetables, rice,
and a plate of fruit.

MONTAGE - RAPE OF XINFANG'S HOUSE

Midnight. Darkness. Silence. Tense anticipation, followed by
STRANGE SOUNDS. Then, Silence again. Sounds grow even
stranger.

A pair of hands fumbles for the flash light. The light is on
and flashes quickly across the room, up and down, side to
side, and finally fixes on the door. The SOUND OF FOOTSTEPS
ascending the staircase gets louder and louder. The flash
light drops, SMASHES to the floor.

INT. XINFANG'S HOUSE - STUDY ROOM - DAY

The same servant, a little older, brings food for Xinfang and
Lillian. As she walks in, the sight is shocking:

The study has been totally destroyed. Xinfang's desk is
propped up on three legs, the armchair lies on the floor, one
bookshelf is gone. The bed is still there, but the pillows
are gone and the blanket is torn.

The servant searches for a space in the debris and mess to
put the tray down. Finally, she dumps it on the floor; two
bowls of plain noddle soup with wilted scallion on top.

Xinfang and Lillian have little appetite, but go through the
ritual regardless. Xinfang puts up the armchair and tries to
set up the table.

 (CONTINUED)

CONTINUED:

> LILLIAN
> Don't bother to tidy up. They will
> be back.
> (beat)
> What's that smell?

> XINFANG
> They are burning all my costumes.

By then, nothing can shock Lillian. They start eating.
Lillian tries to lighten the mood by changing the subject.

> LILLIAN
> When I am sweeping the street... I
> am at a peace.

Xinfang looks at Lillian as though it were the first time
they met. He holds her hand tight.

> LILLIAN (CONT'D)
> Right now, the thing I miss most is
> a pillow.

Xinfang smiles, looks at his scripts on the floor. He squats
and starts gathering them.

> LILLIAN (CONT'D)
> What are you doing?

> XINFANG
> I'll make you a pillow.

> LILLIAN
> But those are all the operas you
> have written.

> XINFANG
> No. They are just papers.

Xinfang gestures for Lillian to sit up, then fashions a
pillow for her with all the manuscripts. Lillian lies down
and smiles. Xinfang laughs.

The door bursts open.

EXT. XINFANG'S HOUSE - YARD

The guards take them to the street.

A bonfire. Beautiful embroidered silk goes up in flames.

EXT. STREET - SHANGHAI - DAY

The guards shove Xinfang and Lillian out the gate. A large open truck and a van await them.

On the truck, each side sit eight Red Guards. A group of actors and actresses stand in the back.

Xinfang is surprised to see his son William among them.

> XINFANG
> (whispers)
> What are you doing here?

> WILLIAM
> When they beat me, they will beat
> you less.

Xinfang looks back and sees Lillian being pushed into the van. The van and truck take off in opposite directions.

EXT/INT. SMALL HOUSE - SHANGHAI - DAY

A small, derelict house in a busy neighborhood. Lillian is with three Red Guards, who take her up the narrow staircase into an empty, doorless room.

INT. MAKESHIFT INTERROGATION ROOM

A vacant chair in the middle of the empty room awaits Lillian. In the corner by the window, the nasty Young Actor sits on the floor, patiently waiting.

Lillian sits still in the middle of the room. Only her eyes move as she watches a Red Guard INTERROGATOR pace before her, holding a stick. Two Red Guards flank the doorway, watching.

> INTERROGATOR
> Why did you send all your children
> abroad?

> LILLIAN
> To get an education.

> INTERROGATOR
> Liar!

192 Lillian glares at him, more angry than scared. 192

> INTERROGATOR (CONT'D)
> Your husband is a counter-
> revolutionary. You must denounce
> him.

> (CONTINUED)

CONTINUED:

He paces before Lillian with his stick.

> LILLIAN
> About me, I'll say anything you
> want. But I will not denounce my
> husband.

She glares at the Interrogator. He pounds the stick on the
floor.

> INTERROGATOR (O.S.)
> (quietly)
> For the last time.

> LILLIAN
> No!

The interrogator raises the stick and BANGS on the table,
shocking the young actor. Silence. SLOWLY PULLING BACK into
the corridor, DOWN THE STAIRCASE, the TRAFFIC FADES IN.

EXT. STREET - SHANGHAI

Moving out of the front door into the busy street where
people are living their normal lives. From both directions, a
flurry of bicycles whizzes by, impervious to the violence
implemented in the room above.

EXT. XINFANG'S HOUSE - LATER

Xinfang returns from the parade. He enters through the broken
gate, dirty, tattered and exhausted. He sees Lillian with
blood on her forehead, slumped, beaten on the front steps.

> XINFANG
> Lillian! Lillian!

Xinfang runs to her and, despite his age, picks her up and
gently carries her inside. She is unconscious.

INT. XINFANG'S HOUSE - STUDY ROOM

The room is a disaster. Smashed glass, photo frames and a few
remaining half-burned books are scattered on the floor.

Xinfang sets Lillian on the armchair and blinks back tears.
She is bruised, clothes dirtied, with blood on her forehead
and trickling from the side of her mouth. The image is a
little blurry; Xinfang's eyes are deteriorating.

Xinfang gets a glass of water and gingerly holds her head to
encourage her to drink. She comes to, pale, sweating and
disoriented. His heart shatters at the sight of her.

(CONTINUED)

CONTINUED:

> XINFANG
> I'm sorry, Lillian -- sorry...

Lillian tries to respond but doesn't even have the strength
to whisper. She merely mouths "No", then loses consciousness
again.

INT. WINDOWSIDE OF XINFANG HOUSE - DAY

Lillian looks out the window at the pale sky. Her body is
still, but her mind is free. Even the grey sky gives her
comfort and hope. Xinfang walks in with a bowl of hot
porridge. He sits before Lillian's bed. Weak, she barely
smiles. Xinfang spoon-feeds her. While she swallows, he
studies her carefully.

INT. XINFANG'S HOUSE - STUDY ROOM - A FEW DAYS LATER - DAY

A brisk autumn wind blows the last leaves from the trees.

> XINFANG
> I must take you to the hospital.

> LILLIAN
> I don't want to see anyone. You
> know they won't take me.
> (beat)
> Can you open the window?

Xinfang hesitates, then nods and opens it for her.

> LILLIAN (CONT'D)
> (in a slow and weak voice)
> Where's William?

Xinfang bows his head, saying nothing. Lillian panics.

> LILLIAN (CONT'D)
> Where is he?

Xinfang meets her gaze. His eyes are moist.

> XINFANG
> William has been arrested.

> LILLIAN
> Why? For what?

A knock on the door. Xinfang opens it and sees two middle-
aged men in uniform. They are not Red Guards. They are
soldiers.

> (CONTINUED)

CONTINUED:

> SOLDIER A
> Zhou Xinfang, we are here to arrest
> you.

> XINFANG
> Do you have any paper work?

> SOLDIER B
> We have, but we don't need to show
> you.

Xinfang shows no emotion or resistance. He looks at them.

> XINFANG
> Give me a few minutes.

The soldiers nod and wait outside.

Xinfang returns to Lillian. Kneeling before her, he gently touches her shoulder and brings her hand to his cheek. He tenderly caresses her face. They whisper to each other.

> SOLDIER A (O.S)
> Zhou Xinfang, that's enough
> talking. Let's go.

> XINFANG
> Lillian, this time I don't know
> when I will be back. You must take
> care of yourself.

Devastated, Lillian gathers all of her strength.

> LILLIAN
> I will be alright. You go now...

With tears in their eyes, they look at each other and understand everything.

Xinfang stands up and slowly walks away from her. Lillian watches Xinfang's back, but he forces himself not to turn around. He walks on and out of the room. The door closes. FOOTSTEPS descend the stairs.

EXT. OUTSIDE, XINFANG'S HOUSE

A driver waits by the jeep. Xinfang gets in with the two soldiers.

INT. XINFANG'S HOUSE - STUDY ROOM

Lillian remains calm. A moment is frozen in time. She gathers all her strength, gets up and runs toward the door. It's no use. She collapses onto the floor.

> LILLIAN
> (in weak voice)
> Xinfang...

EXT. OUTSIDE, XINFANG'S HOUSE

Burning tires SCREECH away.

EXT. PRISON - SHANGHAI - WINTER - NIGHT

The prison looks more ghastly at night.

EXT. PRISION - SHANGHAI - AUTUMN - A FEW YEARS LATER - DAY

Autumn. A leafless day. Door opens, a lone man steps out. It's Xinfang. With his thick glasses and white hair, he has aged tremendously in the last few years.

EXT. STREET - SHANGHAI - DAY

Xinfang's eyes are failing, his health is deteriorating. He rushes home to see Lillian, knowing in his heart she has already passed on. But still, he tries to walk faster...

He passes a number of houses with big faded characters daubed in red paint. Some are boarded up. Most of the signs are gone. Posters are peeling off the walls. Trash and dead leaves roll by in the breeze. Everything is grey and muted. This catastrophe has destroyed the city.

Three young Red Guards approach Xinfang. He avoids eye contact and keeps walking. They gaze at him as they pass by. To them, he is just an old man. Xinfang bears no resemblance to his former self.

In the distance, Xinfang sees a woman sweeping the street. He hopes it is Lillian, but as he approaches her he realizes it is not. Xinfang keeps looking behind him...

Xinfang stops in front of his house. Having been occupied by so many nameless strangers, the house is unrecognizable.

INT. XINFANG'S HOUSE - STUDY ROOM

Xinfang enters, out of breath. With his blurred vision he can see the room has been cleaned up and put in order. Their bed, desk and chair are still there. He opens the window.

(CONTINUED)

CONTINUED:

Xinfang stands still in a hazy patch of sunlight on the
floor, watching it move as time elapses. In the corner is
Lillian's armchair. Xinfang sees a blurred image of her
sitting there smiling at him.

He drops to his knees and crawls to her. Reaching up, he
touches her arm. He takes her hand and brings it to his cheek
and tenderly caresses her ghostly face, moving with the
miming shaking hand gesture so familiar in Beijing Opera.

Lillian smiles peacefully. Sometimes she is there, and
sometimes she disappears...

The sunlight passing on the wall behind Xinfang reveals his
shadow. He is alone in the room.

Xinfang collapses into tears. He doesn't realize the servant
entered the room behind him.

 SERVANT
 What are you doing in my room?
 (off Xinfang's shock)
 I've moved your junk to my old
 room.
 (turns, shouting)
 He is here! He is here!

A moment later, Yaguo's Assistant enters with the nasty Young
Actors. He takes out a piece of paper and holds it in front
of Xinfang.

 YAGUO'S ASSISTANT
 Zhou Xinfang, on behalf of the
 Revolutionary Committee, I am
 informing you that you are stripped
 of all your official titles.
 Furthermore, you are no longer a
 member of the Communist Party.

Xinfang slowly looks up at him, takes off his glasses and
holds them in his hand.

 XINFANG
 I can't see and I don't hear you so
 well. Can you say that again?

 YOUNG ACTOR
 You're no longer a member of the
 Communist Party.

Xinfang remains silent.

 (CONTINUED)

CONTINUED: (2)

> YOUNG ACTOR (CONT'D)
> Stubborn just like your wife. Look
> what happened to her!

> XINFANG
> No!

He bangs violently on the table.

> XINFANG (CONT'D)
> I do not accept!

Xinfang stands up and walks toward the window. For a split second, even the flat grey sky gives him comfort and peace.

Looking down, Xinfang is shocked to see Yaguo standing in the yard staring at him and coughing deeply. His duty to the Party comes before all else.

Xinfang freezes, rancor in his blood. He bursts out of the room, and passing both men rushes downstairs.

EXT. XINFANG'S HOUSE

Xinfang gets to the street. Yaguo sits in the back of a car, looking straight ahead. He signals to the driver and the car speeds off.

Xinfang draws on his last reserves of strength and runs after the car. The Young Actor and Yaguo's assistant chase him.

INT. XINFANG'S HOUSE - MAID'S ROOM

Xinfang is thrown to the floor. One side of his glasses smashes, but remains attached to the frame.

This small room is nearly empty, dust everywhere. Xinfang's view blurs. A DEAFENING SOUND echoes across the room, followed by darkness and silence. A few rats scurry through the gloomy corridor. A small gate is opened and light bursts in. There is a leafless tree and a tombstone on a hill. The firecracker boy smiles, his hands hidden behind his back.

As the boy gets closer, he becomes Yaguo (12), with a wooden splint on his leg. It is dripping with blood. He limps toward Xinfang. From behind his back he produces a gift. Xinfang accepts naively. He looks down. In his hand is the book of "Hai Rui Appeals to Emperor." A white light explodes in his face.

Night falls. Xinfang is half awake. He puts on his shattered glasses. With his blurry vision, Xinfang shuffles over and reaches for it.

(CONTINUED)

CONTINUED:

He sees a photograph peeking out from under the trash. He looks at it. He is taken aback, struck by clarity. The photo drops.

A hand picks it up and hands it to Xinfang.

INT. XINFANG'S ROOM - HOSPITAL - 1975

Xinfang takes the photograph and looks up.

> YOUNG NURSE
> When I was a little girl, every Sunday, my father took my brother and me to see your matinee. My father always said, you were the first to perform operas for ordinary people. I know he got through tough times by singing your operas.
> (In a whisper)
> In our family, you're a good man.

The young nurse starts to cry as she exits. Xinfang picks up his thick glasses. As he puts them on and turns, one eye is hidden behind shattered and frosted glass. The other lens magnifies a glaring oversized eyeball. He studies the photograph.

The MUSIC of the Cultural Revolution fades in as Xinfang's face gets closer and closer.

INT- XINFANG WITH HIS FAMILY - 1968 - DAY

Xinfang looks depressed. Lillian is determined to have her New Year photo ritual. Under one loose floorboard, Lillian takes out a hidden camera. On the floor sits a makeshift table with no dishes.

All Xinfang's bookcases are gone. The armchair lies on the floor, pages strewn here and there. Xinfang's desk is propped up on three legs. Only a torn blanket is left, no bedding, no pillow.

Compared to the rest of the room, the small, circular makeshift table looks distinctive on the floor.

> XINFANG (O.S.)
> You don't need to do this. Not this New Year.

> LILLIAN
> Especially this New Year, I want to have dinner with all my children.
> (MORE)

(CONTINUED)

CONTINUED:

LILLIAN (CONT'D)
I'm glad they are not with us.
(Determined)
I'll have my photo.

Lillian picks up a scrap of red paper, tears it into pieces.
She puts down each piece.

LILLIAN (CONT'D)
This is Susan, Cecilia, Irene,
(looks at the floor)
Michael, Vivian, William. He is
late.

Xinfang looks away.

INT. HOSPITAL - XINFANG'S ROOM - SHANGHAI

Xinfang lies on the bed, staring with blurred vision at the
ceiling. He gasps for air.

INT. NEW ASIA RESTAURANT - FLASH BACK - NIGHT

Michael has dinner with Xinfang. They are about to leave. A
manager and a waiter fuss over the table.

MICHAEL
I want to be just like you, be
famous, have all the people
applauding.

Xinfang smiles, but soon becomes serious.

XINFANG
No, an actor's life is too hard. My
father, your grandfather, gave me a
life in the opera. But, if you must
have applause, don't listen to the
hand clapping. Listen to the heart.

MICHAEL
How do you do that? Have you ever
heard the heart clapping?

His voice fades to the distance.

MICHAEL (O.S.) (CONT'D)
(echoes)
Heart clapping -- heart clapping...

Michael's voice fades out. The BEIJING OPERA ORCHESTRA fades
in.

(CONTINUED)

CONTINUED:

Evening performance. Michael sits in the audience. Everyone leans forward, mesmerized by the performance.

The parting scene between the boy and his father in "Pavilion of the Pure Wind". Xinfang plays the father like in rehearsal, but in costume and a thick long white beard.

Accompanied by the music, in one swoop Xinfang swings his long white beard. It floats over and covers the boy's head.

> XINFANG
> (playing the father;
> reciting in Chinese)
> Son -- Son --
> (beat)
> When we pass away, you must burn
> paper money and call aloud our
> names, bow in front of the tomb. We
> deserve your courtesy.

INT. HOSPITAL - XINFANG'S ROOM - SHANGHAI

Xinfang is overwhelmed by emotion. He struggles and gasps for his last breath.

MONTAGE - XINFANG WITH HIS FAMILY - FLASH BACK

THE SOUND OF A THOUSAND HEARTS BEATING.

The audience, including Michael, is moved to tears. The fading light gets dimmer and dimmer. Darkness surrounds Michael. Thousands of beating hearts turn to a single heartbeat.

The last speck of light diminishes to black. The single heartbeat gets weaker and weaker and finally comes to a stop.

INT. HOSPITAL - XINFANG'S ROOM

The edges of darkness lighten, like a halo. Pulling back further, the young nurse stands before the bed and draws a white sheet over Xinfang.

INT. HOSPITAL - MAIN WARD

Two nurses wheel Xinfang's body into the main ward. Although it's forbidden to pay any respect to a counter-revolutionary, patients, around 40 of them, struggle to get off their beds. One by one, even the most ill, show their last respects to Xinfang. Everybody bows. Most have moist eyes. The old man with the I.V. bows deeper than anyone, tears pouring from his eyes. It's Yaguo.

(CONTINUED)

CONTINUED:

Xinfang's hand slips out from beneath the cover. A flash pops. A photo floats to the ground like a leaf. It's the last New Year's photo with Lillian's makeshift circular table on the floor and torn paper to represent the Zhou family. A lone figure sits cross-legged. It is Xinfang.

INT. MICHAEL'S RESIDENCE - CINEMA - 1978 - LONDON

A flash pops. A hand picks a photo up off the floor.

Michael holds the red lacquer box and takes out the walnuts that Xinfang's father gave to Xinfang on his departure so many years ago. Michael heads to another room with the walnuts and the photo.

INT. MICHAEL'S RESIDENCE - MAXIMILLIAN'S ROOM - LATER

Michael approaches the bed of his eight-month-old son, MAXIMILLIAN, and sets the walnuts beside the sleeping boy.

As Michael turns to leave, he studies the photo. It shows the New Year's day when Lillian gave the children English names. Every chair is filled, everyone is smiling and happy. The only missing person is Xinfang.

Michael gently touches Xinfang's empty chair with his thumb. He freezes. He turns and takes back the walnuts from Maximillian's pillow.

EXT. STREET - SHANGHAI - 1951 - NOON

SUPER: 1951. Shanghai.

Under a clear sky, 12-year-old Michael rides a pedicab. The wind ruffles his hair. He smiles, taking in the city air of Shanghai for the last time, the sunshine, his freedom.

Michael wears his Sunday best as he pedals the vehicle. He has swapped places with the pedicab man who sits in the back with Michael's sister Vivian (6), a cowlick on her forehead.

Michael's smile fades as they return home. A black car waits, its engine running. Michael stops and jumps off the Pedicab. He gestures to the chauffeur, who pays the pedicab. Michael picks up Vivian and puts her down, then runs into the house.

INT. XINFANG'S HOUSE

Michael pats a German Shepherd puppy as he rushes through the entryway.

 SERVANT
 Hurry! Your father is waiting!

INT. XINFANG'S HOUSE - STUDY ROOM

Xinfang is at his desk. When Michael enters, he looks up, opens a drawer and lifts a red box from a bigger box. He hands it to Michael.

> XINFANG
> Open it when you get to London.
> (beat)
> Your grandfather gave it to me when
> we parted.

Father and son study one another. There's a tenderness in Xinfang's eyes that Michael has never seen before. Moved, Michael reaches out and gently touches the scar on Xinfang's forehead. Xinfang's smile is filled with sadness.

> XINFANG (CONT'D)
> Wherever you go, always remember
> that you are Chinese.

Michael nods, then exits. Xinfang watches him go and continues to stare at the door as if the boy might return. Xinfang touches his firecracker scar. He looks down at the open drawer and sees the silk-lined box indented where the walnuts box used to be.

He shuts the drawer and goes to the window to watch Michael approach the car.

E/I. YARD, XINFANG'S HOUSE / THEATER - 1900

While Michael is walking towards the car, he opens the box. Michael freezes. He looks back, sees Xinfang at the window who acknowledges.

Xinfang's father nods and smiles at Xinfang, but as soon as Xinfang's eyes close, his smile fades and he looks weary and sad. He puts the wild mountain walnuts on top of Xinfang's book and sighs.

He sits with his son for a moment, watching him sleeping, studying him as if trying to memorize his every pore.

> XINFANG'S FATHER
> The only thing I can give you is
> opera.

Xinfang's eyes open briefly. He heard his father's words.

EXT. XINFANG'S HOUSE

William, Vivian, a driver and a servant escort Michael to the
car. He goes to the trunk and takes out a stamp book.

> MICHAEL
> William, can you keep my stamps for
> me?

> WILLIAM
> Sure, I'll keep them in a safe
> place till you return.

The brothers nod their good-byes. Michael turns and kneels
down, gives Vivian a tight hug. Mouth to ear.

> VIVIAN
> (starting to cry)
> Who will take me to school?

> MICHAEL
> (silently to himself)
> I love you--
> (aloud)
> Vivian.

EXT. FRONT, XINFANG'S HOUSE

Michael gets in the car and turns around, keeping his eyes on
William, Vivian and his home as the car drives away.

> MICHAEL (V.O.)
> On that sunny day in Shanghai, I
> left the comfort of my home alone,
> and ventured abroad into the
> unknown. From that day on, I was
> never able to communicate with nor
> see my father again.

William and Vivian get smaller and smaller until he can no
longer see them...

- THE END -

Zhou, Xinfang

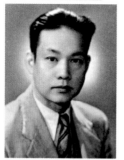

Zhou Xinfang, the founder of Qi style, during his 60 years on stage, he wrote over 200 operas and performed over 600 different characters.

In 1978, Zhou Xinfang was reinstated to his former position. At his memorial ceremony, a wreath was sent by Deng Xiaoping, China's paramount leader, who himself was purged twice during the Cultural Revolution. Zhou Xinfang was declared as the national treasure of China.

Lillian

Lillian, in 1995, rejoined her husband Zhou Xinfang and was interred in the Cemetery of the Elite in Shanghai.

William

William was vindicated in 1978. His first performance was "Hai Rui Appeals to Emperor" in honor of his father, Zhou Xinfang.

Vivian

Six years old, Shanghai, 1951

ZHOU XINFANG'S PERFORMANCE IN REAL FOOTAGE

Sound of Beijing opera music.

"Si Jin Shi" (Four Scholars): A retired court officer helps a woman victimized by the system bring the corrupted judges to justice.

"Zuo Lou Sha Xi" (Killing of the Mistress) : A revolutionary scholar must deliver a vital letter but is blackmailed by his mistress, whom he is forced to kill.

"Xu Ce Pao Cheng" (Dancing on the Castle Walls): Xu Ce, an aged high-ranking minister swaps and sacrifices his own infant son with his ally's soon to be executed son to have him grow up to avenge his slain family on the Emperor. During the dancing sequence on the battlements of the fortress, the minister sings the following lines:

 XINFANG
 (singing; as Xu Ce)
 The clear sky cannot be
 deceived,
 People know what is right and
 what is wrong;
 There will be a result, either
 good or evil;
 The only difference is it's
 coming. Early or late...

Xu Ce joyfully walks away towards the Emperor's palace, knowing that justice is being done under the clear sky.

In 2008, the year of the Beijing Olympics, China celebrated the thirtieth anniversary of the reforms initiated by the visionary leader Deng Xiaoping, which transformed China into a global economic power, and in doing so, changed the world.

List of Works

Four Seasons (Spring), 2013–14
House paint, precious metals, and trash on canvas
147 × 105 × 8 inches (373 × 267 × 20 cm), framed
p. 28

Four Seasons (Summer), 2013–14
House paint, precious metals, and trash on canvas
147 × 105 × 8 inches (373 × 267 × 20 cm), framed
p. 29

Four Seasons (Autumn), 2013–14
House paint, precious metals, and trash on canvas
147 × 105 × 8 inches (373 × 267 × 20 cm), framed
p. 30

Four Seasons (Winter), 2013–14
House paint, precious metals, and trash on canvas
147 × 105 × 8 inches (373 × 267 × 20 cm), framed
p. 31

Beyond White Poles, 2014
House paint, precious metals, and trash on canvas
105 × 291 × 8 inches (267 × 739 × 20 cm), framed
p. 36

Tell Them, the Phoenix Is Rising, 2014
House paint, precious metals, and trash on canvas
165 × 147 × 8 inches (419 × 373 × 20 cm), framed
p. 38

Asia's Island in the Sky, 2013–14
House paint, precious metals, and trash on canvas
165 × 147 × 8 inches (419 × 373 × 20 cm), framed
p. 39

Sorrow for the Fall of the Ming (polyptych), 2013
House paint, precious metals, and trash on canvas
99 × 75 × 8 inches (251 × 191 × 20 cm) each, framed
pp. 42–45

Shoot the Frame, 2014
House paint, precious metals, and trash on canvas
105 × 147 × 8 inches (267 × 373 × 20 cm), framed
p. 47

Remembering 1781 at Sea, 2014
House paint, precious metals, and trash on canvas
105 × 147 × 8 inches (267 × 373 × 20 cm), framed
pp. 23, 49

Under the Clear Sky, 2014
House paint, precious metals, and trash on canvas
99 × 75 × 8 inches (251 × 191 × 20 cm), framed
p. 51

Works on Fire, 2013–14
House paint, precious metals, and trash on canvas
36 × 24 inches (91 × 61 cm) each, framed
pp. 53–59

Ed Ruscha, *MR CHOW L.A.*, 1973
Mixed media on canvas
50 × 60 inches (127 × 152 cm)
p. 167

Peter Blake, *Frisco and Lorenzo Wong and Wildman Michael Chow*, 1966
Collage and mixed media on wood
81 × 27 × 4 inches (206 × 69 × 10 cm)
p. 169

Ed Ruscha, *ZHOU XINFANG*, 1982
Acrylic on canvas
20 × 24 inches (51 × 61 cm)
p. 170

Keith Haring, *Mr. Chow as Green Prawns in a Bowl of Noodles*, 1986
Acrylic on tarpaulin
100 × 100 inches (254 × 254 cm)
p. 171

Andy Warhol, *Untitled* (diptych), 1984
Polymer silkscreened on canvas
40 × 40 inches (102 × 102 cm) each
p. 173

Julian Schnabel, *Eva Holding a Miniature Amulet of Michael*, 1998
Oil on canvas
108 × 102 inches (274 × 259 cm)
p. 174

Julian Schnabel, *Untitled*, 1985
Oil and plate on panel
72 × 60 inches (183 × 152 cm)
p. 175

Jean-Michel Basquiat, *Untitled*, 1985
Acrylic and oil stick on canvas
86 × 68 inches (218 × 68 cm)
p. 177

Alex Israel, *As It LAys – Michael Chow*, 2012
Video portrait
10 minutes
p. 179

Urs Fischer, *Untitled*, 2014
Paraffin wax, microcrystalline wax, encaustic pigment, oil paint, mild steel, and wicks
73 × 22 × 20 inches (185 × 55 × 51 cm)
Edition of 2 + 2 AP
p. 180

Biography

Michael Chow aka Zhou Yinghua

Zhou Yinghua was born into a theatrical Shanghai family in 1939. His father, Zhou Xinfang, the grand master of Beijing opera, is regarded as a national treasure to this day. In his early years, surrounded by a loving family and a famous father, Yinghua developed a passion for Beijing opera, particularly the spontaneity and creativity which his father excelled at. Yinghua dreamed of being a great artist in the opera. This was not to be his fate.

At the age of thirteen, he was sent to London, England. He lost everything familiar: his family, his language, his culture, even his name. Zhou Yinghua was rebranded Michael Chow. Alone and devastated in an alien world, "Michael" struggled to assimilate but found solace in visual arts. In 1956 he studied at Saint Martin's School of Art and the following year at the Hammersmith School of Building and Architecture. Art was a language Michael could grasp with ease and his childhood dream of being an artist shifted from opera to painting. Michael wanted nothing more than to be an artist; however, at that time, being a Chinese artist, he was often met with rejection and exclusion. For over a decade he somehow scraped by, often close to starving. While he knew in his soul he had the talent and drive, he came to the conclusion that it was not enough. The world was not ready. Sacrificing his art for survival, he decided to take a break, a break that became a long, radical sabbatical.

Michael founded his first restaurant, MR CHOW, in 1968, in Knightsbridge, London. It became an international success, spawning locations around the world. He thrived at designing, from specialty boutiques for Giorgio Armani to his own restaurants and home in Los Angeles. Michael has continued to be involved in all walks of creativity, including architecture, theater, and film. He is an appointed member of the board of governors for the Broad Museum in downtown Los Angeles.

Even after half a century, and despite his success, there has always remained a void in his heart that could only be filled with painting. Michael has finally picked up the brush and Yinghua has returned to his childhood home.

Exhibitions

1957 *Young Contemporaries*
 RBA Galleries, London, February–March.

1958 *Young Contemporaries*
 RBA Galleries, London, February–March.

1958 *AIA 25: 25th Anniversary Exhibition*
 RBA Galleries, London, April.

1958 Solo exhibition
 New Vision Centre Gallery, London, May–June.

1958 *Three Contemporary Chinese Painters*
 AIA, London, May–June.

1958 *Artists of Fame and Promise*
 Leicester Galleries, London, July–August.

1958 *Summer Exhibition*
 Redfern Gallery, London, July–September.

1962 *Michael Chow*
 Lincoln Gallery, London, May.

1964 Group exhibition
 ICA London, August.

1965 Group exhibition
 Galleria d'Arte Moderna, Palermo, Sicily, September.

2014 *Recipe for a Painter*
 Pearl Lam Galleries, Hong Kong, January–March.

2014 *Michael Chow aka Zhou Yinghua*
 Vito Schnabel Gallery, New York, May.

His works are in numerous private collections as well as the François Pinault Foundation, the Maurice and Paul Marciano Art Foundation, and the Museum of Modern Art, New York.

Contributors

Jeffrey Deitch
In 1972 Jeffrey Deitch opened his first art gallery, at the age of nineteen. During his forty-plus-year career, he has been an art writer, curator, museum director, and art advisor. Deitch began his dialogue with Michael Chow while serving as director of the Museum of Contemporary Art, Los Angeles. He continues to organize exhibitions and advise some of the world's most prominent art collectors.

Philippe Garner
Deputy Chairman of Christie's, Philippe Garner has been in the auction business since 1970. He is a specialist in all facets of photography and twentieth-century design, fields he has been instrumental in developing through the forty-plus years of his career. Garner has published extensively on his specialist subjects, with many books and essays to his credit. His books range from *Eileen Gray: Designer and Architect* and *Sixties Design* to *Cecil Beaton*, his monograph on the photographer-designer, and *Antonioni's Blow-Up*, his recent study of the cult film. He has curated exhibitions for museum venues in London, Paris, and Tokyo.

Gong Yan
Artist and curator Gong Yan is director of the Power Station of Art and chief editor of *Art World* magazine. After graduating from the École nationale supérieure des Beaux-Arts in Paris, Gong Yan returned to China and established O Art Center in the Shanghai Institute of Visual Arts. O Art Center focuses on art in unstable media and city research, and provides a dynamic platform for young, talented artists and curators. In 2002 and 2006, Gong Yan's work was included in the Shanghai Biennale and in 2007 she was nominated artistic director of Shanghai eARTS Festival.

Christopher R. Leighton
Historian of modern China at the Massachusetts Institute of Technology, Christopher R. Leighton's research interests include business, the Chinese Communist Party, and Sino-foreign cultural exchange over the last century. His dissertation, currently under revision for publication, traces the strange careers of a handful of major capitalists who remained in China after the revolution and made common cause with the Party, shedding business jackets for Mao suits in the 1950s before helping to reconnect the country with global markets (and remaking their lost fortunes) in the 1980s.

Liu Housheng
Born in Beijing in 1921, Liu Housheng's ancestral home is in Zhenjiang, Jiangsu province. Liu worked in Shanghai in the years following the founding of the People's Republic of China. He was Zhou Xinfang's assistant in the 1950s, and, when Zhou served as the bureau chief of the Shanghai Ministry of Culture Opera Improvement Bureau, he acted as deputy bureau chief. When Zhou became the director of the Shanghai Peking Opera Academy, Liu served as deputy director. He is a consultant for the Chinese Dramatists Association, an honorary member of the China Federation of Literary and Art Circles, and honorary chairman of the Zhou Xinfang Art Research Association. He has published a number of research papers on the arts of Zhou Xinfang.

Shan Yuejin
Born in Shanghai in 1958, Shan Yuejin is the director of the Shanghai Peking Opera Academy, which he joined in 1981. He is also a council member of the Shanghai Dramatists Association and the deputy director of the Zhou Xinfang Art Research Association. He holds a degree in Chinese literature from Shanghai Television University (now Shanghai Open University) and also attended the graduate program of the Shanghai Theater Academy. He has acted as producer and creative planner for many new works of traditional Chinese opera. Long involved in theater criticism and theoretical research, Shan was the winner of the fourth Chinese Theater Theoretical Criticism Prize.

Philip Tinari
Director of the Ullens Center for Contemporary Art in Beijing, Philip Tinari has curated Michael Chow's first exhibition in China. Prior to joining UCCA, Tinari was editor-in-chief of *LEAP*, the international art magazine of contemporary China, which he founded and ran from 2009 to 2011. He has worked as China representative for Art Basel, as a contributing editor to *Artforum*, and lecturer in art criticism at the China Central Academy of Fine Arts. Tinari holds degrees from Duke and Harvard universities, and was a Fulbright fellow at Peking University.

Christina Yu Yu
Director of USC Pacific Asia Museum in Pasadena, California, Christina Yu Yu was previously a curator of Chinese and Korean art at the Los Angeles County Museum of Art. She worked for ten years at the Beijing branch of the New York gallery Chambers Fine Art, where she first became immersed in China's contemporary art scene. Yu Yu received her PhD in art history from the University of Chicago.

Acknowledgments

Special thanks to the following people who helped make this book a reality
and to all of the artists who are an integral part of Michael Chow's story.

Bian Ka
Yu Chen
Asia Chow
Cecilia Chow
China Chow
Eva Chow
Maximillian Chow
Dustin Cosentino
Laurent Degryse
Zoe Diao
Philippe Garner
Gong Yan
Richard Green
Luluc Huang
Monica Hyun
Jin Kim
Lana Jokel
Bettina Korek
Christopher R. Leighton
Li Jing
Li Xu
Li Zhong Cheng
Ailsa Liu
Liu Housheng
Karen Marta
Fredrik Nilsen
Jacquie Poirier
Patrick Rhine
Julian Sands
Rusty Sena
Shan Yuejin
Philip Tinari
David Torrone
Guy and Myriam Ullens
Xiaoqing Wang
Lorraine Wild
Xiang Liping
Xie Yindi
May Xue
Christina Yu Yu
Zhao Wei Na
Zhang Qin
Zhang Xin Zhong
Zhou You Cheng

Francis Bacon
Donald Baechler
Paul Bartel
Georg Baselitz
Jean-Michel Basquiat
Peter Blake
Ross Bleckner
Peter Brandt
Anthony Caro
Patrick Caulfield
John Chamberlain
Sandro Chia
Brian Clarke
Francesco Clemente
George Condo
Ronnie Cutrone
Jim Dine
Ian Dury
Urs Fischer
Dan Flavin
Joe Glasco
Red Grooms
Mark Grotjahn
Richard Hamilton
Keith Haring
Damien Hirst
David Hockney
Howard Hodgkin
Dennis Hopper

Alex Israel
Jasper Johns
Allen Jones
Alex Katz
Jeff Koons
Roy Lichtenstein
Mystery guest 1
Mystery guest 2
Mystery guest 3
LeRoy Neiman
Louise Nevelson
Isamu Noguchi
Gary Oldman
Eduardo Paolozzi
Richard Prince
Robert Rauschenberg
Larry Rivers
James Rosenquist
Dieter Roth
Ed Ruscha
David Salle
Kenny Scharf
Julian Schnabel
Tony Shafrazi
Richard Smith
Joe Tilson
Cy Twombly
Andy Warhol
Zao Wou-ki

Many thanks to Gucci for their sponsorship of this exhibition. G U C C I

Published on the occasion of the exhibition
Michael Chow: Voice for My Father

Ullens Center for Contemporary Art, Beijing
January 24–March 22, 2015

Power Station of Art, Shanghai
April 17–June 28, 2015

Andy Warhol Museum, Pittsburgh
January 2016

EDITORS
Karen Marta and Philip Tinari
DESIGN
Lorraine Wild and Xiaoqing Wang,
Green Dragon Office, Los Angeles
ASSISTANT EDITORS
David Torrone and Patrick Rhine
PRODUCTION MANAGEMENT
Monica Hyun and Yu Chen
PRODUCTION
Dustin Cosentino and Jacquie Poirier (Clementine Books)
PHOTOGRAPHY
Fredrik Nilsen
COPY EDITOR
Miles Champion
COLOR SEPARATIONS
Echelon, Los Angeles

ISBN: 978-9-881-62236-5

Ullens Center for Contemporary Art (UCCA)
798 Art District, 4 Jiuxianqiao Rd, Chaoyang District
Beijing, China 100015
Tel: +86 10 5780 0200
www.ucca.org.cn

Available in China from UCCASTORE

Distributed in North America by
D.A.P. / Distributed Art Publishers, Inc.
155 6th Avenue, 2nd Floor
New York, NY 10013, USA
Tel: +1 212 627 1999
www.artbook.com

Printed in China

COVER Zhou Xinfang as Deng Ai in *Crossing the Yinping River*, 1915 (LEFT), Michael Chow, *Self-Portrait*, 1959 (RIGHT).

PAGE 22 J. M. W. Turner, *Slave Ship (Slavers Throwing Overboard the Dead and Dying, Typhoon Coming On)*, 1840. Oil on canvas. Photograph © 2015 Museum of Fine Arts, Boston.

PAGE 160 © Michael Halsband

MURDER IN THE ORATORY

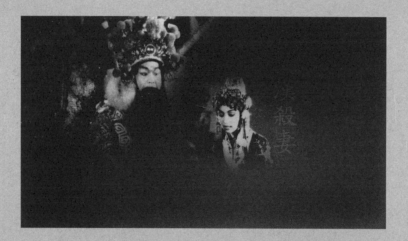

Murder in the Oratory, directed by renowned film director Fei Mu, was released in 1937 on the eve of the August 13 Battle of Shanghai during the Second Sino-Japanese War. Drawing on the popular cultural reservoir of Beijing opera (the same story, entitled *Wu Han Killing His Wife*, was made famous by the Hui School), Fei deftly merges the operatic and the filmic, crossing the stylized flair and song of Beijing opera with the expressive camera possibilities of film (including point-of-view camera angles and movement).

Zhou Xinfang, who played the leading role of General Wu Han, adopted the Shaoxing Opera *Tong Pass* style to create a work rich in theatricality that emphasized both singing and acting. Zhou said at the time, "Shooting a film is even more difficult than theater to get everything just right. Because on the stage you can get your lines out in a single breath, and the actors have a sense of their own presence. But on screen, a play is composed of countless shots. You cannot finish your lines within a single go, and some must be split into several days of filming. You cannot film [in an order] determined by the script. You often film scenes in reverse, so it is often difficult for the actors to become engrossed within the scene, and sometimes they can't even remove their makeup as they wait for the director's schedule."

On its release, *Murder in the Oratory* sold out for 31 days straight, a total of 93 showings. Many renowned figures sang its praises; Mei Lanfang described it as "Innovative in its observation of the past," and Tian Han commented, "The silver screen brings new life to the old stage."